DRAWING IN COLOR

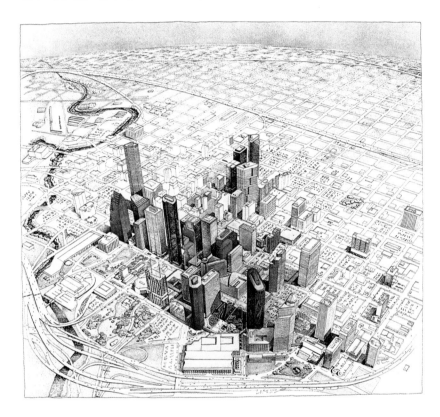

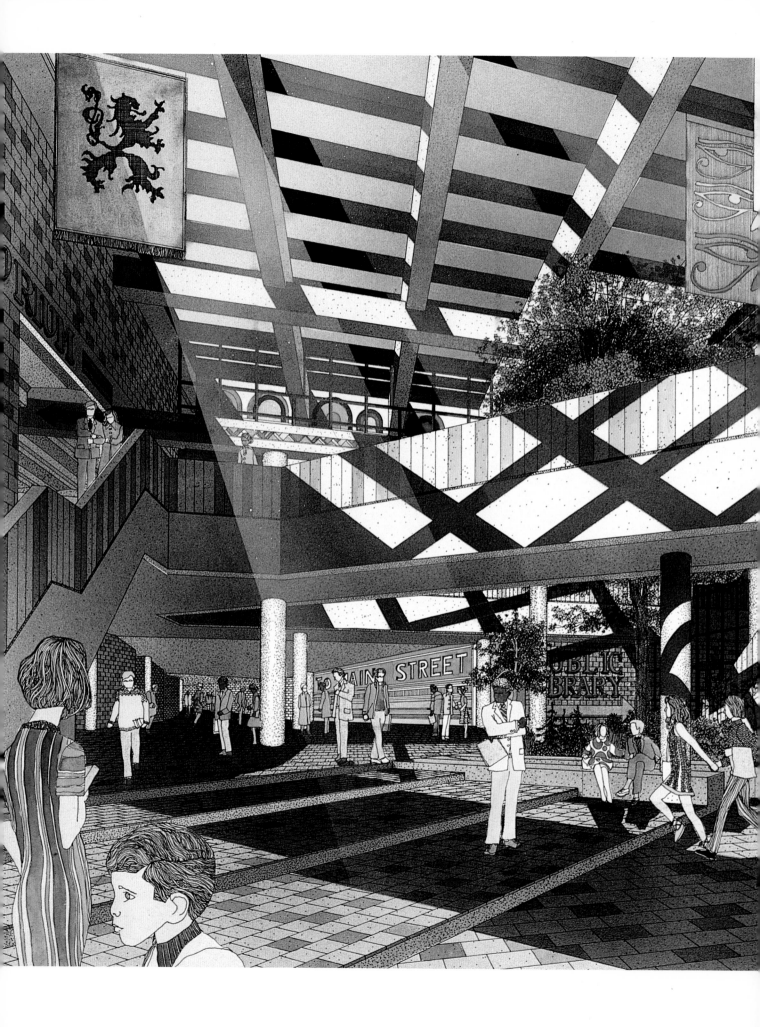

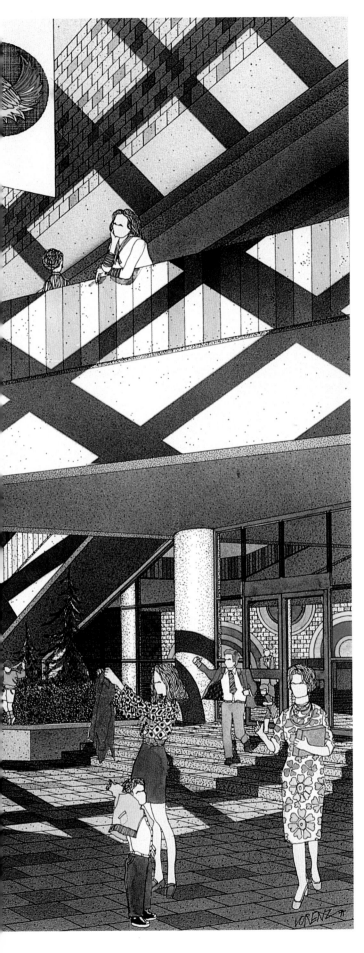

ALBERT LORENZ AND
STANLEY SALZMAN

DRAWING IN COLOR

RENDERING TECHNIQUES FOR ARCHITECTS AND ILLUSTRATORS

WHITNEY LIBRARY OF DESIGN
An imprint of Watson-Guptill Publications/New York

For our families:
Sue, Bly, Brie, Amy, Maureen, Margaret, Kirsten

First published in 1991 by the Whitney Library of Design,
an imprint of Watson-Guptill Publications,
a division of BPI Communications, Inc.,
1515 Broadway, New York, N.Y. 10036

Library of Congress Cataloging-in-Publication Data
Lorenz, Albert.
 Drawing in color : rendering techniques for architects
and illustrators / Albert Lorenz and Stanley Salzman.
 p. cm.
 Includes index.
 ISBN 0-8230-1384-7
 1. Color drawing—Technique. 2. Visual communication.
1. Salzman, Stanley. II. Title.
NC758.L67 1991 91-2431
741.2—dc20 CIP

Distributed in the United Kingdom by Phaidon Press, Ltd.

Manufactured in Singapore

First Printing, 1991

1 2 3 4 5 6 7 8 9 10/96 95 94 93 92 91

ACKNOWLEDGMENTS

Maureen Lorenz
Joy Schleh

Ron Hoina
Christian Xatrec
Leonard Lizak
Gonzalo Bustamante
Neil Mahimtura
John Alastick
Myron Mirgorodsky
Kirsten Lorenz
Christopher Clay
Peter Primak

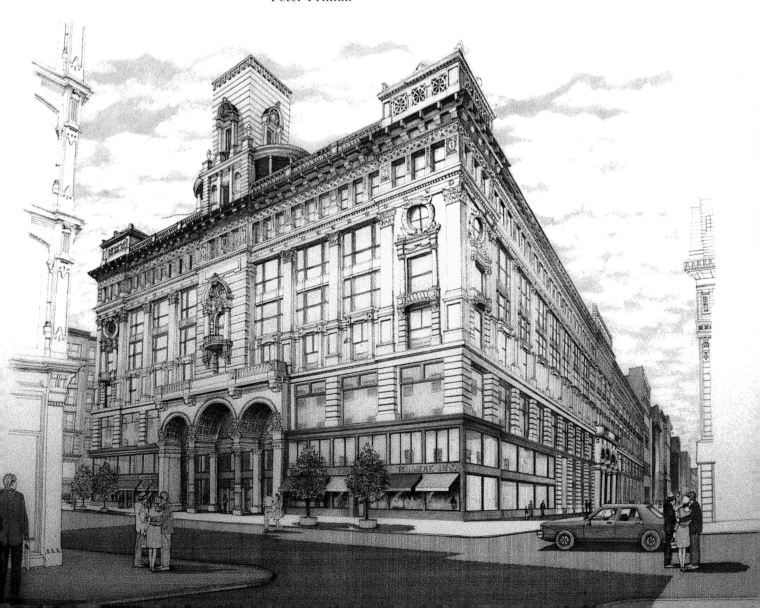

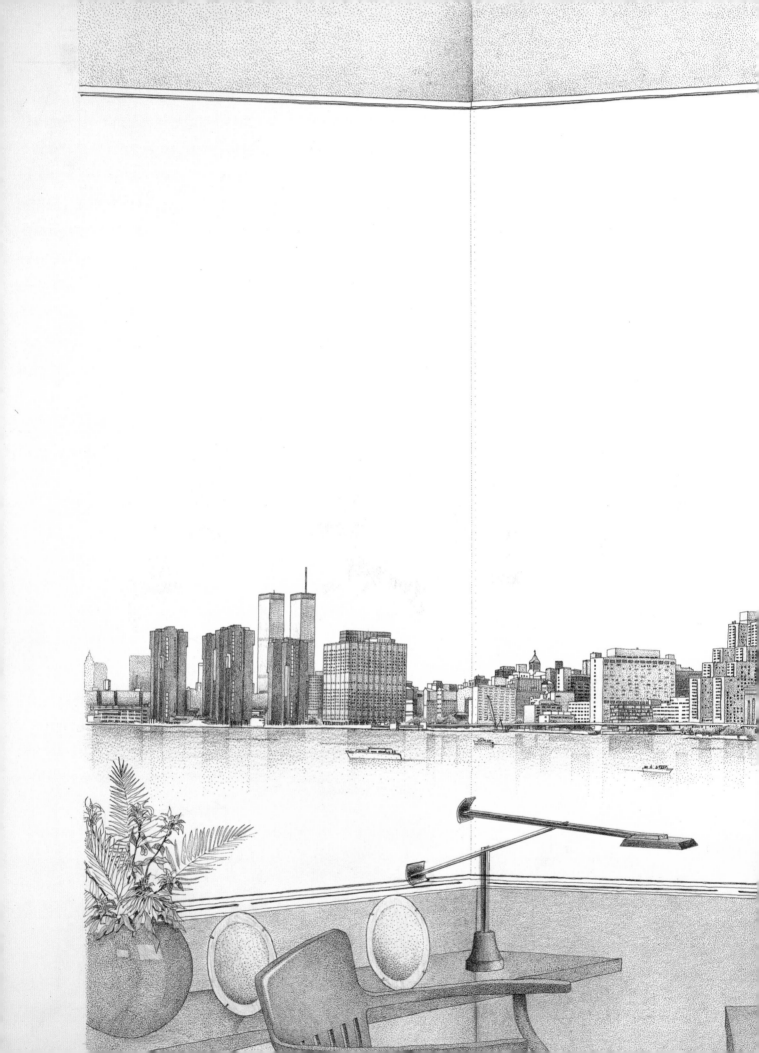

CONTENTS

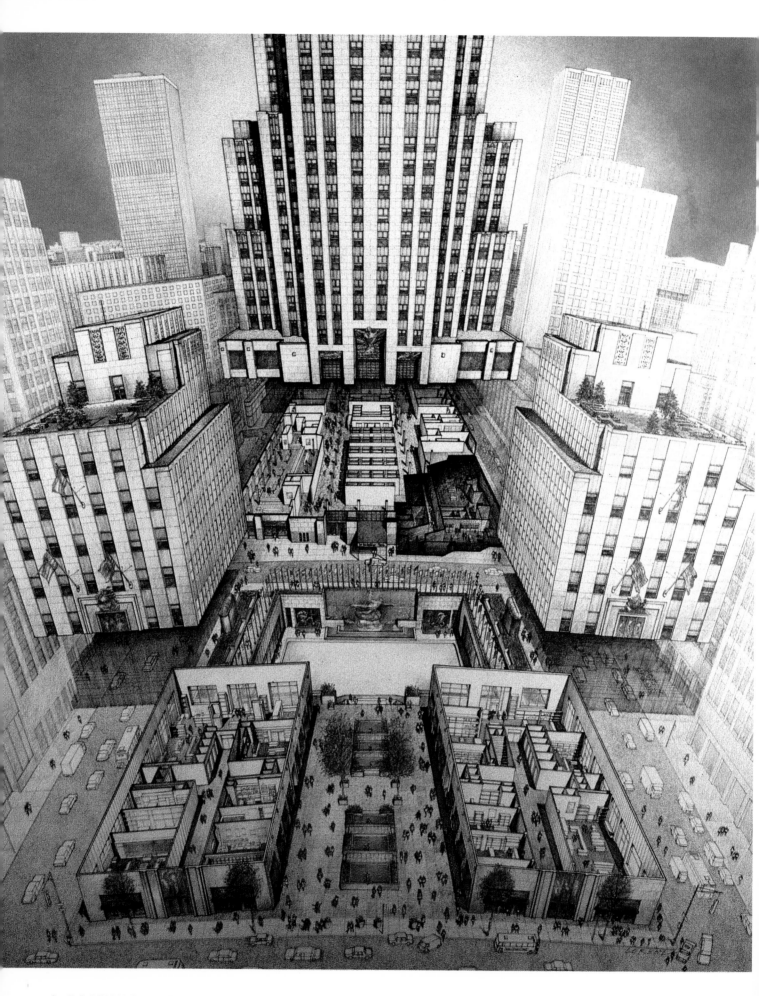

INTRODUCTION

This book is designed to celebrate color and to stimulate the illustrator in the creative use of color. Color can be used to communicate ideas, moods, and emotions; to define volume and space; and to simulate materials. The architect and interior designer are involved with all of these uses of color, while the illustrator is primarily concerned with color as a communication device.

Illustrators work for a variety of clients, including architects, interior designers, advertising agencies, and magazine and book publishers. The challenge to the illustrator is to creatively account for the specific needs of a client in terms of space, message, and materials. The illustrator must work within a given time frame and budget, and a job may involve original works, slides, brochures, or even reproductions of color illustrations in black and white. To effectively present a job in color, the illustrator must understand color. We thus begin this book with a simple presentation of color theory and explanation of systems of color identification.

Most books on color end with schemes for color harmony. Harmonious color schemes support the creative use of color, but they are not creative within themselves. This book, therefore, begins with systems of color harmony, then moves beyond theory. In discussions on drawing and on media, we show how, why, and when to use the various color media, and with illustrations, we show the results of combining drawing assignments with the proper color media.

Many of the architectural and interior designs in this book are the works of our students. As Distinguished Professors at the Pratt Institute School of Architecture, we asked students to find existing projects that they would enjoy illustrating in color. The students invented clients with specific requirements and color schemes. They then completed the work as if they were practicing professional illustrators. They had great fun completing their drawings, and we wish to congratulate and thank them for the use of their projects (which are denoted by an asterisk following the title of each work).

It is our hope that this book is of creative and pragmatic value to architects, interior designers, landscape architects, other design artists, illustrators, and students.

COLOR AND DRAWING

THERE IS NO COLOR IN THE REAL WORLD. THE PERCEPTION OF COLOR IS DEPENDENT ON ENERGY, ELECTROMAGNETIC WAVES THAT RADIATE TO THE EYE AND STIMULATE THE SENSATION OF COLOR IN THE BRAIN. TO EXPERIENCE THIS SENSATION THERE MUST BE LIGHT, OBSERVED MATERIAL, AND THE ABILITY TO PERCEIVE COLOR. THE ABILITY TO PERCEIVE COLOR MEANS THAT THERE IS VISIBLE LIGHT AND THAT THE EYES, COLOR RECEPTORS, OPTIC NERVES, AND BRAIN FUNCTION NORMALLY.

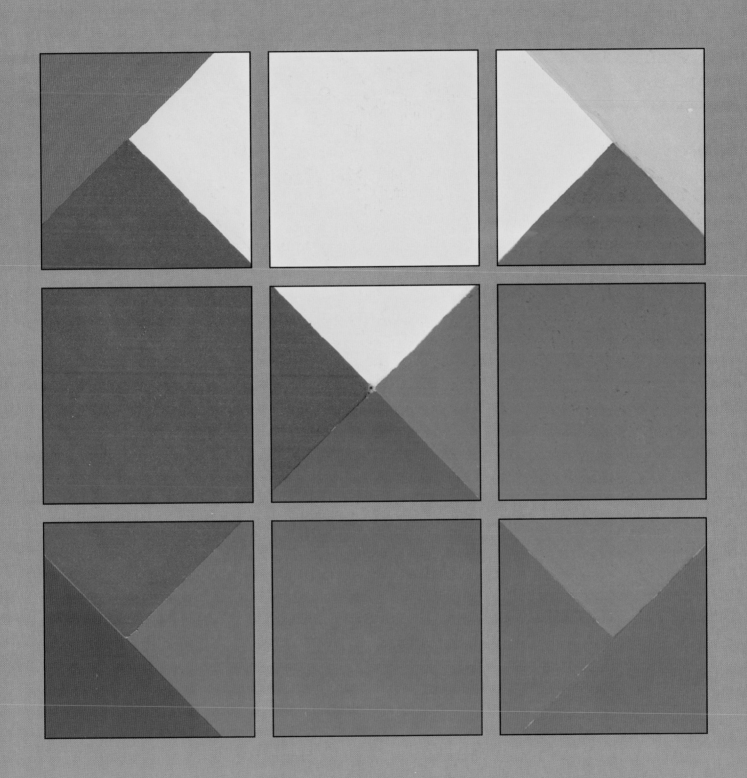

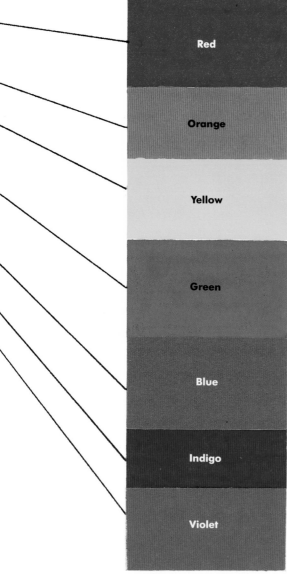

Longest wavelengths

Red

Orange

Yellow

Green

Blue

Indigo

Violet

Shortest wavelengths

Figure 1. Refraction of light through a prism. Newton's spectrum of seven colors from red (with the longest wavelength) to violet (with the shortest wavelength).

COLOR

Sunlight, or white light, is the wavelength between violet and red visible to the human eye. Sir Isaac Newton, refracting sunlight through a glass prism, found seven spectral colors: the rainbow.

The artist communicates a color by filtering light. These filters are *pigments*. A surface appears red when all the wavelengths other than red are filtered or absorbed and the red wavelengths are reflected to the eye. The chemist uses a *vehicle* to turn pigment into a liquid, such as paint, stain, or dye.

Colors in pigment are subtractive. As they are mixed, they lose brightness. When colors in light are mixed, however, strength is gained; the colors are therefore additive. For example, mix red and green in pigment and the result is gray. Mix red and green in light and the result is yellow. Mirrorlike materials reflect most of the spectral wavelengths, so light, and not color, results. Mat materials absorb certain wavelengths and reflect others that send sensory information to the brain to signal a color. Rough, smooth, dense, and loose textures affect absorption and reflection.

White light varies from sunrise to sunset, as creatively painted by Monet, and from season to season. The colors of technically produced or artificial light vary as well. Colors as perceived, then, are variable. Colors change as the light changes, as the observed material changes, and as the observer changes.

LIGHT According to Newton, there are seven colors or hues in the spectrum, which is the order of colors in light. The spectrum of visible light represents a very small district within the total electromagnetic field. Red, a color that most people can see, has the longest visible wavelength. Infrared, radar waves, and radio waves have longer wavelengths than red and cannot be seen. Violet has the shortest perceptible waves. Ultraviolet, X-rays, and gamma rays have shorter wave lengths than violet and are not visible. The colors, then, from long to short waves are red, orange, yellow, green, blue, indigo, and violet (purple is not a spectral color). Newton's experiment to prove this was quite simple. He passed a beam of sunlight through a glass prism, projecting the light onto a screen. The spectrum appeared with the longest waves, red, at the top and the shortest waves, violet, at the bottom (see fig. 1). Passing the spectrum through an inverted prism resulted in white light.

Although mixing all of the spectral colors creates white light, mixing three—red, blue, and green—will create light without the others. These three are the *primary colors* of light. Paired off, they create the secondary colors, magenta (red and blue), cyan (blue and green), and yellow (red and green). As mentioned above, mixed colors in light become brighter, since they approach white light itself (see fig. 2). Understanding the interaction between light and pigment provides the artist with a process for understanding expression and communication in color.

PIGMENT Materials are filters. They absorb some light waves and reflect others. These materials, natural or synthetic, reflect color to the eye and then to the brain for identification. Visual artists use filters: pigments in vehicles of water, oil, milk, and other substances. Of these, water- and oil-based colors provide the vehicles for the illustrator. Although water- and oil-based colors are opaque, excluding dyes and inks, they can change from opaque to translucent or even transparent when diluted, offering other dimensions for color communication. The surface on which these color filters are positioned affects the color as seen. In the visual arts, the surface is usually opaque. Canvas or paper—rough, smooth, glossy, or mat—has a strong impact on how colors are perceived.

The Phoenicians produced purple from the murex snail and provided the bridge to change the linear rainbow of light into the color circle of pigment. In pigment the basic colors are red, blue, and yellow. When mixed, the primary colors red and blue become purple, red and yellow become orange, and blue and yellow become green, the secondary colors of pigment. Violet, a spectral color in light, becomes a tertiary color in pigment (purple and blue), and indigo in pigment is quaternary (violet and blue). One could continue to subdivide pigments but most color wheels stop at the tertiary level.

The number of colors in the color wheel varies from ten to twenty-four. The specific color, red, yellow, green, blue, or all the others, is called the *hue* of the color. A color, however, is identified by more than hue. Black or white, when added to the hue, can change the color. Black shades and white tints the hue and changes its *value* or tone to generate different colors. Hues that are opposite on the color wheel are complementary. Complementary hues, when mixed, contain red, yellow, and blue, and being subtractive,

Figure 2

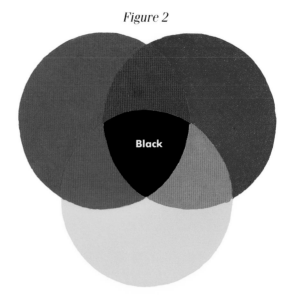

Primaries of pigment are subtractive

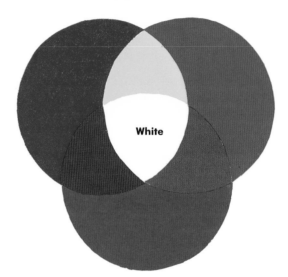

Primaries of light are additive

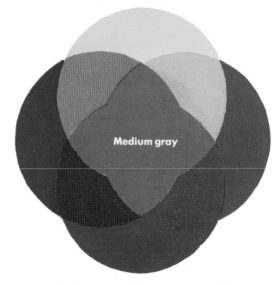

Primaries of vision are neutral

Figure 3. Color wheels

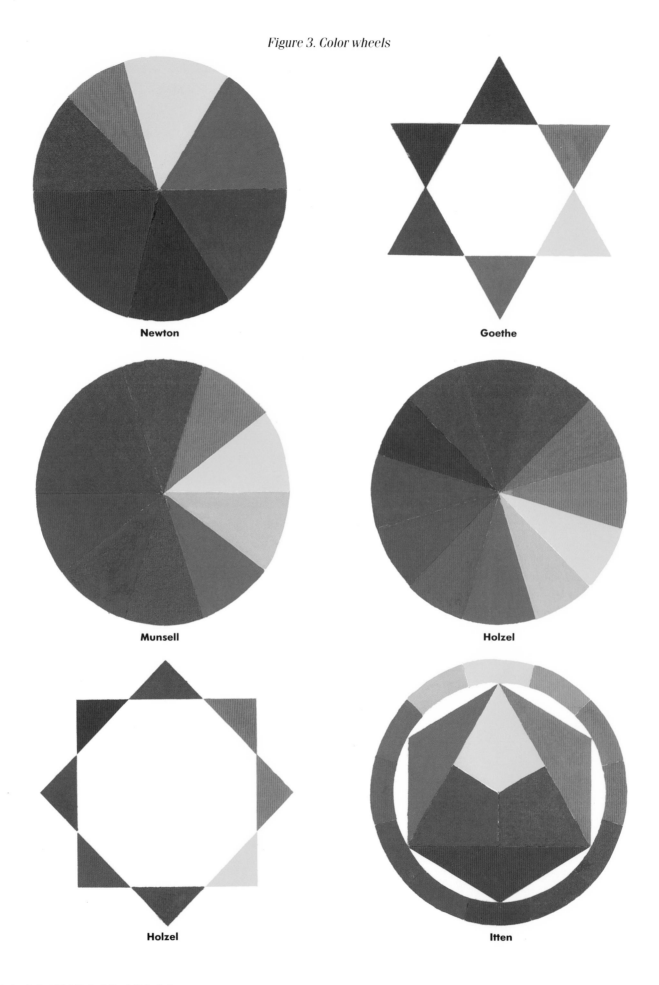

Newton

Goethe

Munsell

Holzel

Holzel

Itten

they become black in theory. In reality, the mix of these hues reflects some light so that the visual combinations are actually grays. Red and green, blue and orange, and yellow and purple are complementary and create wonderful grays. The third identification of a color is its *intensity* or strength, purity, saturation, or chroma. The brightness of a color can be measured by the quantity of its complementary hue in the color. If a color contains less of its complementary hue, it is brighter; if it contains more, it becomes less intense. A color in pigment is therefore identified by hue, value, and intensity.

The color wheel is a flat, two-dimensional surface, that can only show hue. Value is identified on a linear, one-dimensional scale with black and white as extremities and the hue in the middle. Intensity is also linear, with complementary colors at the ends and gray (theoretically black) in the center.

It is possible to chart intensities and values of one hue on one surface. The values and intensities of the entire color wheel, all hues, require a three-dimensional configuration. It is fascinating to examine the two- and three-dimensional systems that have been designed during the past three centuries to identify color (see fig. 3). Of these systems of color identification, the Munsell system (see fig. 4) in the

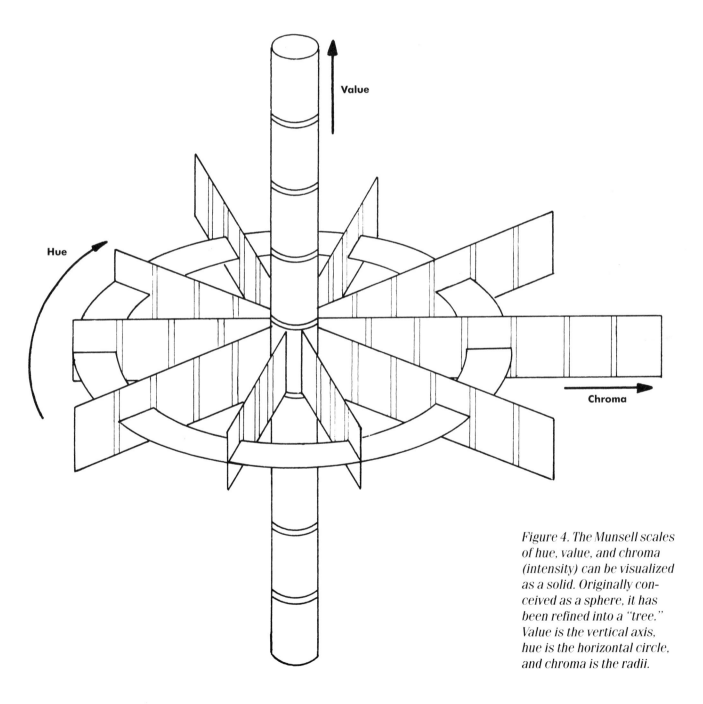

Figure 4. The Munsell scales of hue, value, and chroma (intensity) can be visualized as a solid. Originally conceived as a sphere, it has been refined into a "tree." Value is the vertical axis, hue is the horizontal circle, and chroma is the radii.

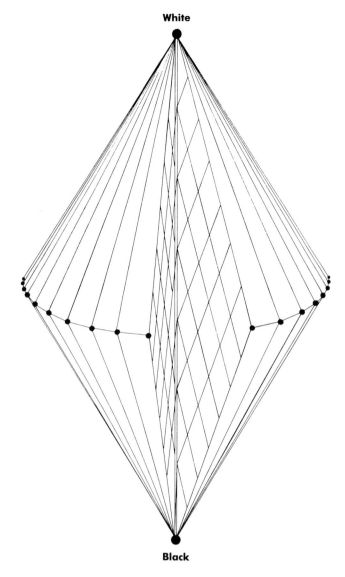

White

Black

Figure 5. Ostwald's double cone. The neutral axis runs from top (white) to bottom (black). On the equator the colors are brightest. Every color is thus measured as a triangle with white at the top vertex, black at the bottom, and the color at the third vertex. Every triangle shows a color and all gradations when mixed with white and with black.

United States and the Ostwald system (see fig. 5) in Europe are the most widely used.

During the early nineteenth century, Michel Eugene Chevreul, a French chemist, was hired to determine why a red yarn that had been woven with other colored yarns changed color in the Gobelin tapestries. From this study came his theory of simultaneous contrasts. This theory states that when two colors are placed next to each other, they each project their complementary color onto the other. If red is placed next to blue, for example, then the complement of red, green, changes the blue to the green side; the complement of blue, orange, changes the red to the orange side. Black next to a color lightens the color, since white is the complement of black, and white next to a color darkens the color. If you wish to strengthen a color, it should be placed next to its complement; for example, green projects red on red and red projects green on green. Chevreul's work, incidentally, had significant influence on Seurat and other pointillist painters.

The brain itself, like the color wheel, requires color balance. This balance is afforded by complementary colors, since their combination creates a gray or neutral color. If you concentrate visually on one color and then look up or close your eyes, you see the complementary color as an afterimage. The afterimage neutralizes the color you have seen, and the resulting gray creates visual equilibrium. An example of this in practice can be seen in surgical suites, which are painted green so that doctors and nurses who concentrate on red blood will have the green afterimage absorbed by the walls.

SIGHT The human eye is spherical in shape (see fig. 6). It is enclosed by the sclera, a white skin. The front central section of this membrane is the cornea, which is transparent. Behind the cornea is a clear refracting substance, the aqueous humor. This, in turn, is backed by a crystalline lens, which acts like a camera lens. The bulk of the eye lies behind the lens and is a gelatinous substance, the vitreous humor. Light entering the cornea passes through these three parts to converge on the innermost lining of the sclera, the retina.

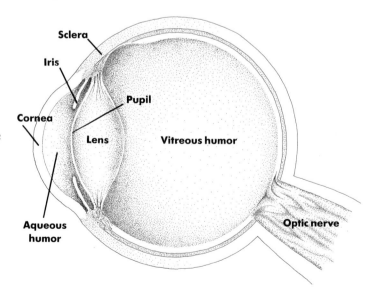

Figure 6. Anatomy of the eye

In front of the lens is the pupil. The iris in front of the pupil is an adjustable diaphragm that enlarges or contracts the opening of the pupil as light levels change. Since the inner lining of the eye is dark, the transparent pupil appears dark. The retina contains rods and cones that relay achromatic (black, white, and gray) and chromatic (color) information to the brain via optic nerves. The rods are the receptors of achromatic colors, and the cones collect chromatic colors. The optic nerves bring the stimulation of color to the brain for identification.

SYMBOL The colors on the yellow, orange, and red side of the color wheel are defined as warm. Purple, blue, and green are cool. An environment painted purple, black, or green causes a psychological drop in temperature; the opposite holds for yellow, orange, or red. Cool colors recede and warm colors advance. Cool colors are relaxing and passive, and warm colors are energizing and active. The locker rooms in a sports arena might be painted blue to ease the pregame tensions of the athletes. At half-time, however, when the athletes are tired, an orange space would be energizing.

As a color is moved away from the observer, the atmosphere will change the color toward blue and the edges of the color will become unclear. This is called *aerial perspective* (not to be confused with a bird's-eye drawing).

Colors alone or in combination can have psychological impact as symbols. In the western world, for example, black is a mourning color. In Asian cultures, white has the same meaning. Rage or anger, however, is almost always expressed by red and cowardice by yellow. Purple, of course, is always regal, and blue represents depression. How about "green with envy"? Cool colors are usually seen as stable and mature. Warm colors are dynamic and young (see fig 7). The measurement of color from science to art, obviously, moves from objective to subjective evaluation.

HARMONY Treatises on successful color combinations since Chevreul's time generally describe monochromatic or triadic systems. Although these systems are helpful, they should not preclude creative experimentation on the part of the illustrator (see fig. 8). This is basic information. To make a space visually appear larger, use cool colors; to energize a space, use warm colors. Yet there must be a dialogue between colors. They can love or hate each

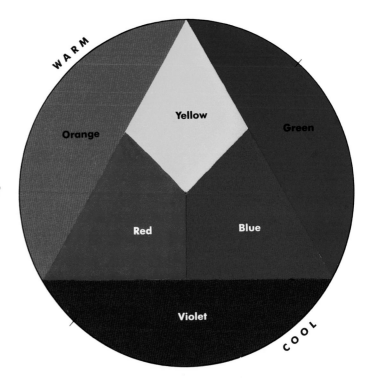

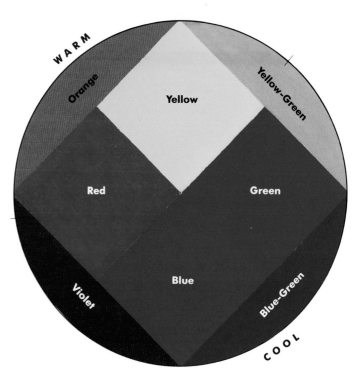

Figure 7. Relative distribution of warm and cool colors on two types of color circles

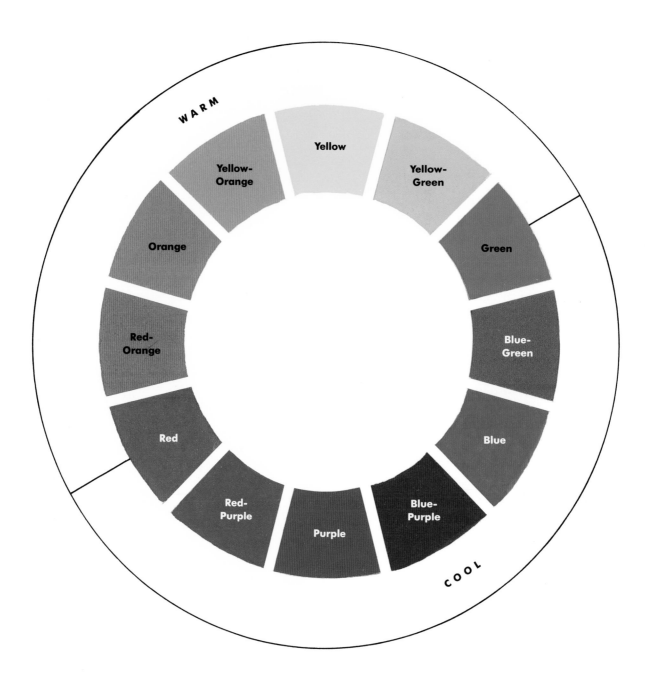

Figure 8. The twelve-hue color wheel with warm and cool colors

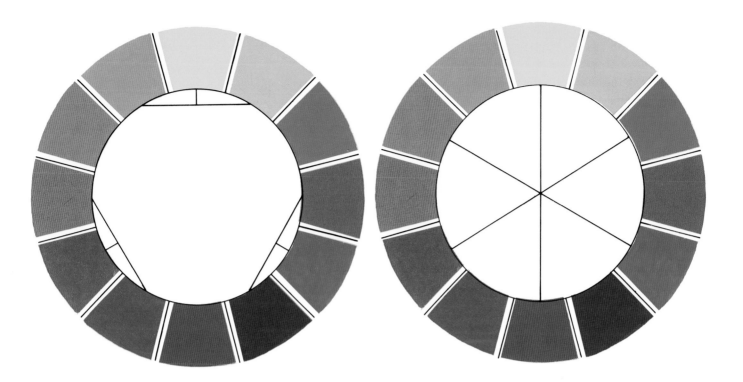

Figure 9. Analogous color schemes. Adjacent colors are shown on the color wheel. Three schemes are illustrated.

Figure 10. Complementary color schemes. Opposite colors are shown on the color wheel. Three schemes are illustrated.

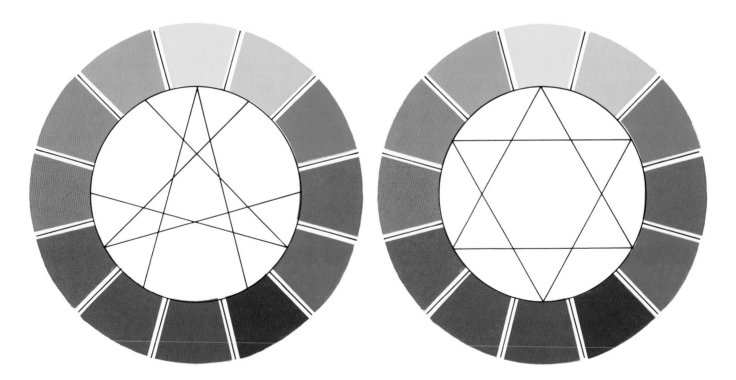

Figure 11. Split complementary color schemes. Primary colors are shown with split complements. Three schemes are illustrated.

Figure 12. Triadic color schemes. Two schemes are illustrated.

other, but one must be dominant. Dominance can supplied by hue, value, intensity or a combination of these factors. If the colors love each other, they will be similar in hue, value, or intensity. If they declare war, they will be opposite or complementary. The safest color system is monochromatic: one hue. The single hue, however, can be changed in value by tinting it with white or shading it with black. The hue can also be changed in intensity by mixing it with its complement. Both can be used in a harmonious color scheme.

An analogous system (see fig. 9) uses colors that are adjacent on the color wheel. If the central hue is primary or secondary, the scheme will be stronger visually, since color in pigment is subtractive. Again, contrast and dominance can be controlled not only by hue, but also by value and intensity. Opposite or complementary colors (see fig. 10) strengthen each other—the theory of simultaneous contrasts. This is a hard fight, yet these colors create harmony. In addition, in complementary schemes one color is warm and the other cool. A split complementary scheme (see fig. 11) is more subtle than the complementary. Red is used with blue-green and yellow-green rather than with green. Another harmonious group is triadic (see fig. 12), in which an equilateral triangle is placed within the color wheel and results in such excitement as red with yellow and blue or orange with green and purple. In all of these systems of color harmony, the statement can also be tempered by dilution of color. An opaque pigment is visually stronger than a transparent one.

PRINTING Since many illustrations in color are reproduced in magazines, brochures, and books, the illustrator should be familiar with the four-color printing process. The inks used are cyan, yellow, magenta, and black, and they are combined in various densities of halftone screens to simulate a full spectrum of color. The screens must be angled to avoid visual moiré (the French word for "watered" silk). The moiré pattern would confuse the visual image. In halftone screening, the line rulings are either at right angles to each other or there can be three 30-degree angles before the system is repeated. Yellow, being lightest, is printed at 15 degrees from magenta and cyan. The halftone screen angles are black, 15 to 45 degrees; magenta, 45 to 75 degrees; yellow, 75 to 90 degrees; and cyan 90 to 105 degrees. When printed, the four combine as rosettes of dots.

DRAWING

DRAWING FOR CLIENTS In general, architects and interior and industrial designers give the illustrator specific perspective angles, materials, and colors. Advertising agencies, magazine and book publishers, and professional and government agencies afford greater latitude.

An illustrator can also be his or her own client and design drawings for self-promotion. The illustrator should keep sketch books of drawings made in the field and in the studio. These sketches are impressions that can be included in illustrations designed throughout the professional career.

THE DRAWING PROCESS Every illustration starts with a conceptual sketch, usually small in size, drawn freehand in pencil and on any available surface. Drawings to be printed in color must be prepared on a flexible base, since color illustration will be placed on a drum before being scanned by computer. Tracing paper, being transparent, offers overlays that are both flexible and easy to refine. Tracing paper, however, accommodates only dry media and, at best, markers. Water- and oil-base color pencils can be used, although water-base pencils are easier to erase.

The conceptual sketch should be drawn in black and white. As the concept clarifies, the colors are tested. The sketches can be enlarged, and the lines can be sharpened with a straight-edge. If color and material samples are in order, the conceptual sketch or mechanical can be drawn on an opaque surface with the colors and materials actually rendered. Alternatively, the mechanical can be a pencil sketch on tracing paper, and the colors and materials can be rendered on an accompanying piece of opaque material. Make it a policy not to send original mechanicals to clients. Photocopies or facsimilies are usually satisfactory. Color photocopiers and fax machines, however, are currently too expensive for many studios so color and material samples, if necessary, can be sent to clients by messenger or by express mail services. In most cases, client criticisms should be minimal, and a second mechanical will not be required.

The mechanical, once corrected, must be transferred to the final drawing surface. If the final surface is tracing paper, trace the mechanical onto vellum or another 100 percent rag paper. If the final drawing is

ink on tracing paper, prepare the paper with *pounce* (drafting powder) on all surfaces. If the final surface is opaque, a transfer sheet must be prepared. Never use carbon paper. The lines will be too coarse and cannot be erased. Cut a sheet of vellum and cover one side with a graphite stick or a soft lead pencil. Blend the graphite with cotton dipped in benzene or rubber-cement thinner. Draw over the original lines, using this transfer sheet as you would use carbon paper. Most opaque surfaces preferred by illustrators have a medium-tooth finish. Bristol board is flexible and is a good choice when color reproduction of an illustration is specified. Illustration board is a widely used color support, and if the drawing is primarily colored with watercolor, use watercolor paper or board.

Of the eight mediums discussed in this book two are opaque: water-base gouache and oil-base crayons. The other six—analine dyes, markers, oil-base pencil, water-base pencil, natural-pigment watercolor, and inks—are transparent. These six can approach opacity by overlayering. The more washes of a transparent medium that are applied, the more translucent, then opaque, the medium becomes. If the illustration is meant to be opaque, then the pencil base is all that is needed. These pencil lines guide the illustrator but will be covered by pigment. If, however, the illustration is to be primarily transparent or translucent, the base drawing is most important.

Pencil lines, stippling, and crosshatching are softer and less specific than ink lines. Hard-edge pencil lines, created with a straight-edge, are colder and more formal than freehand lines. Pencil smudges, but it is easy to erase, and ink will be a disaster if it is not waterproof. On one hand, pencil must be regularly sharpened, and hand pressure affects the density and thickness of the line. On the other hand, technical pens can be a bore—constant cleaning is required to keep them in good working order. Pencil is thus faster than pen. In any case, a pencil base must precede any ink application.

Some words on cleanliness are in order. Always keep your hands clean and work with clean tools. Oils in the skin of the hands can ruin a carefully laid water-base wash. Although most media can be erased, the *nap* of the surface can be marred. Such marring can destroy an illustration. Keep a can of liquid cleanser near the drawing table to clean all tools, and wash hands frequently. Remember that your table is for hands, tools, and media and not for coffee or tea.

The next chapter examines the appropriate uses of the eight media used in this book. Taking chances (in the studio and not on the final illustration) is encouraged. Advanced technology will not make the illustration more creative, but it will certainly afford opportunities to study aspects of the drawing and to prepare the finished illustration in less time.

MEDIA AND TECHNIQUES

Explanations of the eight basic color media follow. It is important to know when and how to choose each; the best surfaces for each; and the tools for application. The five water-base media are natural-pigment watercolors, color pencils, analine dyes, inks, and gouache. The oil-base media are color pencils, markers, and crayons. The supporting surface can be illustration board or bristol board of various textures or tooths, watercolor papers, or tracing papers. Why and when to choose and the tools for application are discussed with each medium.

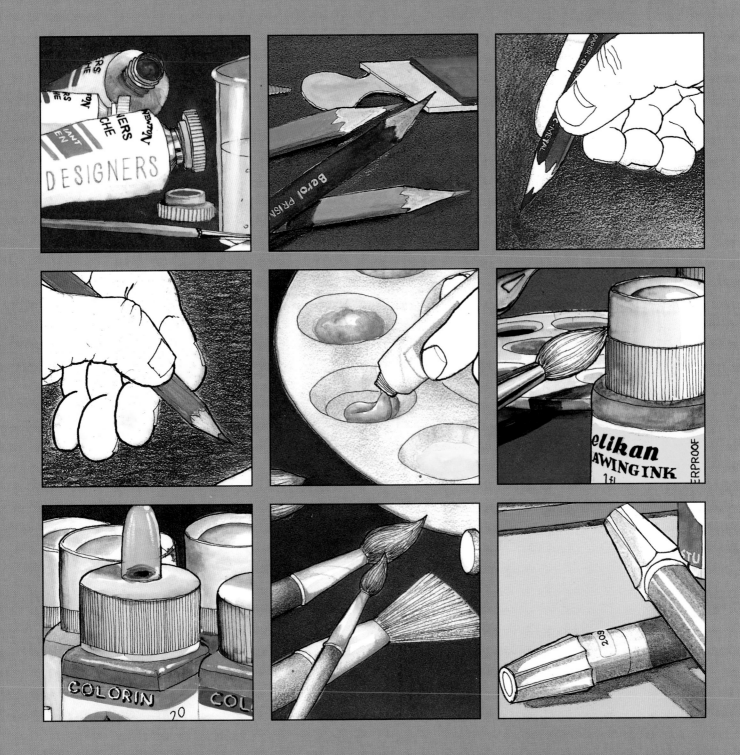

GOUACHE An opaque watercolor, gouache is used mainly to delineate opaque surfaces and materials. It can be applied with brush (preferably red sable) or airbrush. Gouache is not erasable, but it can easily be painted over.

This water-base medium performs ideally on a medium-tooth surface, but as with natural-pigment watercolors the warping of the drawing surface can be a problem.

OIL-BASE COLOR PENCIL Oil-base pencils are often used when there is a need for intensive colors or when a color more opaque than water-base pencils is required. Oil-base pencils also provide a greater variety of color than water-base pencils, but they are softer, break easily, and are therefore more difficult to apply.

This medium adheres best to a medium-tooth surface, and colors can be blended using rubber-cement thinner carefully applied with cotton or tissue. Oil-base pencils can be erased by hand using a plastic eraser.

CRAYON All crayons are oil-base. They can be blended using rubber-cement thinner and paper towels.

The ideal surface for crayon is any smooth surface, such as tracing paper or illustration board. Oil-base crayons can be easily erased with a plastic eraser. Crayon will cover any type of color completely. It should be used over large areas, and it is not really an ideal media for small areas.

WATER-BASE COLOR PENCIL Water-base pencils can be used to create drawings quickly. The speed with which this medium can be applied and the ease with which it can be erased makes it a relatively inexpensive choice for the illustrator or architect. Use water-base pencils for quick drawings, for small areas within a drawing, or when a transparent medium is desired.

MEDIA REFERENCE GUIDE

Medium	Characteristics	Ideal Working Surface	Remarks
Water-base gouache	When opaque surfaces and materials are desired	Medium tooth	Difficult to erase but can be worked over
Oil-base pencils	Intensive colors and great color variety available; works well in small areas and with a transparent medium	Medium tooth	More difficult to apply and erase than water-base pencils
Oil-base crayons	Covers other media opaquely; limited colors available	Medium tooth or tracing paper	Erasable with plastic eraser
Water-base pencils	Applies quickly and easily; easily erased; works well in small areas and with a transparent medium	Medium tooth	Colors lack intensity
Natural-pigment watercolor	Applies quickly; transparent colors available; works well over large areas	Watercolor paper or board or medium tooth surface	Requires more skills to apply and is more difficult to erase than color pencils
Water-base inks	Applies quickly; works well as a transparent wash; small range of colors available; colors lack intensity	Medium tooth	Works well in technical pens
Water-base analine dyes	Large variety of transparent colors available; works well with airbrushing; easily erased with bleach	Medium tooth	Can use brush for small areas; colors can be fugitive; cannot use in technical pens
Oil-base markers	Applies quickly; creates excellent grays	Medium tooth or tracing paper	Only oil-base pencils can work over markers; nonerasable

This medium adheres best to a medium-tooth surface, and it is best served by a base of ink or pencil. The color is applied by hand and may be blended using a brush dipped in water. The color may be erased using a plastic eraser. Be aware that the colors lack intensity.

NATURAL-PIGMENT WATERCOLOR

Natural-pigment watercolors are used when transparent colors must be applied over large areas quickly and evenly. The colors are applied using different sizes of brushes. Natural pigment watercolors do not allow the same precision of application that water-base pencils do.

The ideal surface is watercolor board, which is usually made thick to prevent warping from the absorption of too much water. The surface itself has to be rough, allowing better control of absorption.

Erasing watercolors is all but impossible. This means that the application has to be well thought

out prior to working on the board. Natural-pigment watercolors are available in tubes or cakes. Brushes are available in a wide range of prices and materials.

COLOR INK Water-base inks are ideal for transparent washes, since they are easily applied and are nonfugitive. They are easy to work with and are water-soluble, but the lack of color variety available is a drawback. Once dry, these inks are indelible; they do not fade, and they are nonerasable.

The ideal surface for these inks is a medium-tooth paper. The ideal base is pen and ink or pencil. Pens can be technical pens or dip pens. Water-base inks can also be easily applied with a brush. They are an ideal medium for large, premixed washes.

ANALINE DYE Analine dyes allow the greatest premixed variety of any water-based color. Another positive quality of these colors is their erasability. Using a mixture of laundry bleach and water, it is possible to eradicate analine dyes by carefully blotting them out in stages. Apply the bleach mixture with cotton; wait to see if any color remains after the bleaching action. If color remains, repeat the process until the dye is eradicated. Of course, it is important not to use too many applications of bleach solution or the drawing surface will be destroyed.

Analine dyes may be applied to very small areas using a narrow brush. It is almost impossible to apply analine dyes to large areas with a brush because the wash cannot be kept smooth and even. When you are applying dye with an airbrush, the masking tools needed are frisket film and an X-acto knife. Analine dyes are extremely fugitive (they fade). Therefore, never subject the original drawing to sunlight, direct or reflected.

OIL-BASE MARKER Most oil-base markers have excellent warm and cool gray tones. Oil-base markers can be applied to any surface, including tracing paper or illustration board. The problem is that, with time, the colors spread and are absorbed by the surface of the paper.

Oil-base markers cannot be erased in any way; they are absolutely permanent. When working over marker with color pencil, only oil-base pencil can be used. Water-base color pencil will not work well over a marker base. Rubber-cement thinner and cotton can be used to blend oil-base markers.

Ideal Drawing Base	Tools
N/A	Water-base gouache; brushes; water; mixing dish; plastic erasers
Ink or pencil	Oil-base pencils; rubber-cement thinner; stump or cotton or tissue; plastic or ink erasers
Pencil	Oil-base crayons; rubber-cement thinner
Ink or pencil	Water-base pencils; water; brushes; plastic erasers
Ink or pencil	Watercolor tubes or blocks; water; brushes; mixing dish; ink eraser
Ink or pencil	Water-base inks; dip pens; brushes; mixing dish; water; ink eraser and bleach
Ink or pencil	Water-base analine dyes; brush; airbrush; mixing dish; frisket; X-acto knives; plastic eraser and bleach
N/A	Oil-base markers; rubber-cement thinner on tracing paper

GOUACHE

Gouache is a nontransparent water-base paint that can be applied with brush or pen.

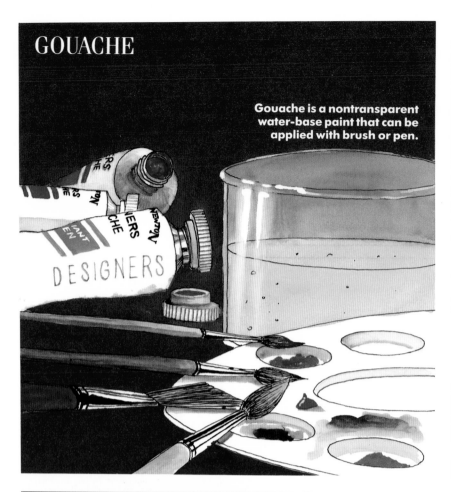

As you apply more water, the color becomes more transparent.

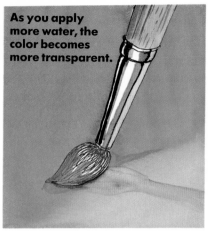

Run your brush along a straight-edge for lines of varying thicknesses.

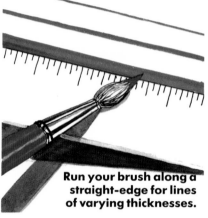

Clean your brush gently on your palm with soap and warm water.

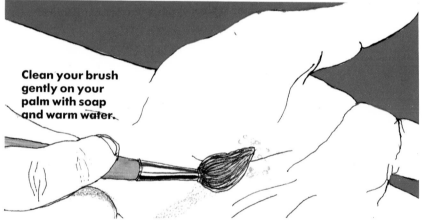

Stippling with a brush is our method of applying texture and color at the same time.

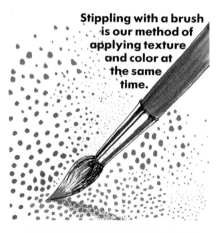

Gouache highlights.

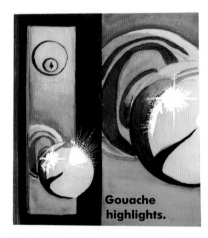

Gouache texture.

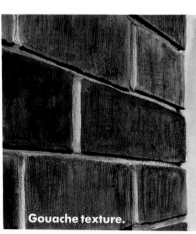

Since you cannot erase when using gouache, you must cover the error, then repaint the correct image.

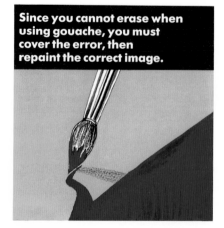

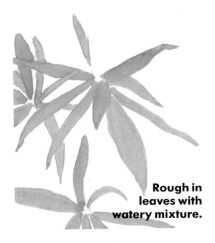

Rough in leaves with watery mixture.

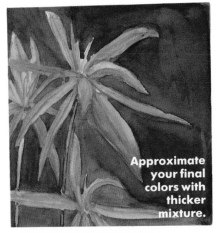

Approximate your final colors with thicker mixture.

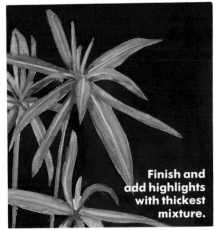

Finish and add highlights with thickest mixture.

Rough in thick sky color.

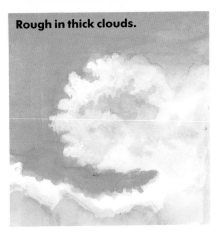

Rough in thick clouds.

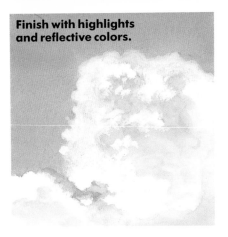

Finish with highlights and reflective colors.

Background and material of rough watery mixture.

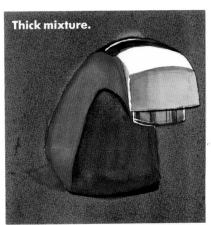

Thick mixture.

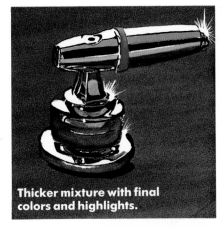

Thicker mixture with final colors and highlights.

Rough, watery mixture.

Thick mixture.

Thicker mixture with highlights and final details.

OIL-BASE COLOR PENCIL

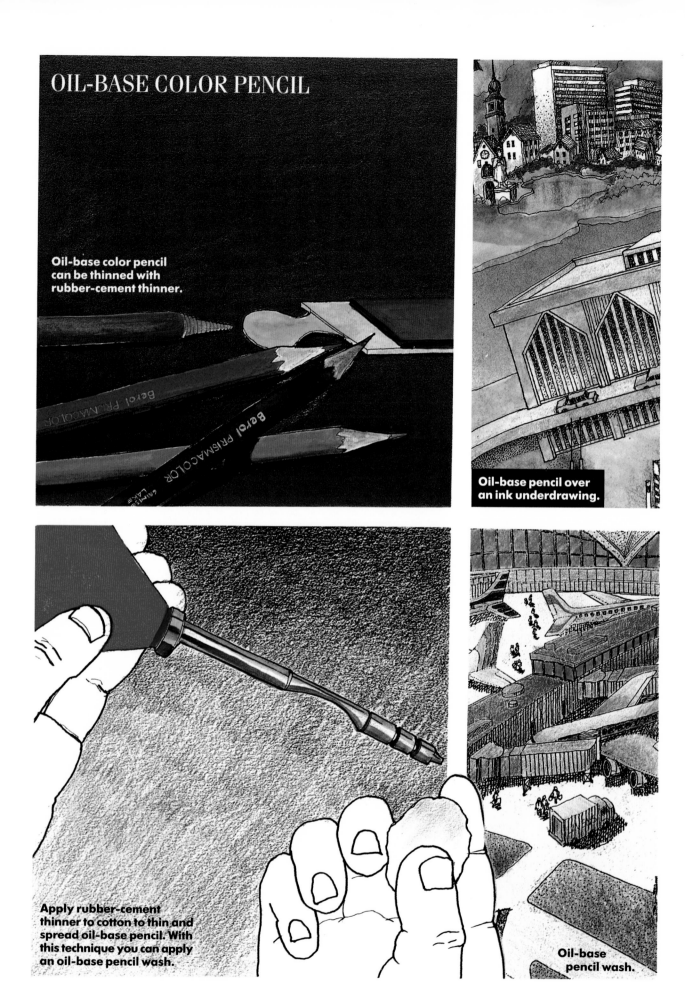

Oil-base color pencil
can be thinned with
rubber-cement thinner.

Oil-base pencil over
an ink underdrawing.

Apply rubber-cement
thinner to cotton to thin and
spread oil-base pencil. With
this technique you can apply
an oil-base pencil wash.

Oil-base
pencil wash.

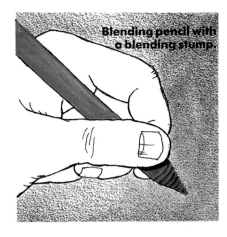

Blending pencil with a blending stump.

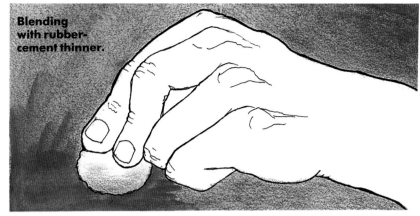

Blending with rubber-cement thinner.

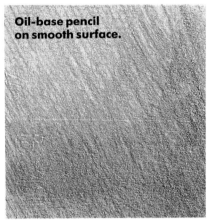

Oil-base pencil on smooth surface.

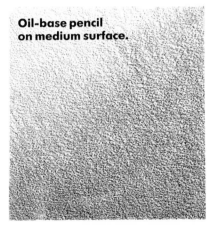

Oil-base pencil on medium surface.

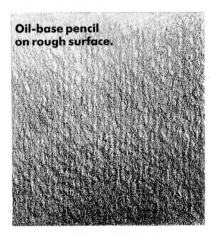

Oil-base pencil on rough surface.

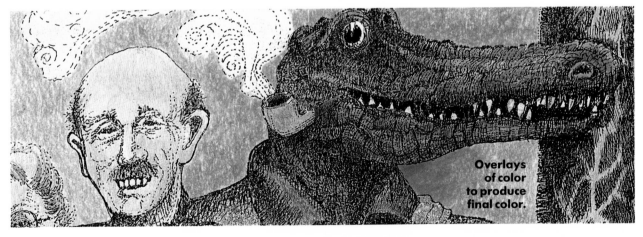

Overlays of color to produce final color.

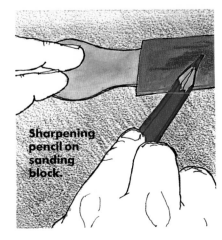

Sharpening pencil on sanding block.

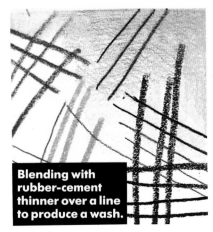

Blending with rubber-cement thinner over a line to produce a wash.

Erasing to produce a special effect.

CRAYON WITH PENCIL

Using all-purpose pencils with crayons, you can draw on and cover anything.

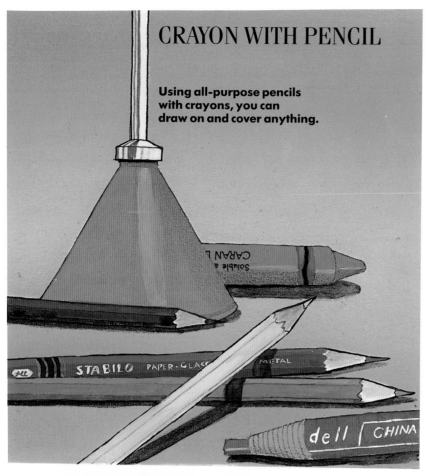

Since crayon is oil-base, it can be thinned with rubber-cement thinner.

You can draw in ink over crayon.

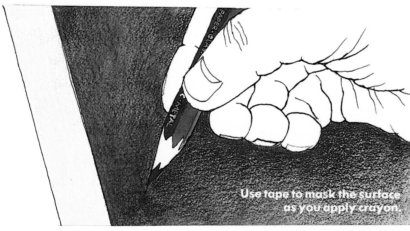

Use tape to mask the surface as you apply crayon.

Crayon will work over watercolor, gouache, or marker.

Apply rubber-cement thinner with cotton.

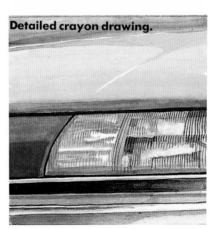

Detailed crayon drawing.

Crayon on photograph.

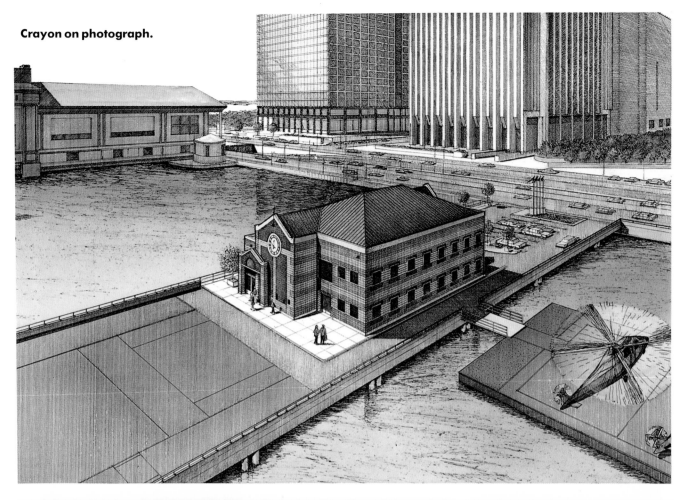

Crayon on glossy stat.

Crayon on glossy photograph.

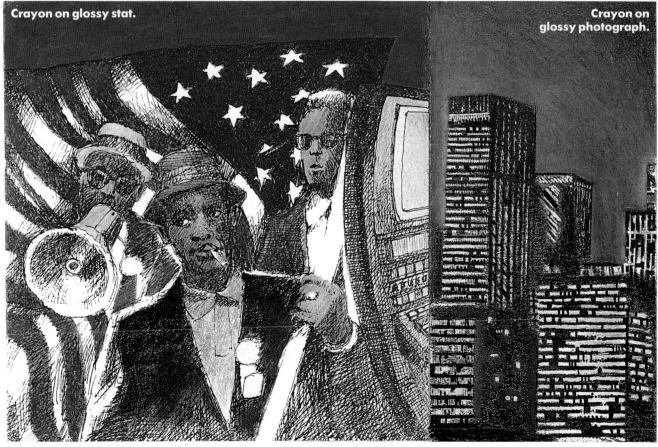

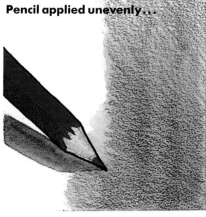

Pencil applied unevenly...

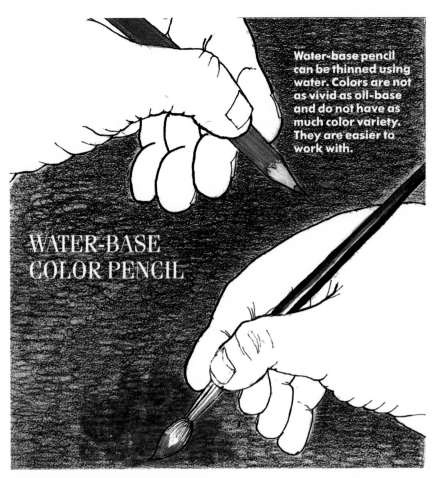

Water-base pencil can be thinned using water. Colors are not as vivid as oil-base and do not have as much color variety. They are easier to work with.

WATER-BASE COLOR PENCIL

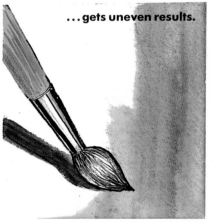

...gets uneven results.

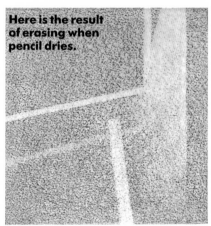

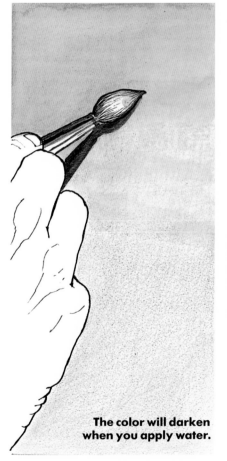

The color will darken when you apply water.

Colors can be easily mixed to produce a multitoned wash.

Here is the result of erasing when pencil dries.

Here is the result of erasing when pencil is wet.

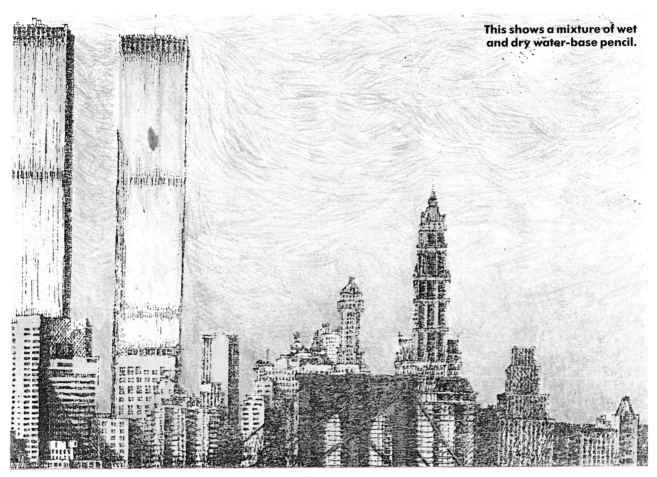

This shows a mixture of wet and dry water-base pencil.

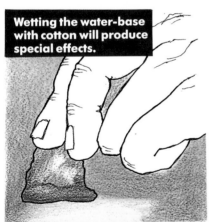

Wetting the water-base with cotton will produce special effects.

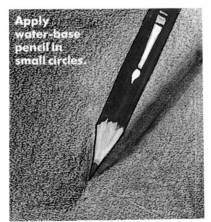

Apply water-base pencil in small circles.

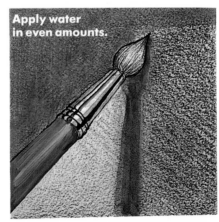

Apply water in even amounts.

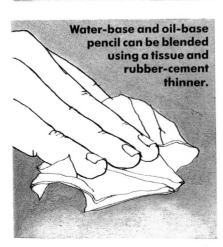

Water-base and oil-base pencil can be blended using a tissue and rubber-cement thinner.

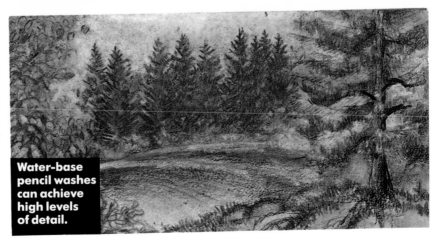

Water-base pencil washes can achieve high levels of detail.

NATURAL-PIGMENT
WATERCOLOR

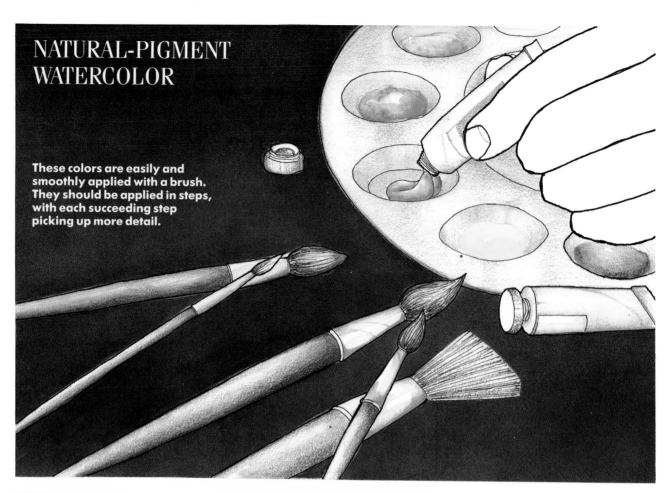

These colors are easily and
smoothly applied with a brush.
They should be applied in steps,
with each succeeding step
picking up more detail.

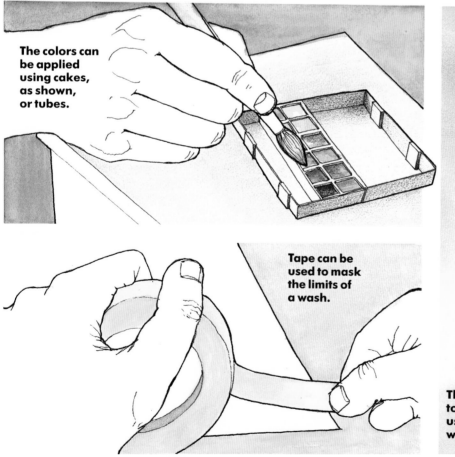

The colors can
be applied
using cakes,
as shown,
or tubes.

Tape can be
used to mask
the limits of
a wash.

The easiest way
to blend colors is to
use natural-pigment
watercolors.

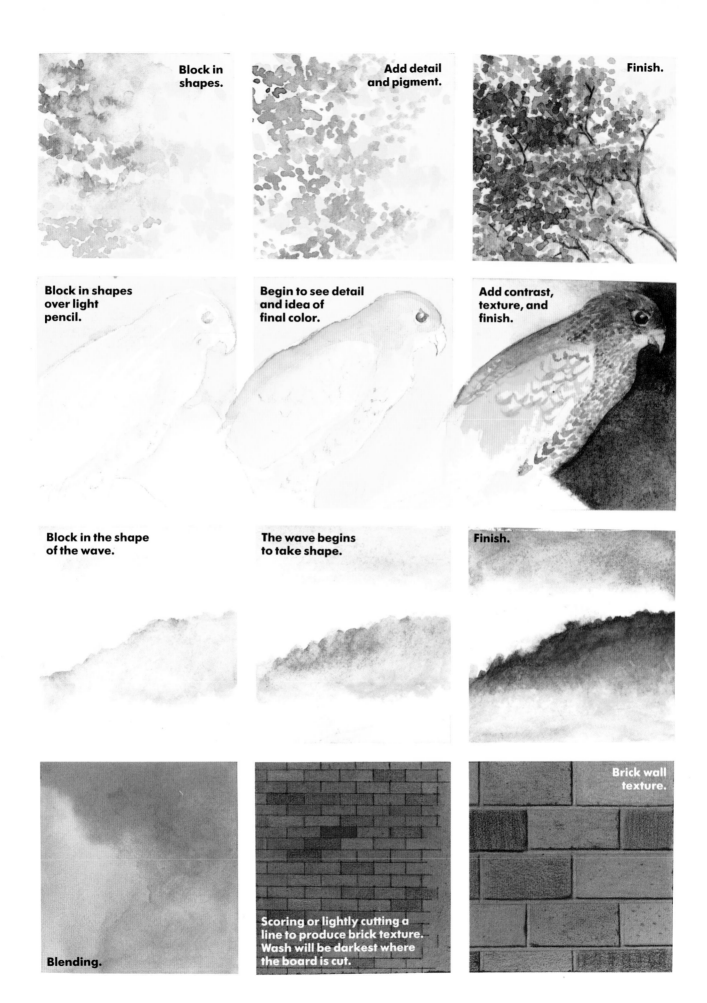

Block in shapes.

Add detail and pigment.

Finish.

Block in shapes over light pencil.

Begin to see detail and idea of final color.

Add contrast, texture, and finish.

Block in the shape of the wave.

The wave begins to take shape.

Finish.

Blending.

Scoring or lightly cutting a line to produce brick texture. Wash will be darkest where the board is cut.

Brick wall texture.

COLOR INK

Color ink is nonfading, nonerasable, and water-based. It can be applied with air brush, pen, or brush.

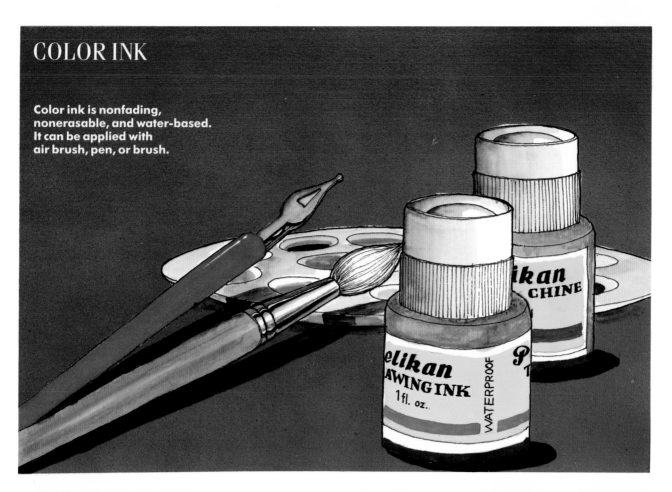

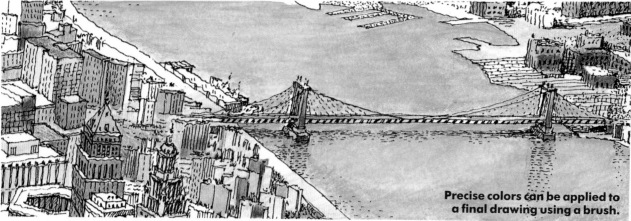

Precise colors can be applied to a final drawing using a brush.

Inks produce clean, smooth washes when applied with a brush.

When applied with a sketch pen, color ink can be crosshatched.

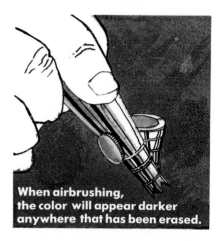

When airbrushing, the color will appear darker anywhere that has been erased.

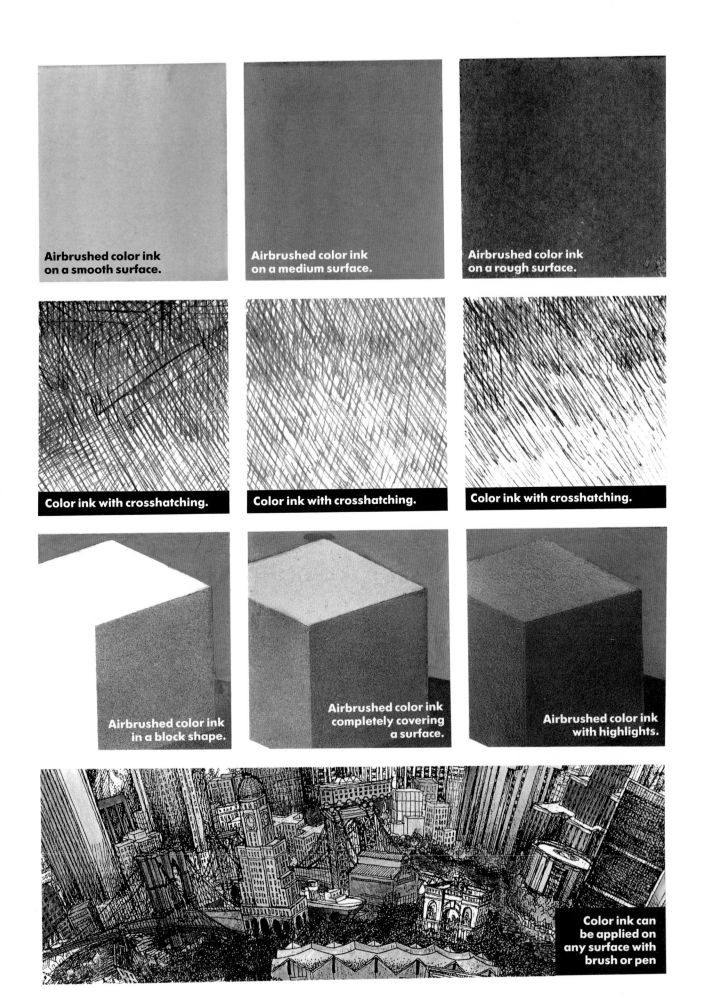

Airbrushed color ink
on a smooth surface.

Airbrushed color ink
on a medium surface.

Airbrushed color ink
on a rough surface.

Color ink with crosshatching.

Color ink with crosshatching.

Color ink with crosshatching.

Airbrushed color ink
in a block shape.

Airbrushed color ink
completely covering
a surface.

Airbrushed color ink
with highlights.

Color ink can
be applied on
any surface with
brush or pen

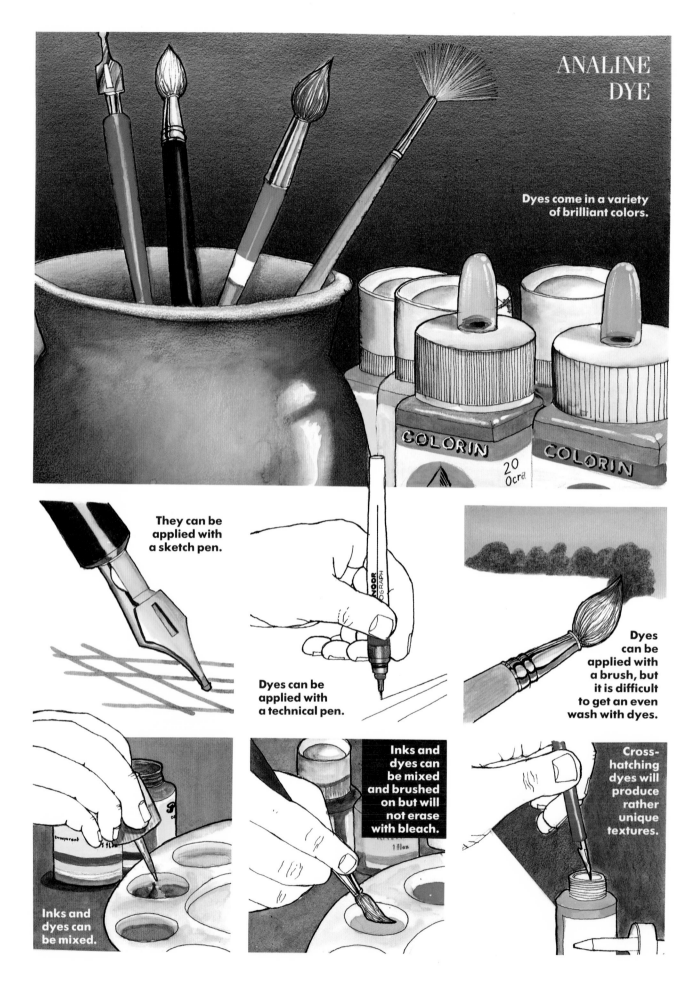

ANALINE
DYE

Dyes come in a variety
of brilliant colors.

COLORIN

COLORIN

20
Ocra

They can be
applied with
a sketch pen.

Dyes can be
applied with
a technical pen.

Dyes
can be
applied with
a brush, but
it is difficult
to get an even
wash with dyes.

Inks and
dyes can be
mixed and
brushed
on but will
not erase
with bleach.

Inks and
dyes can
be mixed.

Cross-
hatching
dyes will
produce
rather
unique
textures.

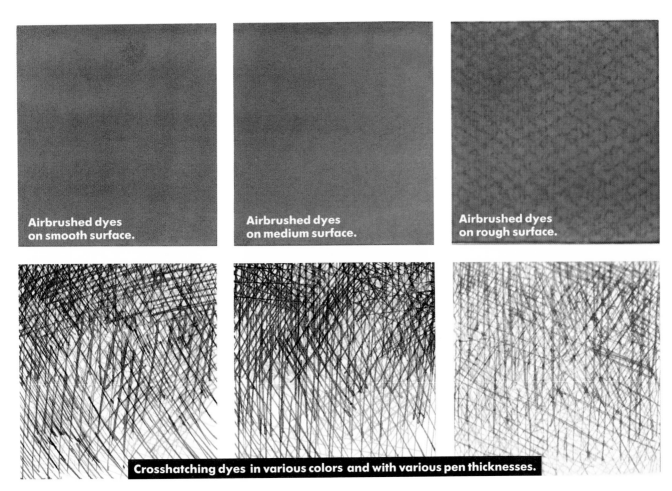

Airbrushed dyes
on smooth surface.

Airbrushed dyes
on medium surface.

Airbrushed dyes
on rough surface.

Crosshatching dyes in various colors and with various pen thicknesses.

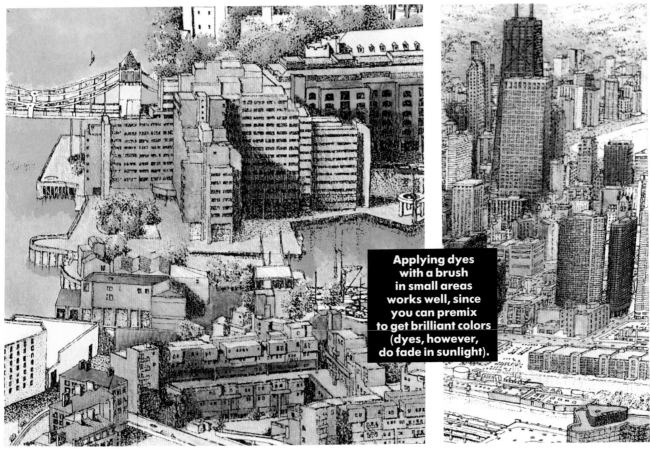

Applying dyes
with a brush
in small areas
works well, since
you can premix
to get brilliant colors
(dyes, however,
do fade in sunlight).

OIL-BASE MARKER

Markers allow you to apply premixed, permanent colors easily and quickly.

Markers come in a variety of points: blunt, sharp, round, pointed, and so forth.

Marker can be worked over with pencil and rubber-cement thinner.

Markers are easily mixed and blended.

Oil-base pencils can be blended easily into marker using cotton and rubber-cement thinner.

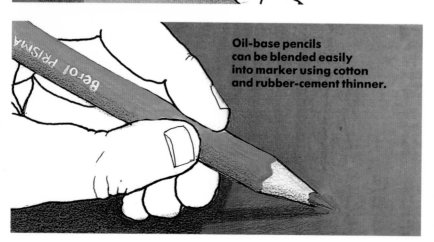

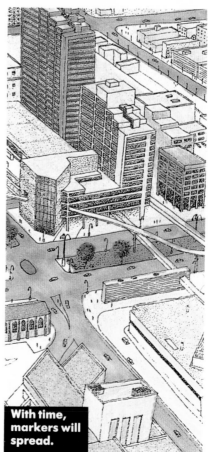

With time, markers will spread.

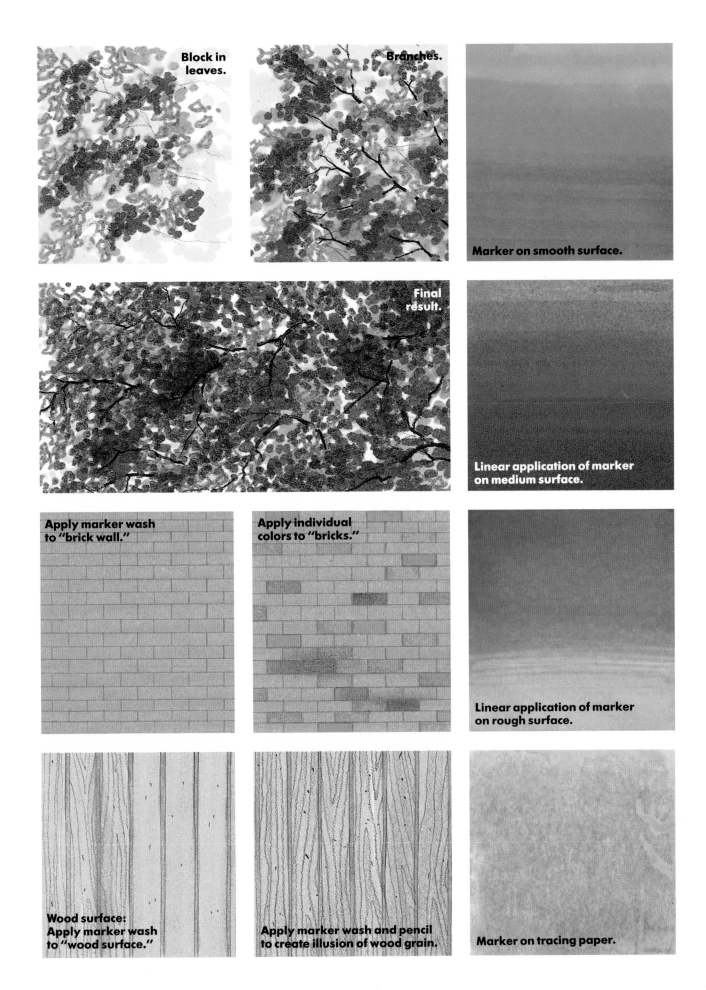

Block in leaves.

Branches.

Marker on smooth surface.

Final result.

Linear application of marker on medium surface.

Apply marker wash to "brick wall."

Apply individual colors to "bricks."

Linear application of marker on rough surface.

Wood surface: Apply marker wash to "wood surface."

Apply marker wash and pencil to create illusion of wood grain.

Marker on tracing paper.

AIRBRUSH

Airbrush is a tool, not a medium. It allows us to apply almost every type of color.

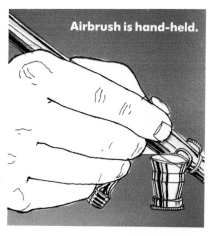

Airbrush is hand-held.

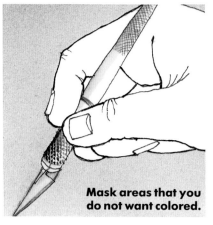

Mask areas that you do not want colored.

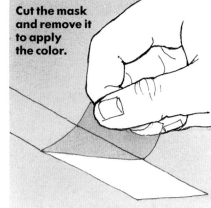

Cut the mask and remove it to apply the color.

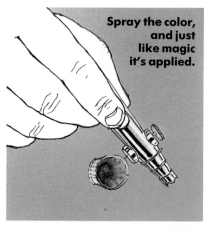

Spray the color, and just like magic it's applied.

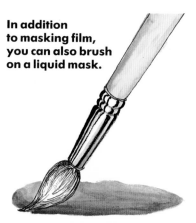

In addition to masking film, you can also brush on a liquid mask.

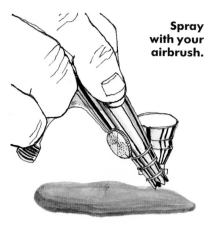

Spray with your airbrush.

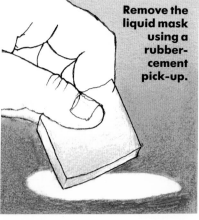

Remove the liquid mask using a rubber-cement pick-up.

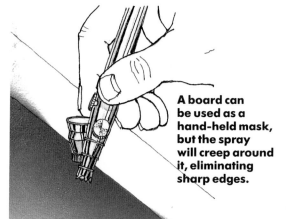

A board can be used as a hand-held mask, but the spray will creep around it, eliminating sharp edges.

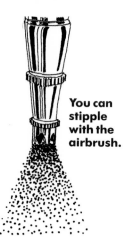

You can stipple with the airbrush.

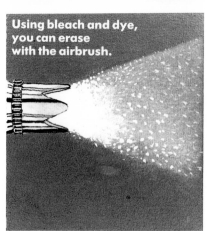

Using bleach and dye, you can erase with the airbrush.

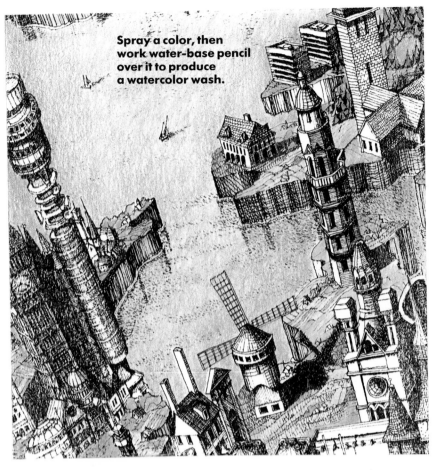

Spray a color, then work water-base pencil over it to produce a watercolor wash.

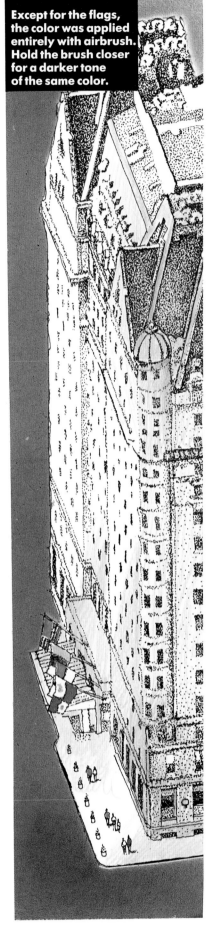

Except for the flags, the color was applied entirely with airbrush. Hold the brush closer for a darker tone of the same color.

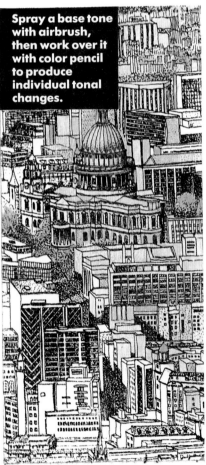

Spray a base tone with airbrush, then work over it with color pencil to produce individual tonal changes.

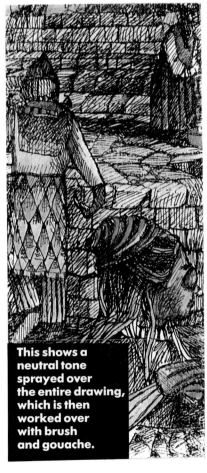

This shows a neutral tone sprayed over the entire drawing, which is then worked over with brush and gouache.

MULTIMEDIA TECHNIQUES

This drawing was done using airbrush, pen and ink, and water- and oil-base pencil. The sky was done by spraying dye, and the clouds were made by blotting bleach with cotton.

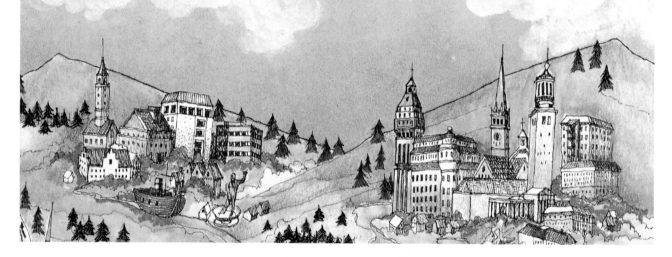

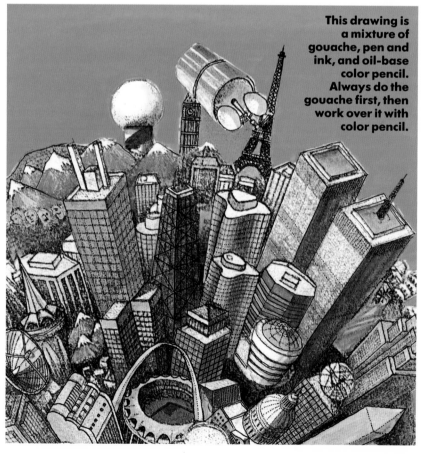

This drawing is a mixture of gouache, pen and ink, and oil-base color pencil. Always do the gouache first, then work over it with color pencil.

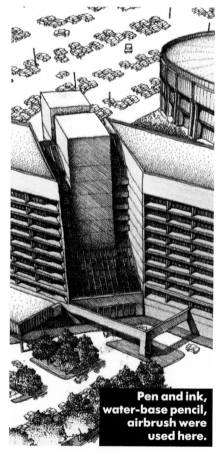

Pen and ink, water-base pencil, airbrush were used here.

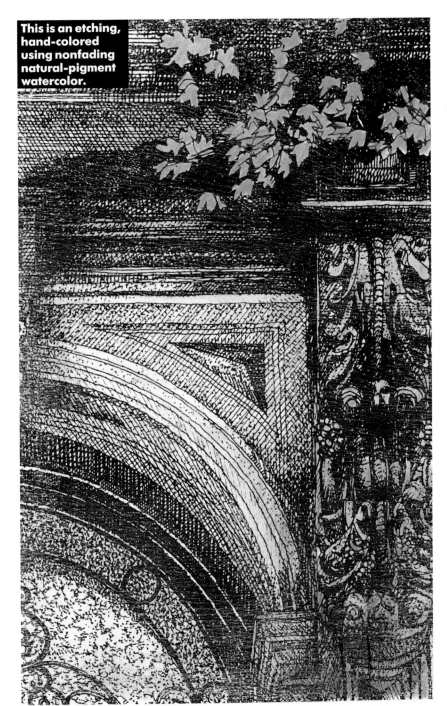

This is an etching, hand-colored using nonfading natural-pigment watercolor.

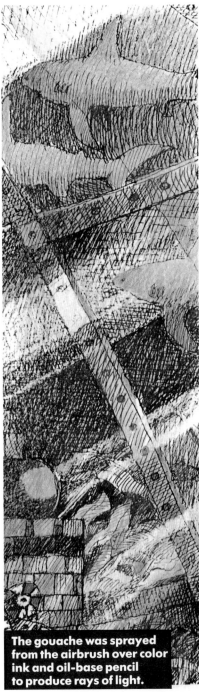

The gouache was sprayed from the airbrush over color ink and oil-base pencil to produce rays of light.

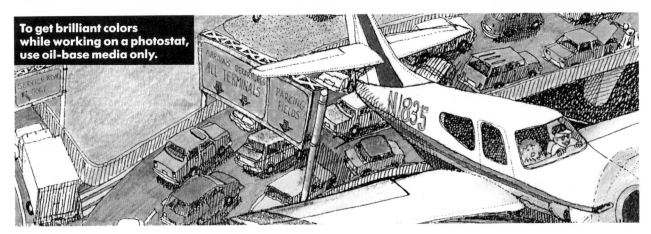

To get brilliant colors while working on a photostat, use oil-base media only.

INTERIOR DRAWING

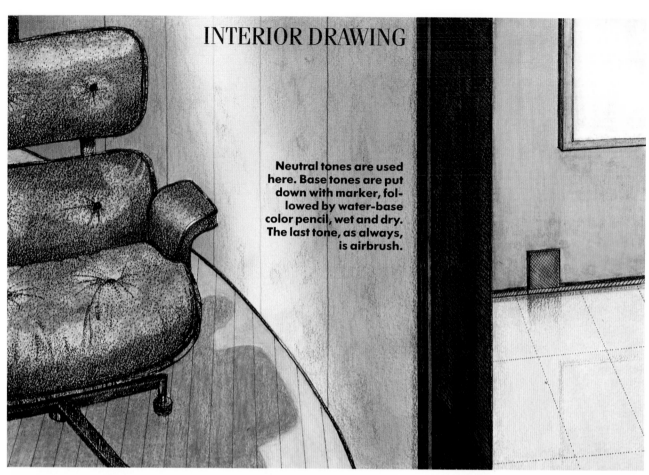

Neutral tones are used here. Base tones are put down with marker, followed by water-base color pencil, wet and dry. The last tone, as always, is airbrush.

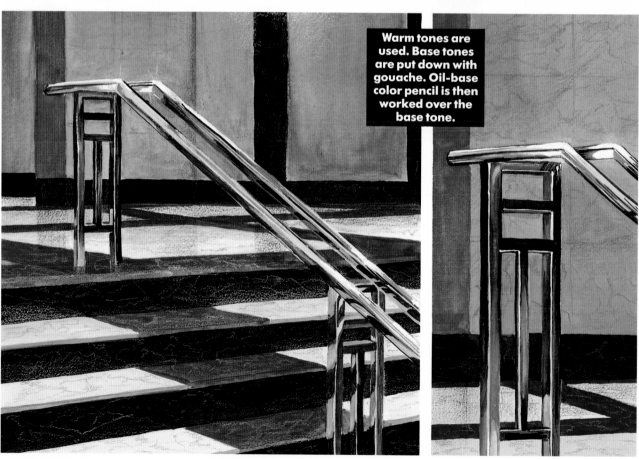

Warm tones are used. Base tones are put down with gouache. Oil-base color pencil is then worked over the base tone.

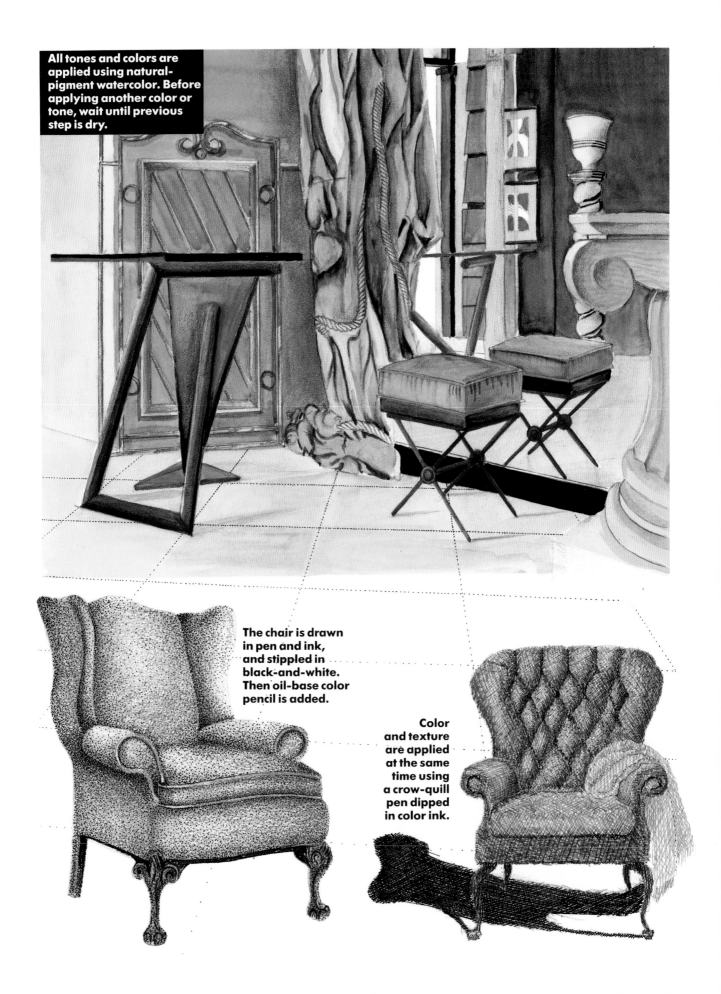

All tones and colors are applied using natural-pigment watercolor. Before applying another color or tone, wait until previous step is dry.

The chair is drawn in pen and ink, and stippled in black-and-white. Then oil-base color pencil is added.

Color and texture are applied at the same time using a crow-quill pen dipped in color ink.

EXTERIOR ARCHITECTURAL MATERIALS

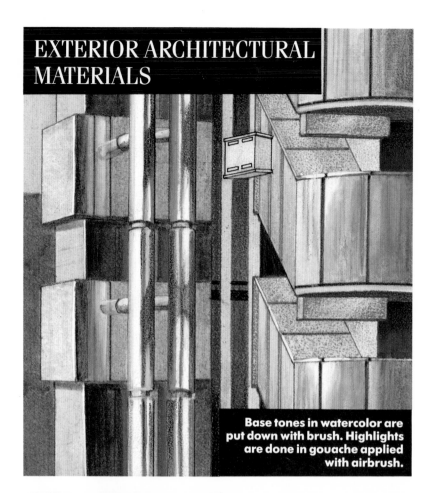

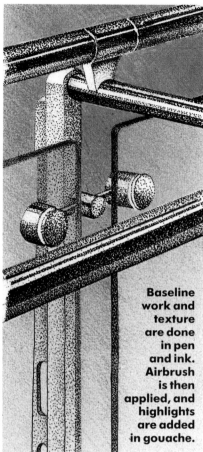

Base tones in watercolor are put down with brush. Highlights are done in gouache applied with airbrush.

Baseline work and texture are done in pen and ink. Airbrush is then applied, and highlights are added in gouache.

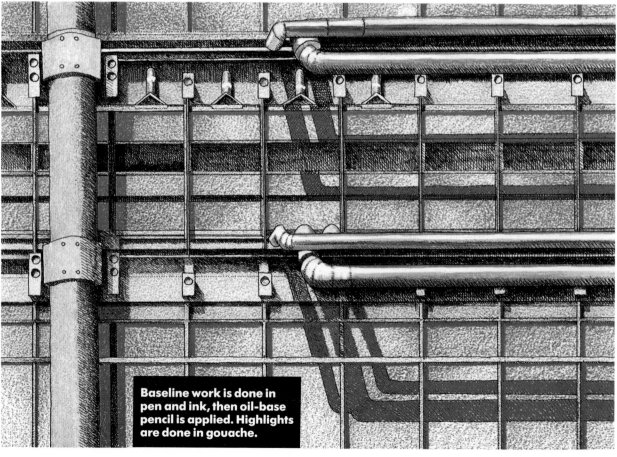

Baseline work is done in pen and ink, then oil-base pencil is applied. Highlights are done in gouache.

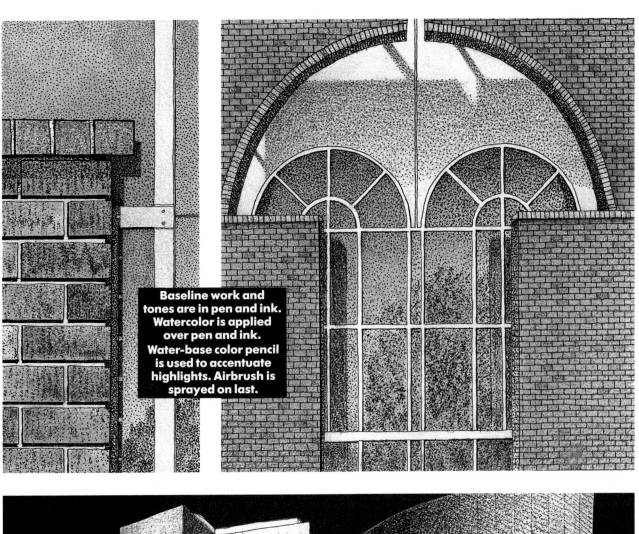

Baseline work and tones are in pen and ink. Watercolor is applied over pen and ink. Water-base color pencil is used to accentuate highlights. Airbrush is sprayed on last.

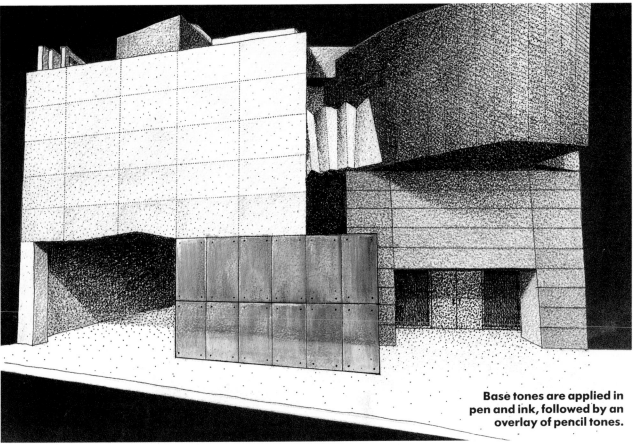

Base tones are applied in pen and ink, followed by an overlay of pencil tones.

ENTOURAGE

THE TERM ENTOURAGE COMES TO THE ILLUSTRATOR FROM THE BEAUX ARTS SCHOOL IN PARIS. IT REFERS TO ARCHITECTURAL SURROUNDINGS. THE SPECIFIC PARTS OF A DRAWING THAT SUPPORT AND SURROUND THE SUBJECT, SUCH AS TREES AND STREET FURNITURE, ARE ENTOURAGE. GENERALLY, THE ENTOURAGE IS DESIGNED OR SELECTED BY THE ARCHITECT OR LANDSCAPE ARCHITECT. MUCH OF THE ENTOURAGE, HOWEVER, CAN BE ON OR ADJACENT TO THE SITE BEFORE THE BUILDING IS DESIGNED. ILLUSTRATORS ADD PEOPLE AND CARS TO THE ENTOURAGE FOR SCALE AND INTEREST. IT IS NECESSARY TO LEARN WHAT HAS TO BE DRAWN, AND HOW AND WHY TO DRAW IT, IN ORDER TO SUPPORT THE SUBJECT PROPERLY.

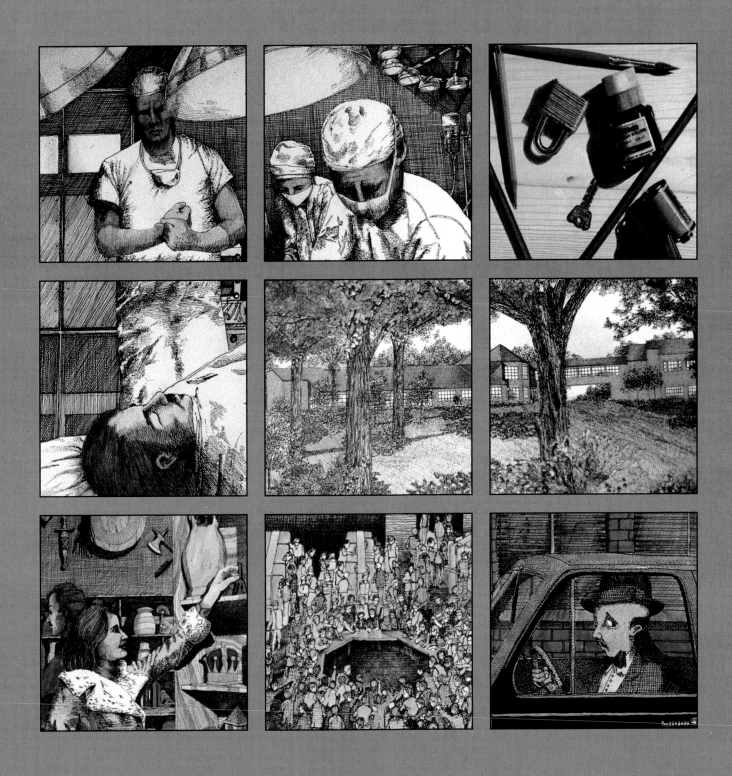

TREES

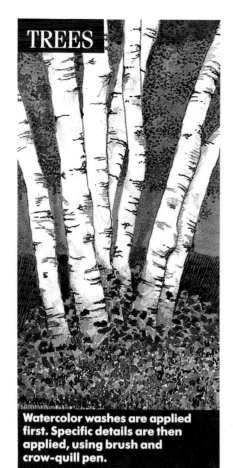

Watercolor washes are applied first. Specific details are then applied, using brush and crow-quill pen.

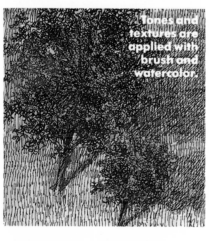

Tones and textures are applied with brush and watercolor.

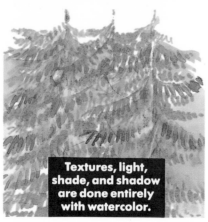

Textures, light, shade, and shadow are done entirely with watercolor.

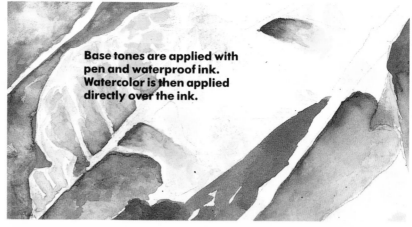

Base tones are applied with pen and waterproof ink. Watercolor is then applied directly over the ink.

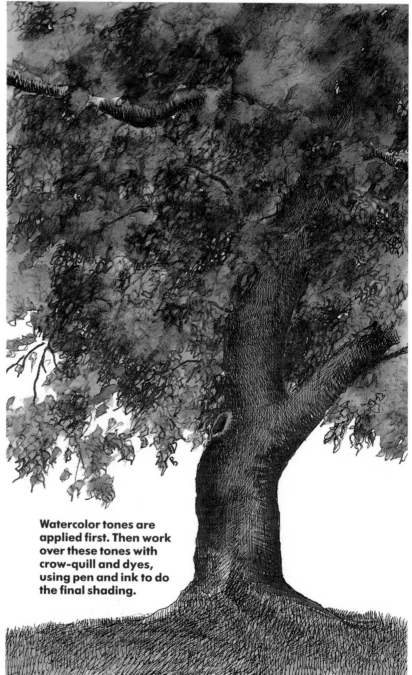

Watercolor tones are applied first. Then work over these tones with crow-quill and dyes, using pen and ink to do the final shading.

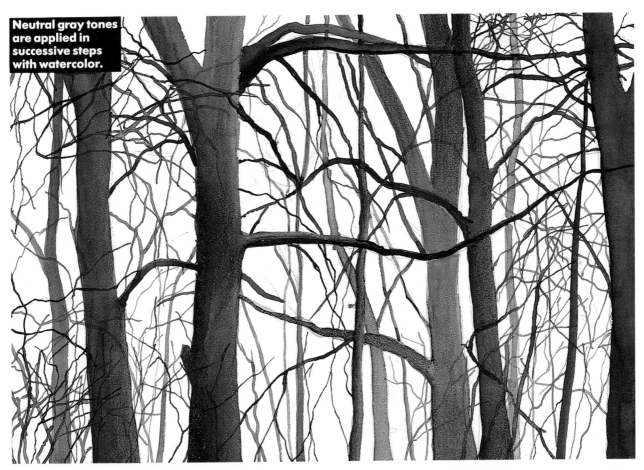

Neutral gray tones are applied in successive steps with watercolor.

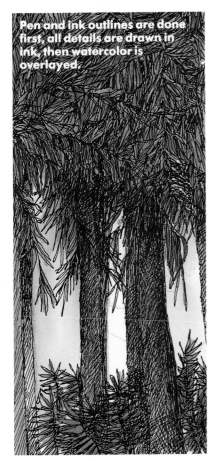

Pen and ink outlines are done first, all details are drawn in ink, then watercolor is overlayed.

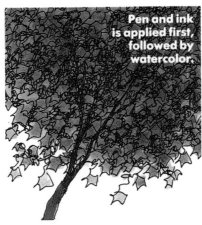

Pen and ink is applied first, followed by watercolor.

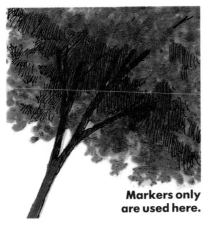

Markers only are used here.

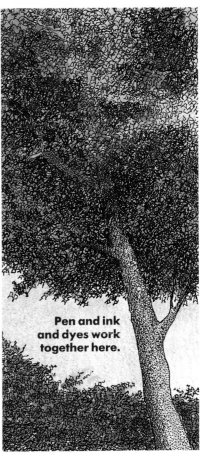

Pen and ink and dyes work together here.

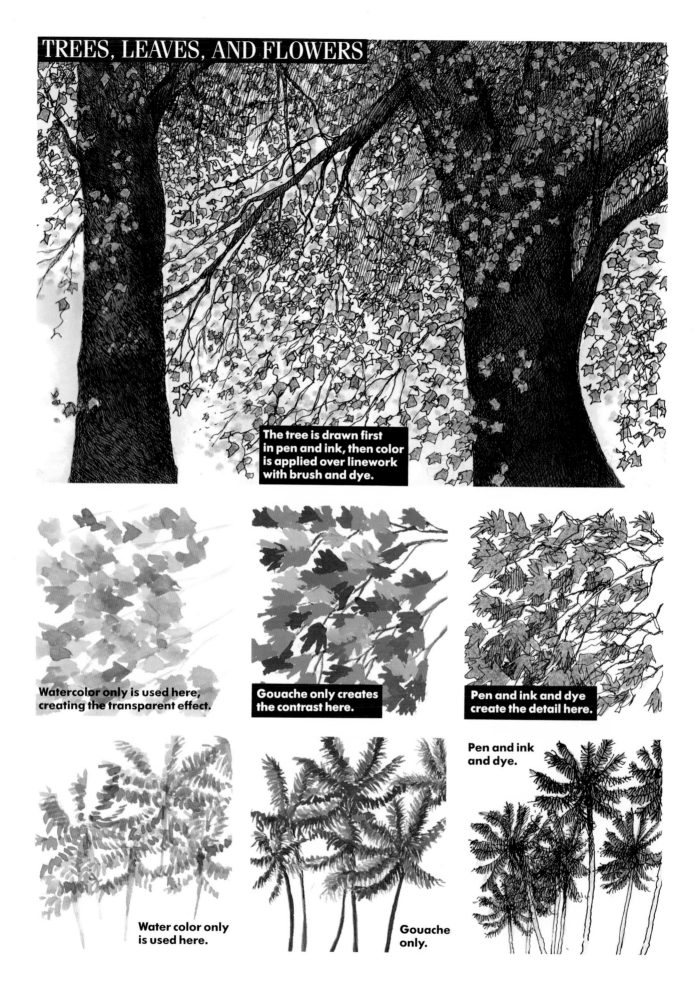

TREES, LEAVES, AND FLOWERS

The tree is drawn first in pen and ink, then color is applied over linework with brush and dye.

Watercolor only is used here, creating the transparent effect.

Gouache only creates the contrast here.

Pen and ink and dye create the detail here.

Water color only is used here.

Gouache only.

Pen and ink and dye.

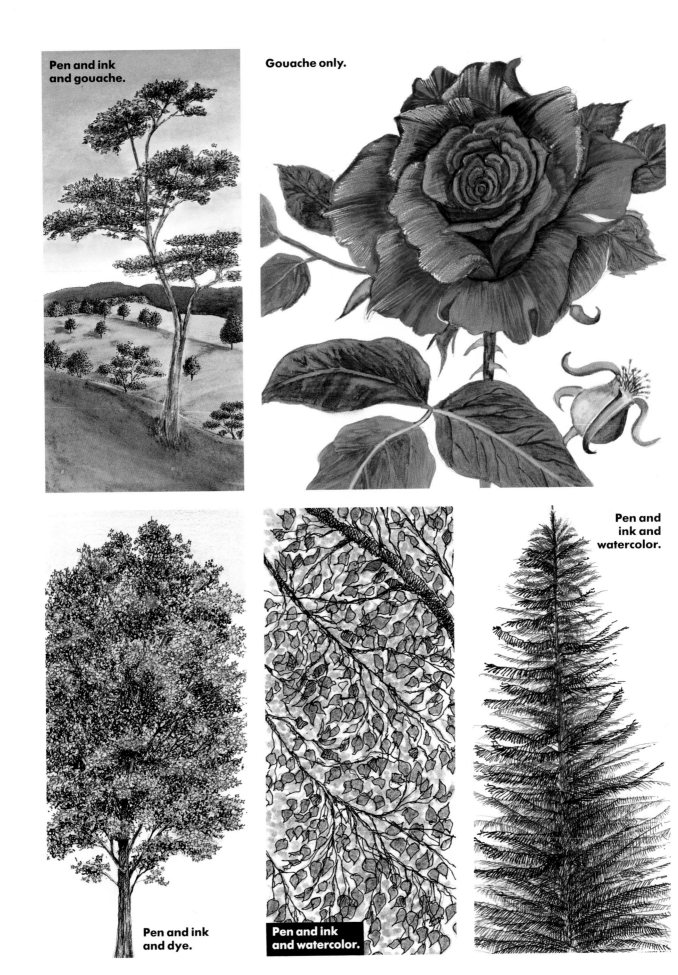

Pen and ink
and gouache.

Gouache only.

Pen and ink
and dye.

Pen and ink
and watercolor.

Pen and
ink and
watercolor.

SKY, SNOW, AND SPECIAL EFFECTS

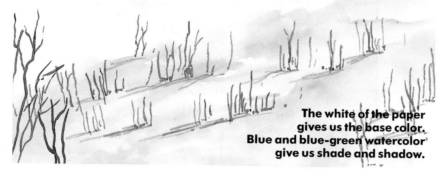

The white of the paper gives us the base color. Blue and blue-green watercolor give us shade and shadow.

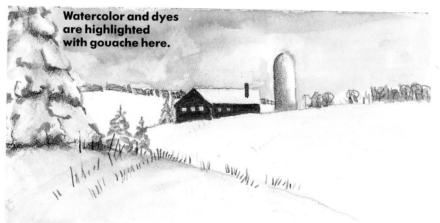

Watercolor and dyes are highlighted with gouache here.

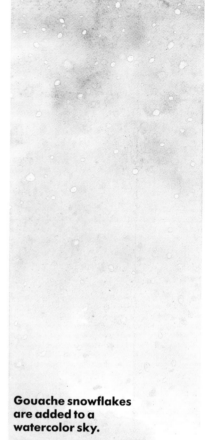

Gouache snowflakes are added to a watercolor sky.

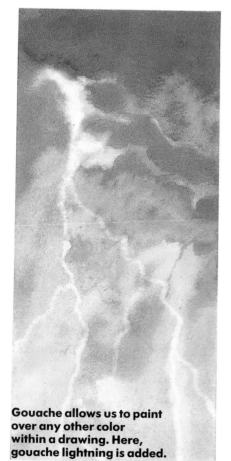

Gouache allows us to paint over any other color within a drawing. Here, gouache lightning is added.

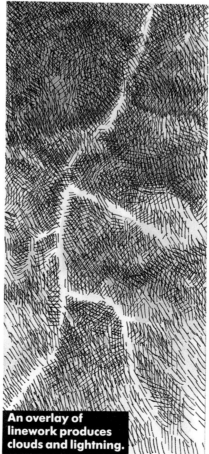

An overlay of linework produces clouds and lightning.

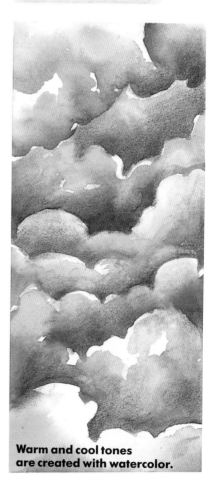

Warm and cool tones are created with watercolor.

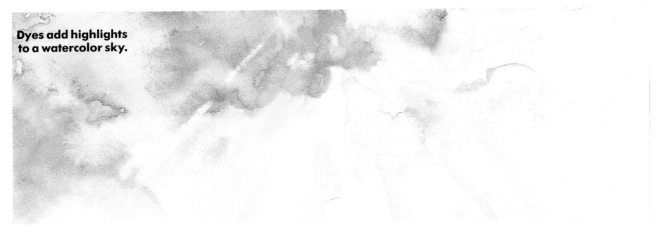

Dyes add highlights
to a watercolor sky.

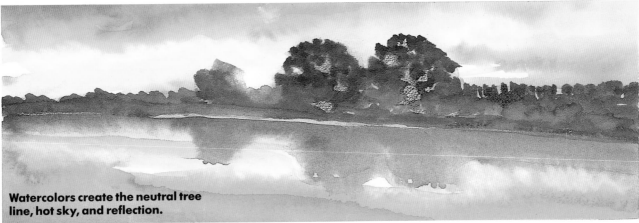

Watercolors create the neutral tree
line, hot sky, and reflection.

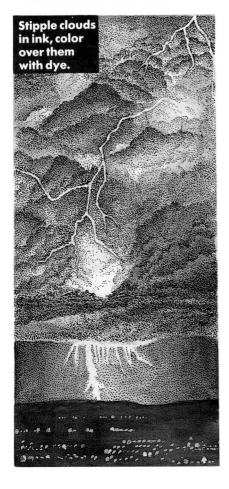

Stipple clouds
in ink, color
over them
with dye.

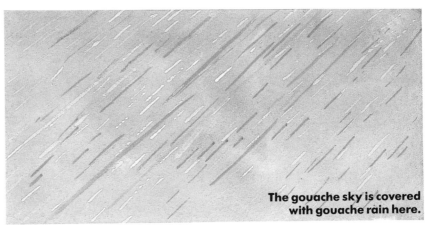

The gouache sky is covered
with gouache rain here.

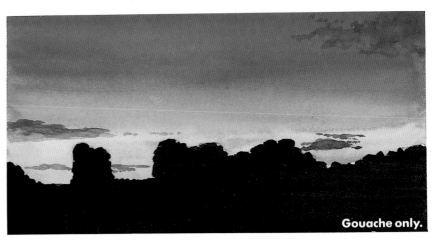

Gouache only.

CARS AND TRUCKS

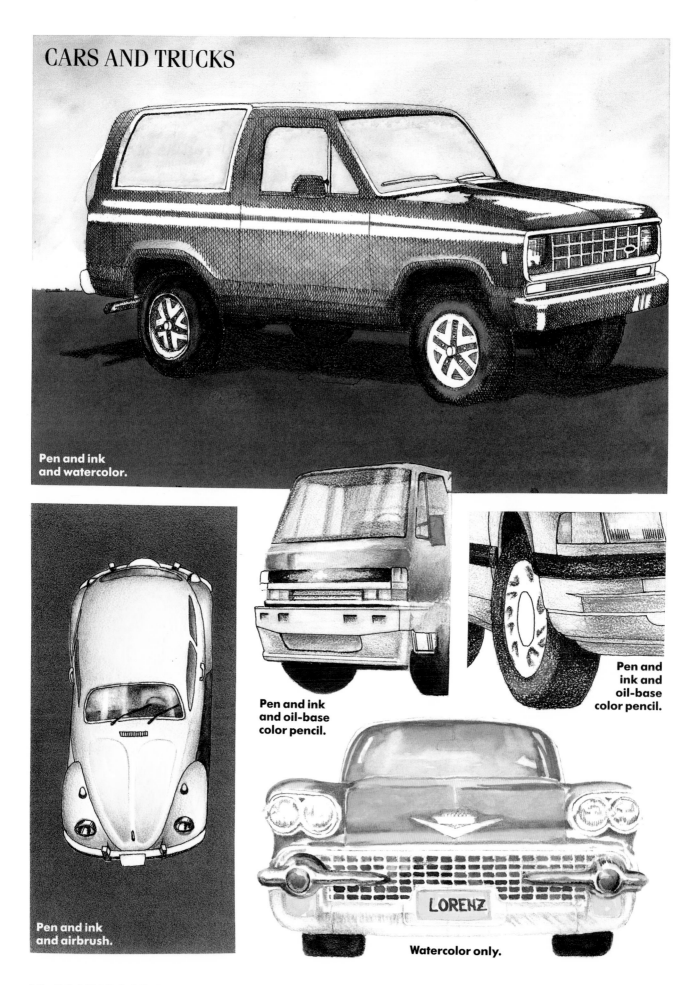

Pen and ink
and watercolor.

Pen and ink
and oil-base
color pencil.

Pen and
ink and
oil-base
color pencil.

Pen and ink
and airbrush.

LORENZ

Watercolor only.

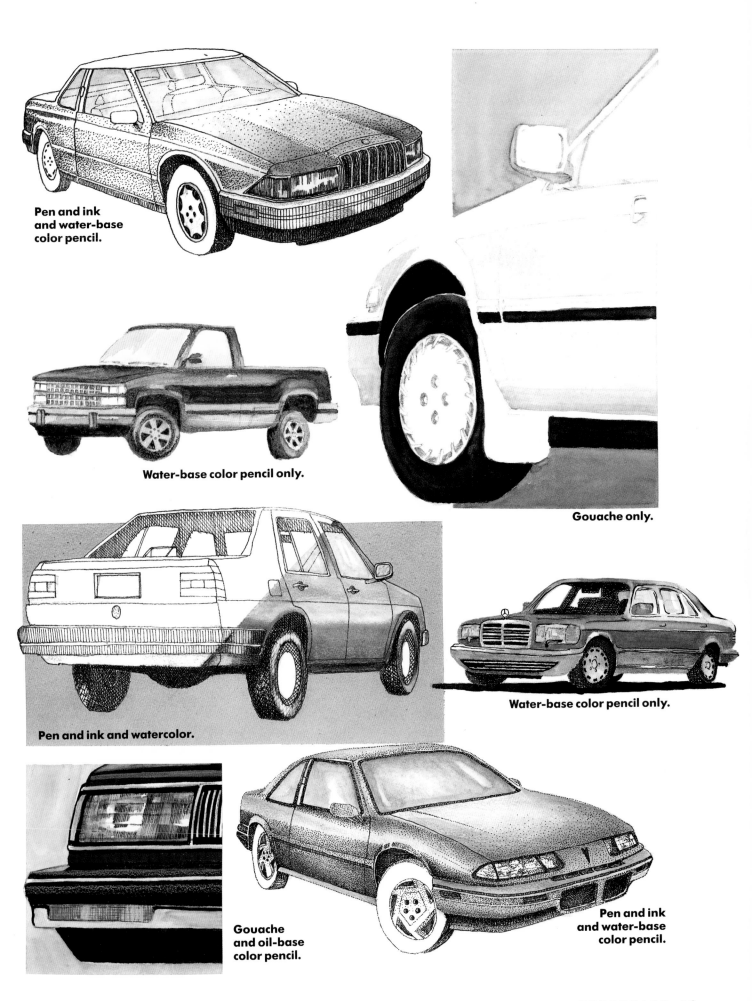

Pen and ink and water-base color pencil.

Water-base color pencil only.

Gouache only.

Pen and ink and watercolor.

Water-base color pencil only.

Gouache and oil-base color pencil.

Pen and ink and water-base color pencil.

CARS

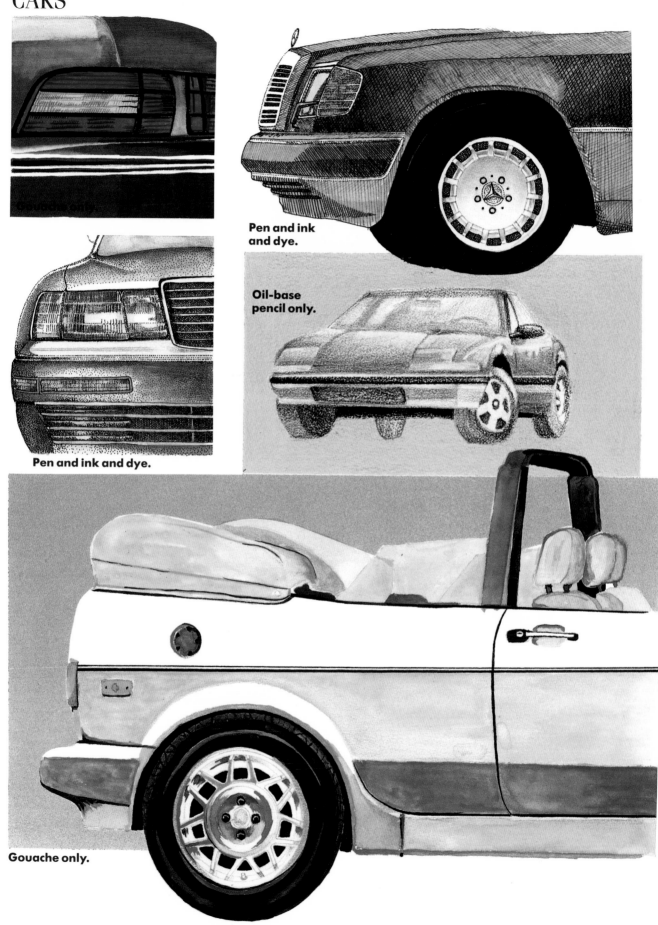

Gouache only.

Pen and ink and dye.

Pen and ink and dye.

Oil-base pencil only.

Gouache only.

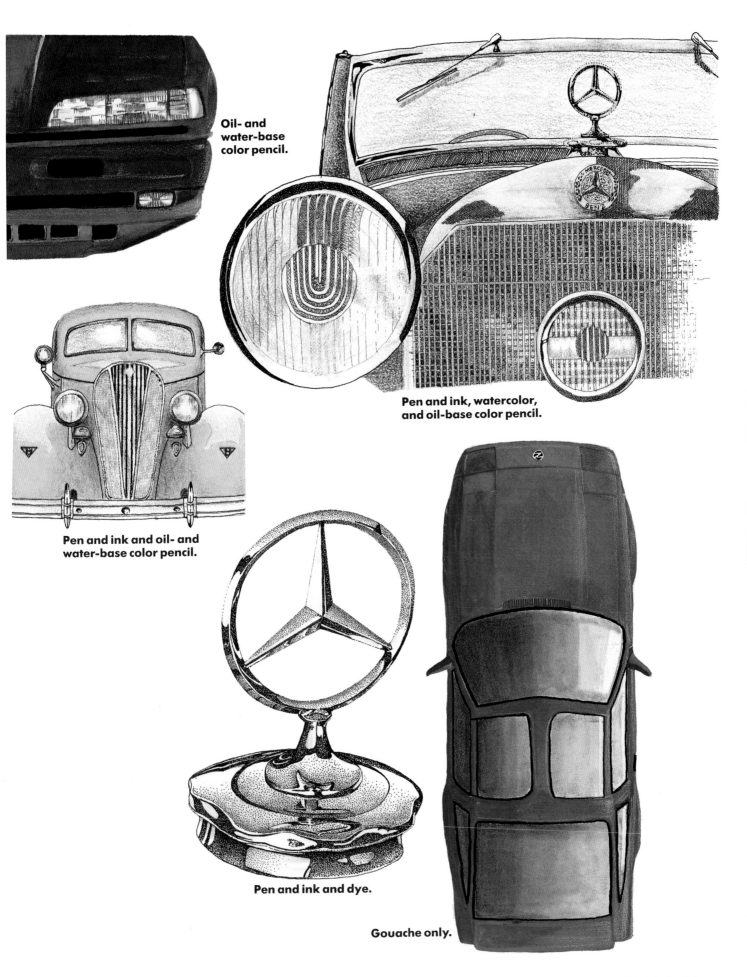

Oil- and
water-base
color pencil.

Pen and ink, watercolor,
and oil-base color pencil.

Pen and ink and oil- and
water-base color pencil.

Pen and ink and dye.

Gouache only.

PEOPLE

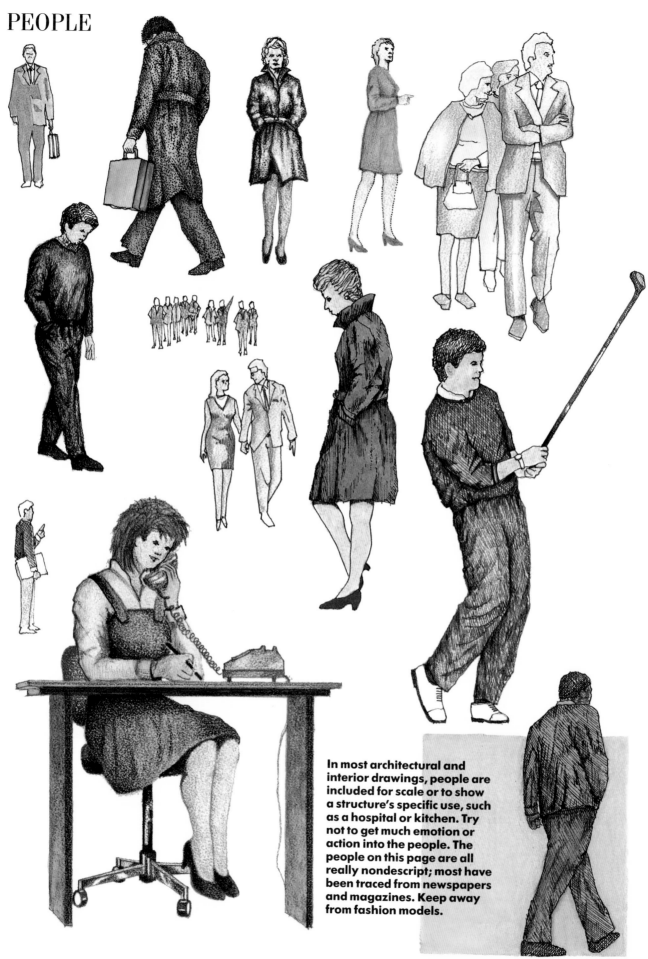

In most architectural and interior drawings, people are included for scale or to show a structure's specific use, such as a hospital or kitchen. Try not to get much emotion or action into the people. The people on this page are all really nondescript; most have been traced from newspapers and magazines. Keep away from fashion models.

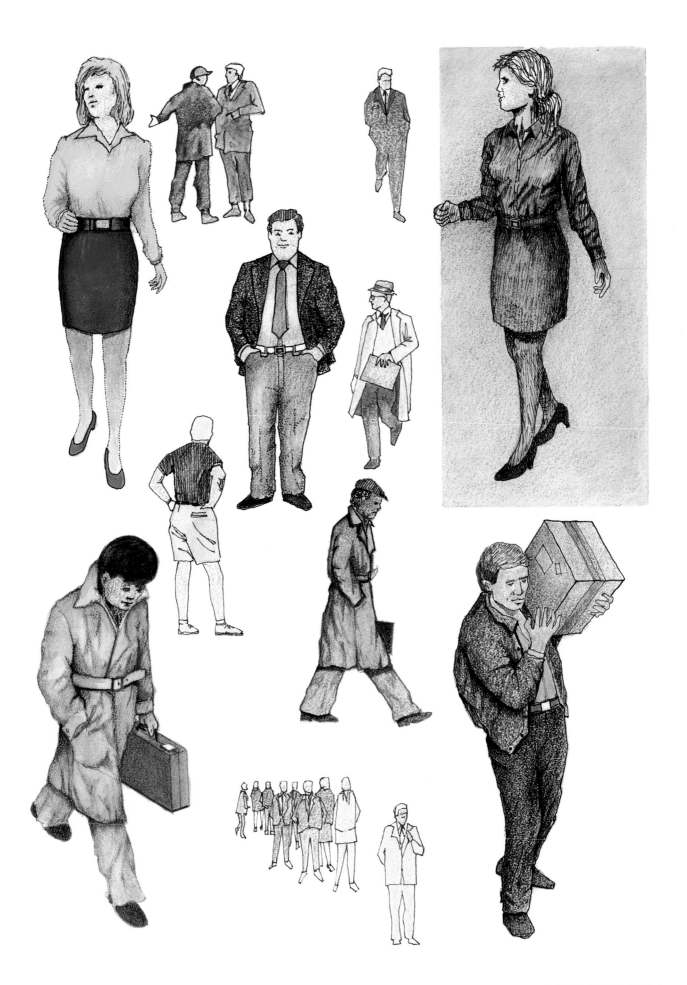

FACES

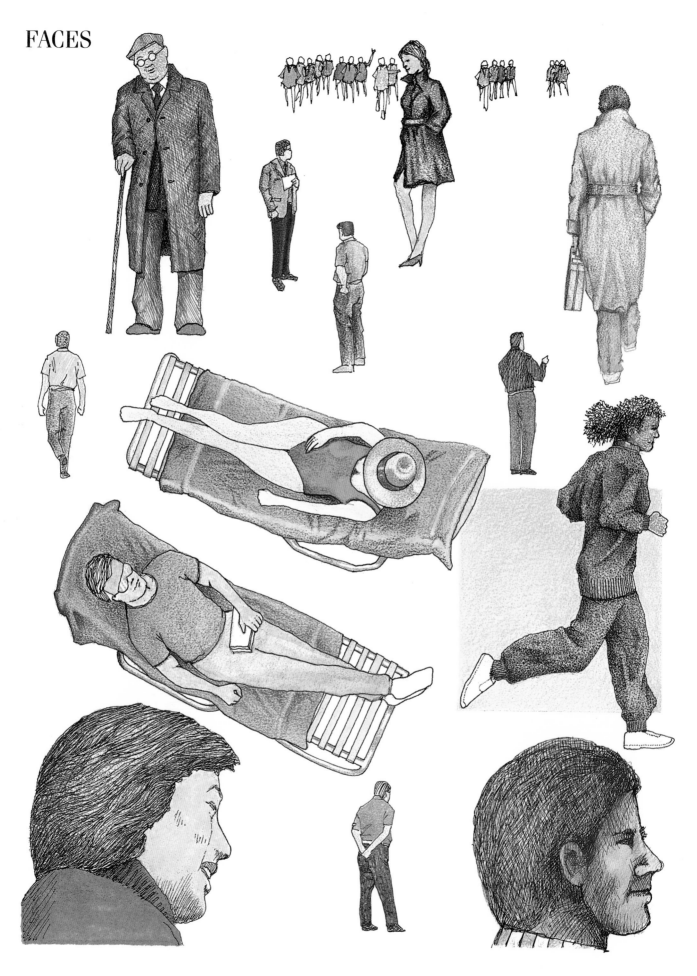

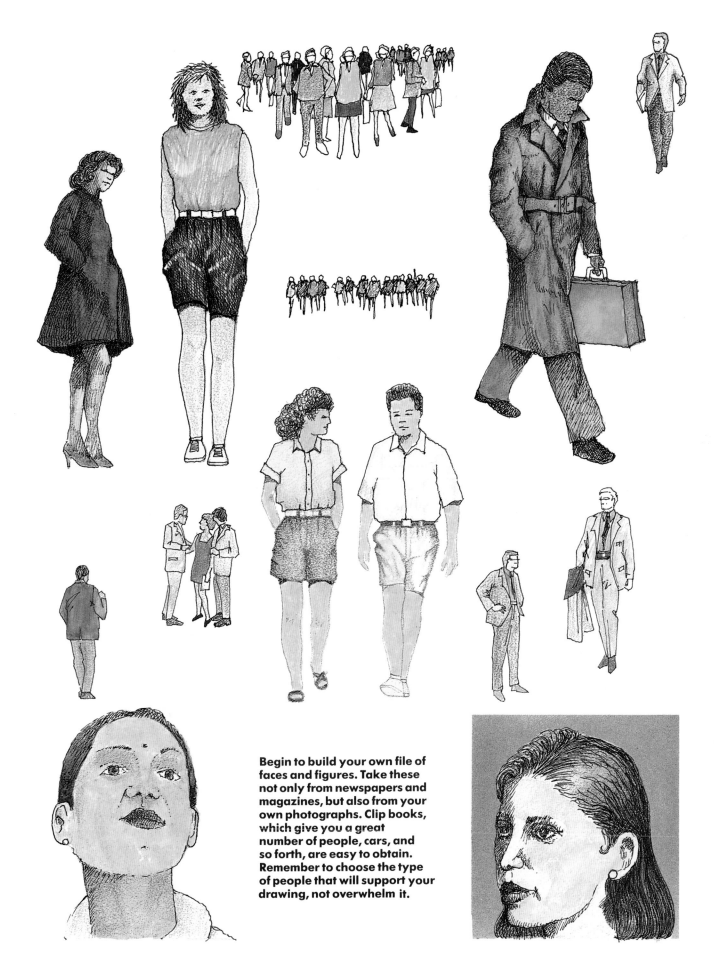

Begin to build your own file of
faces and figures. Take these
not only from newspapers and
magazines, but also from your
own photographs. Clip books,
which give you a great
number of people, cars, and
so forth, are easy to obtain.
Remember to choose the type
of people that will support your
drawing, not overwhelm it.

INTERIORS

THE DESIGNER USUALLY PROVIDES THE ILLUSTRATOR WITH BASIC INFORMATION: THE SPACE, FURNITURE AND FURNISHINGS, MATERIALS, AND COLORS. THE MOOD, THE AMBIENCE, IS THE CREATIVE CHALLENGE TO THE ILLUSTRATOR. THE ANGLE OF THE PERSPECTIVE, THE MANIPULATION OF NATURAL AND ARTIFICIAL LIGHT, THE TEXTURES, AND, OF COURSE, THE MEDIUM OR MEDIA IN COMBINATION CREATE THE MOOD. A CAREFUL ASSESSMENT MUST BE MADE BEFORE THE DRAWING IS BEGUN TO ACHIEVE THE DESIRED AMBIENCE AND TO ASSURE THAT AN UNDERSTANDING OF THE SPACE WILL BE CONVEYED THROUGH THE DRAWING. THE INTERACTION OF COLOR AND MEDIA SHOULD BE POLISHED AND CAREFULLY CONCEIVED.

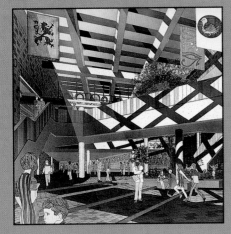
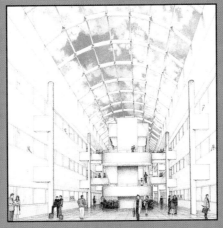

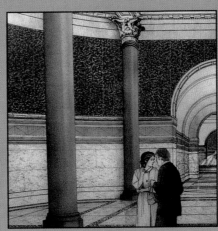
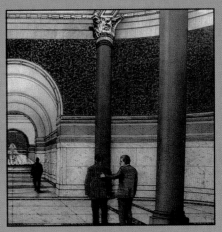
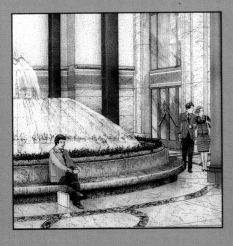
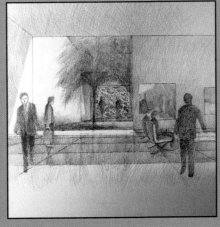
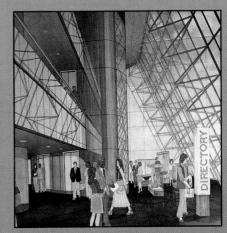

LIBRARY INTERIOR*

An interior designer commissioned us to draw
this reading alcove. We used cool colors—blue,
violet, and green—to create a relaxed ambience.
Water-base color pencils were used to add a soft
texture.

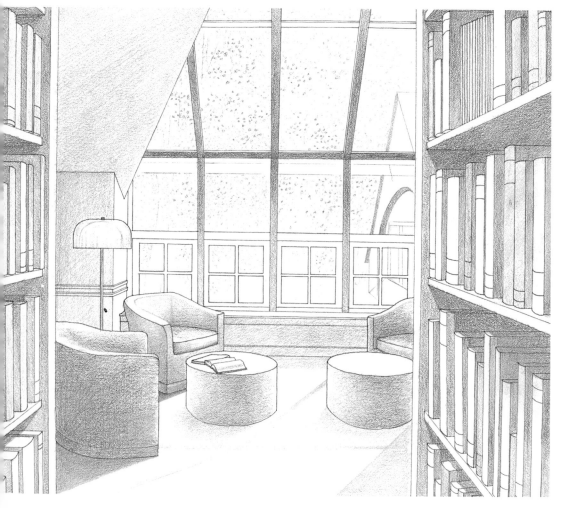

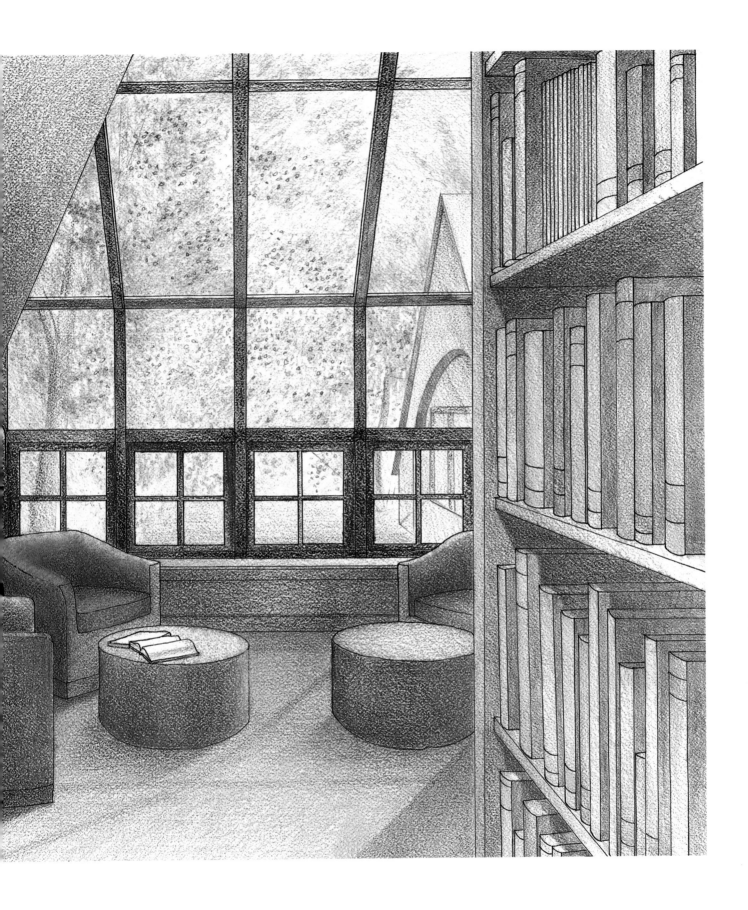

OFFICES FOR YOUNG LAWYERS*

This drawing was commissioned by an interior designer. Water- and oil-base color pencils were used. Some of the details were done with pen and ink. The conservative warm-cool colors suggest the dignity of the law, while the red column and the Mondrian-like painting symbolize youth.

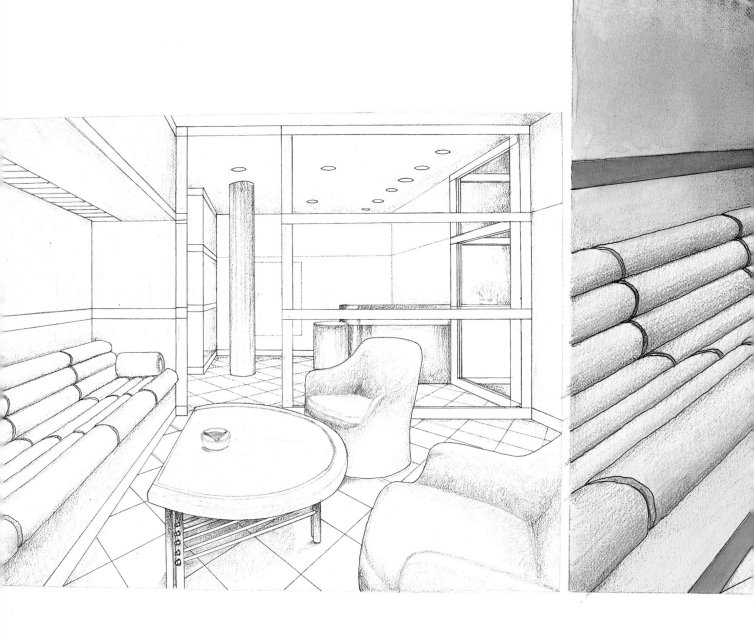

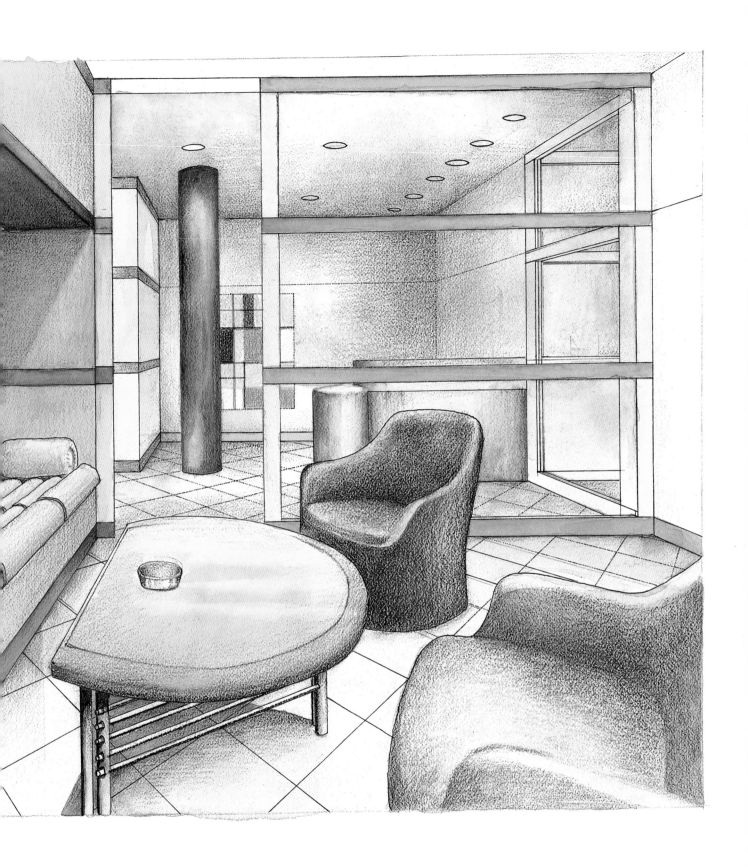

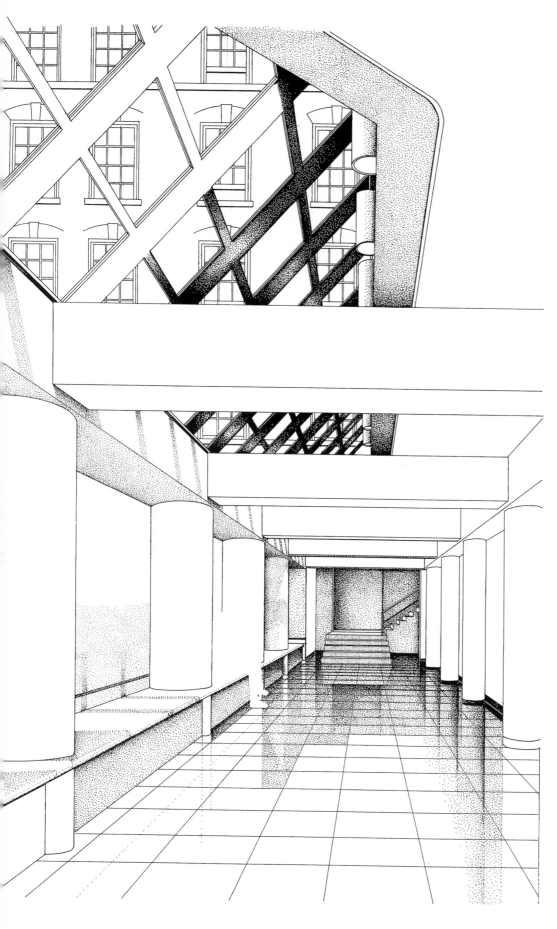

FAMILY COURT INTERIOR*

This very strong architectural interior was illustrated for a presentation to clients. The architect was afraid that the concrete and glass interior would appear too cold. We chose neutral but warm colors. There is a subtle contrast in the floor and the soffits. The base drawing is pen and ink. A straight-edge was used. Light, shade, shadow, and reflection are key in this drawing. Airbrushed gouache gave substance to the concrete structure, walls, and the cement floor. The surfaces were then rendered with oil-base color pencils and stippling. This was a time-consuming illustration.

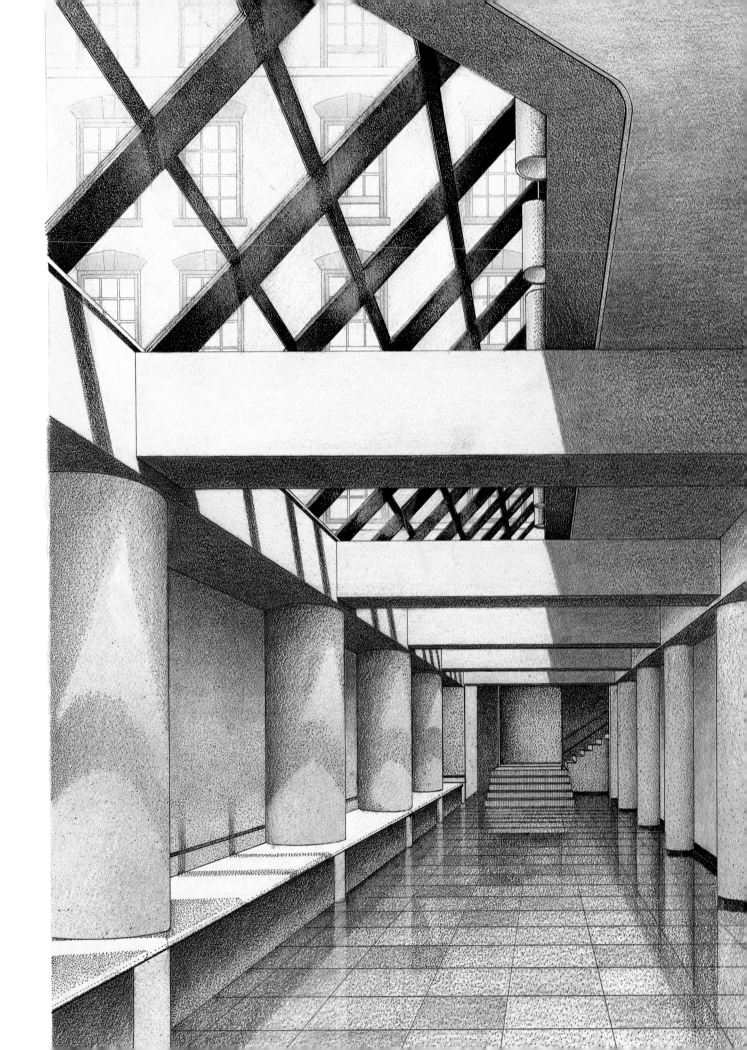

OFFICE INTERIOR*

This high-tech interior was drawn for a space
planner. We used a warm-cool color scheme. The
ceiling was airbrushed. The rest of the illustra-
tion was done in color pencils and watercolor.
Details are in pen and ink.

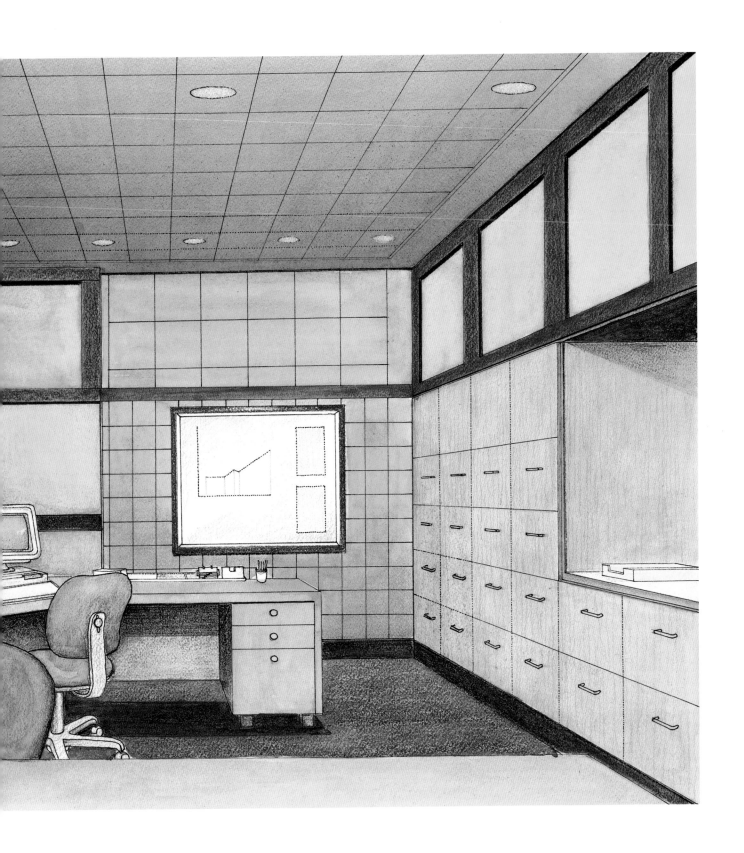

RESTAURANT*

We were given the black chairs and window and mirror trim by the interior designer. We chose warm colors to balance the black. Ink and color pencils were used, both water- and oil-base.

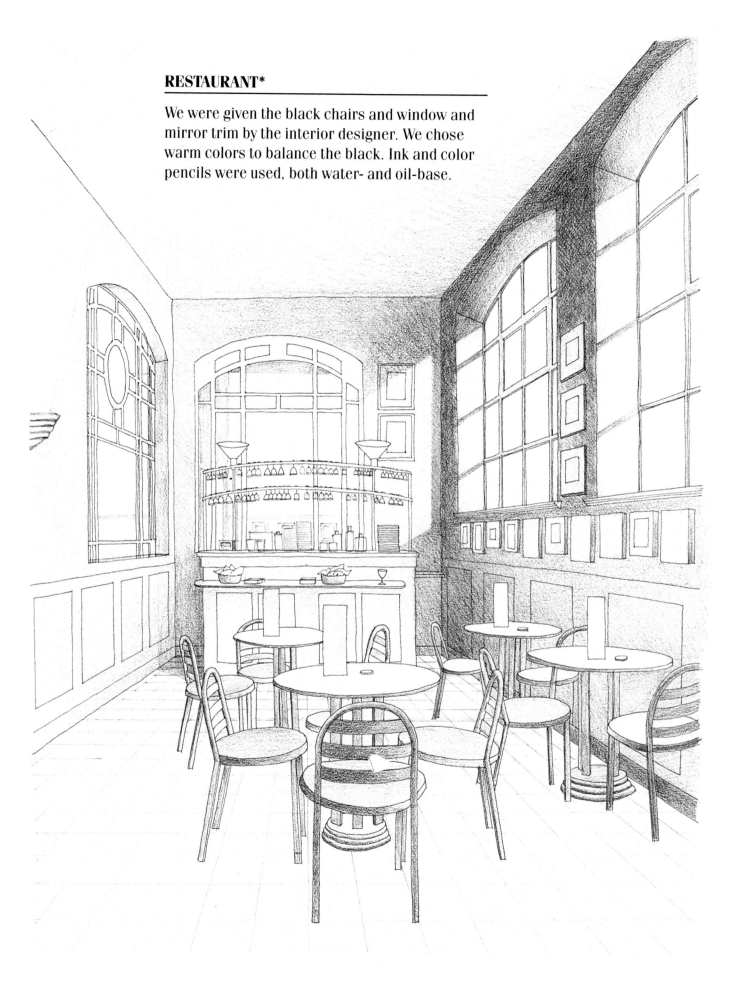

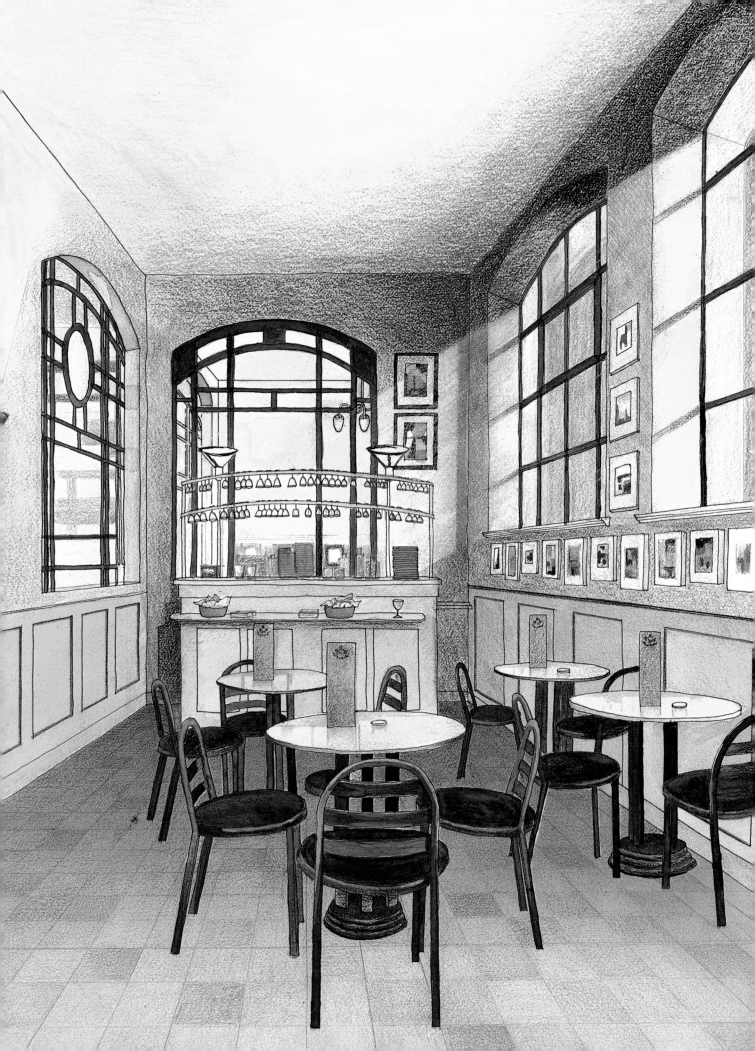

READING AREA IN A SMALL LIBRARY*

Commissioned by an architect, this drawing was washed with watercolor, then textured with water-base color pencils, and finally stippled with black ink. The warm color scheme is contrasted by the greens in the tree and the exterior.

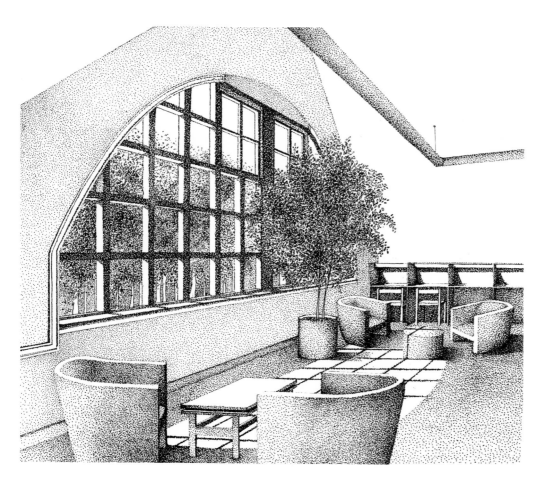

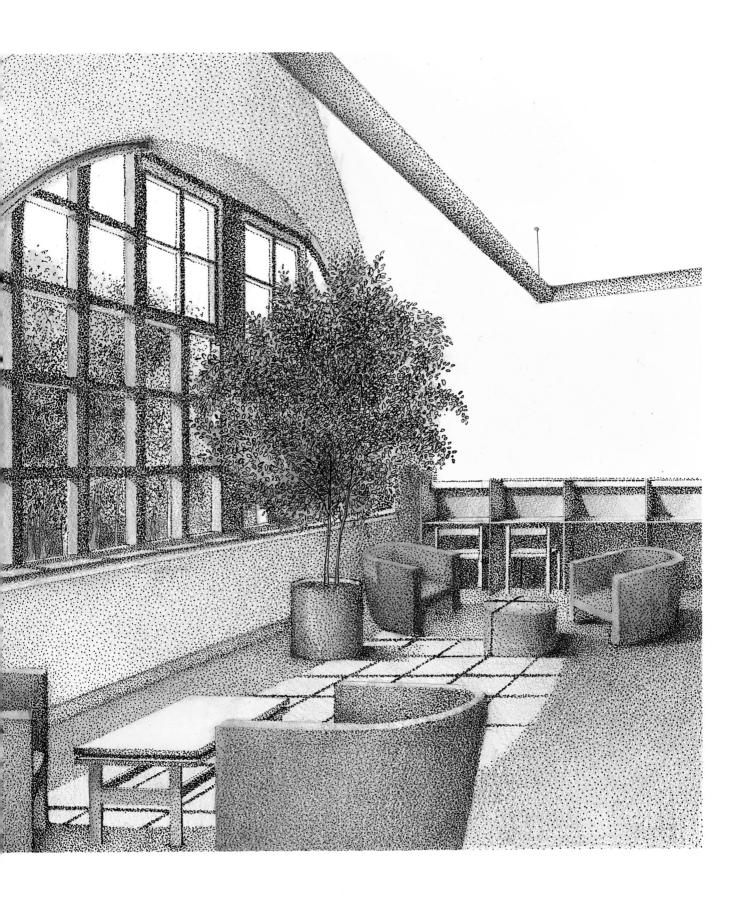

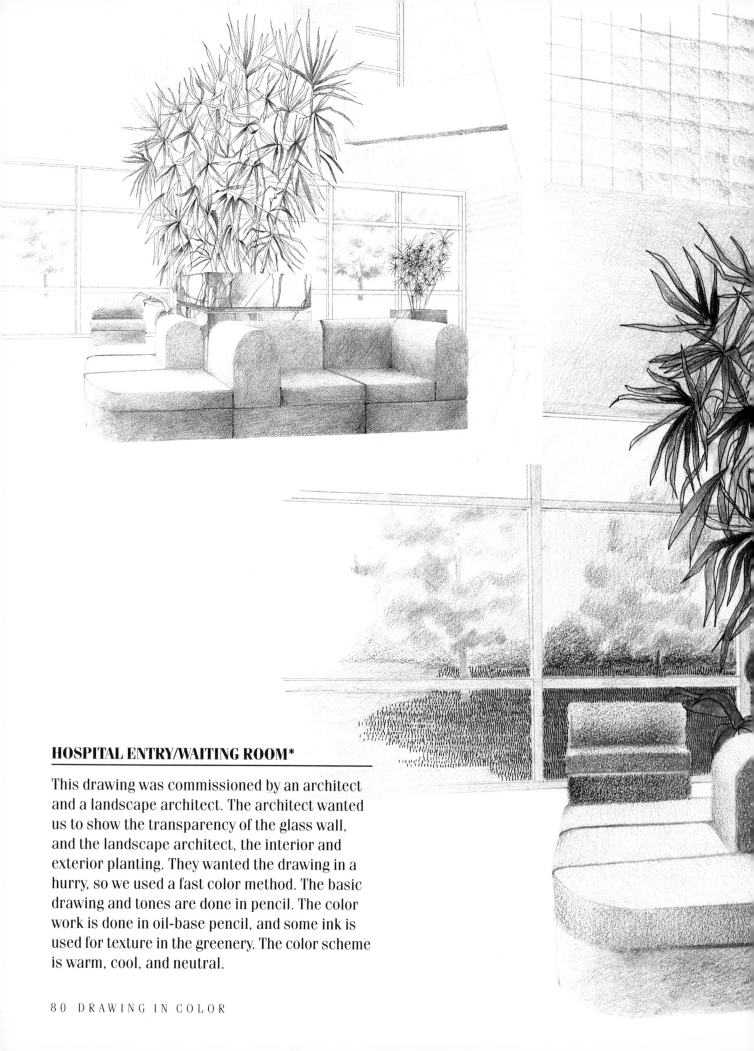

HOSPITAL ENTRY/WAITING ROOM*

This drawing was commissioned by an architect
and a landscape architect. The architect wanted
us to show the transparency of the glass wall,
and the landscape architect, the interior and
exterior planting. They wanted the drawing in a
hurry, so we used a fast color method. The basic
drawing and tones are done in pencil. The color
work is done in oil-base pencil, and some ink is
used for texture in the greenery. The color scheme
is warm, cool, and neutral.

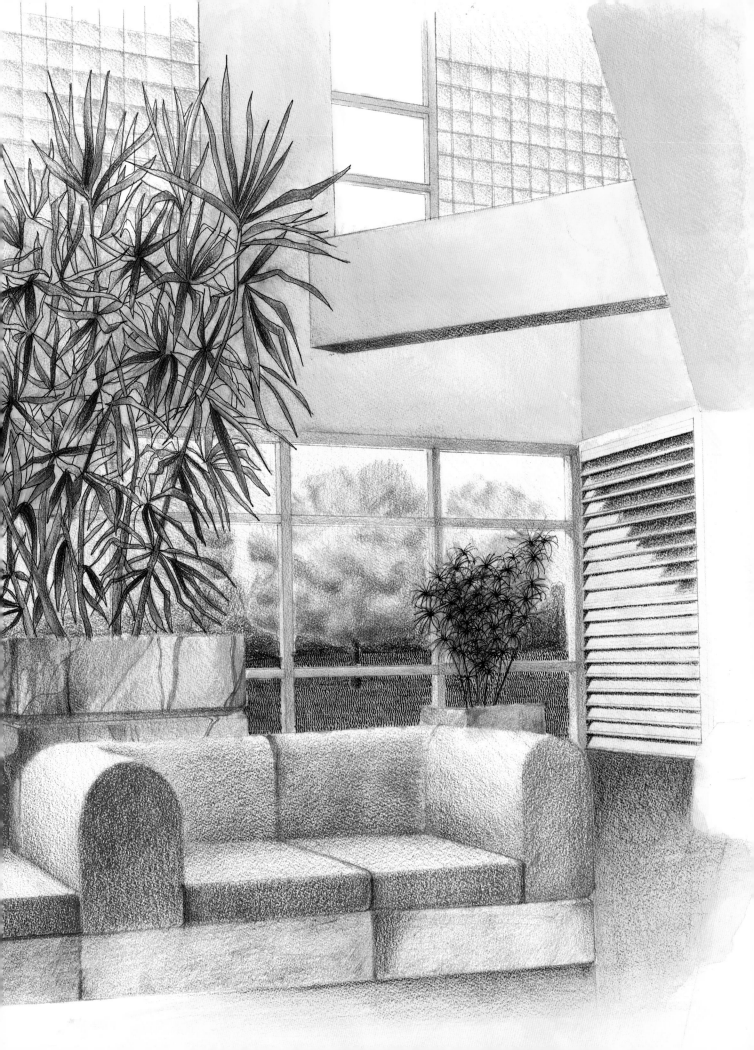

OFFICE FOR A FINNISH DESIGNER*

In this case, the designer gave us the color
scheme. The wood is Asian teak. The chair is an
imitation of an Alvar Aalto design. The colors are
watercolor and oil- and water-base color pencils.

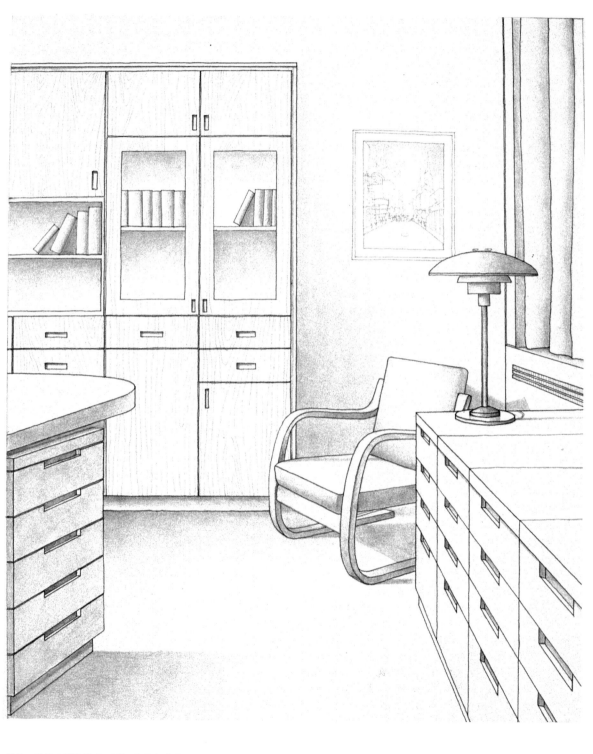

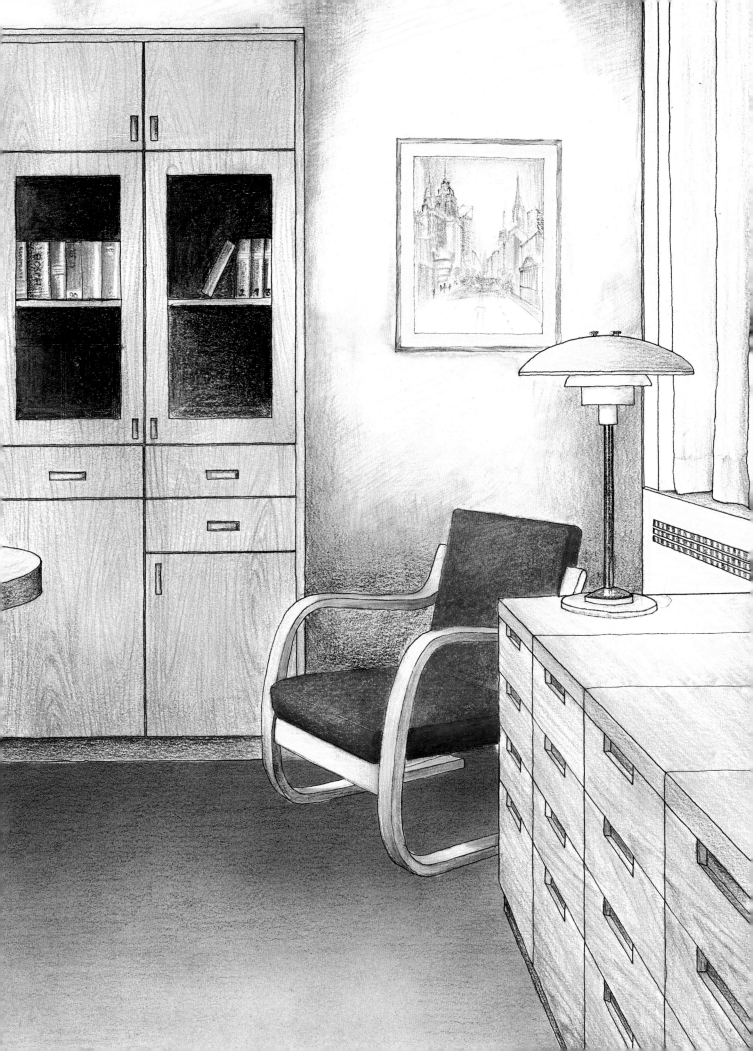

COUNTRY CLUB*

This is an illustration of the lounge area of a suburban club. The designer requested that we feature the flush-butt corner glass detail. The continuity of the patio and the trees through the glass provide the focus on this detail. The color scheme plays warm against cool. The red flowers add a touch of energy to the complimentary greens. The walls were airbrushed, then textured with oil-base color pencils. The balance of the drawing used watercolor with water-base pencils and pen and ink for textures.

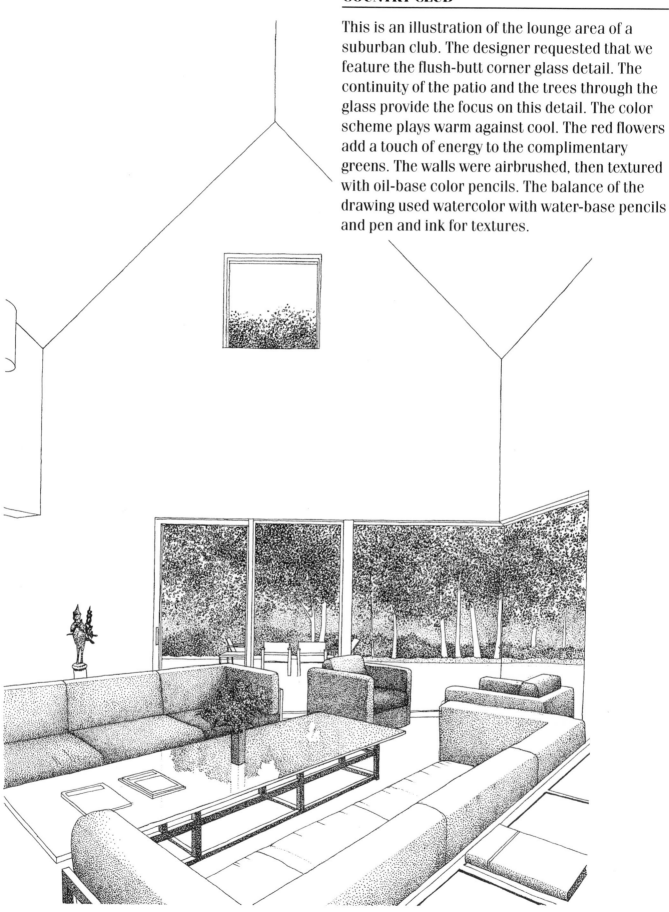

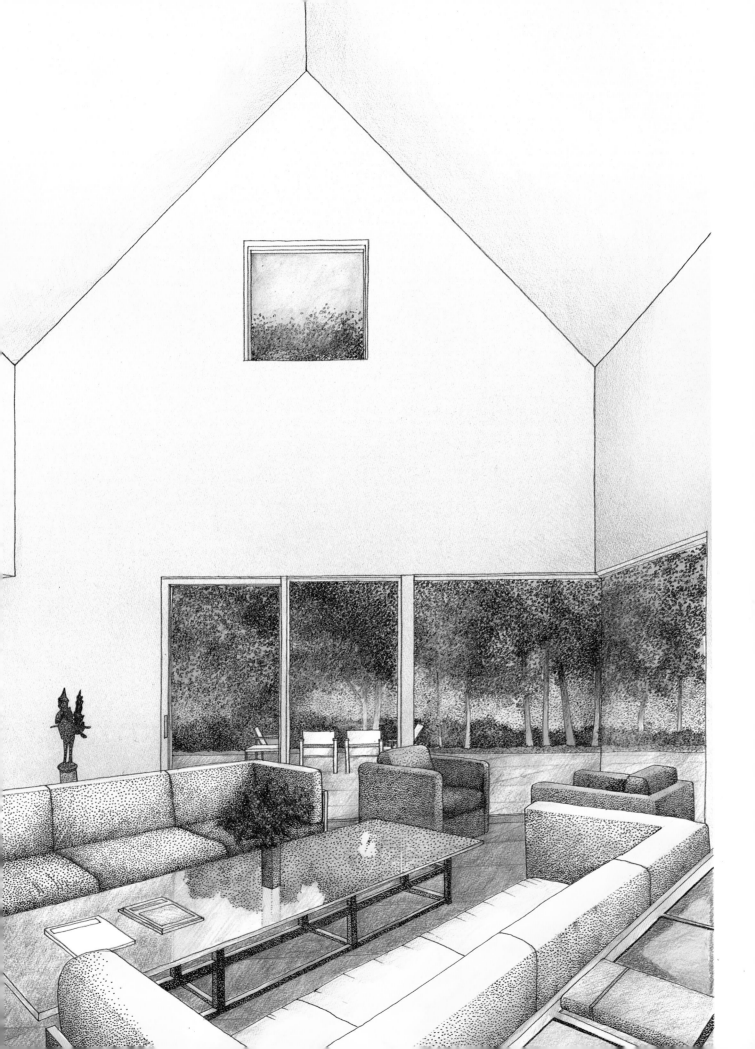

MEN'S CLOTHING STORE

This complicated cut-away perspective was pre-
pared for a space planner. Warm and cool tones
were used to illustrate the racks and displays.
Floor coverings were textured with water-base
color pencils and pen and ink. The colors were
intentionally neutral to highlight the pen and
ink details.

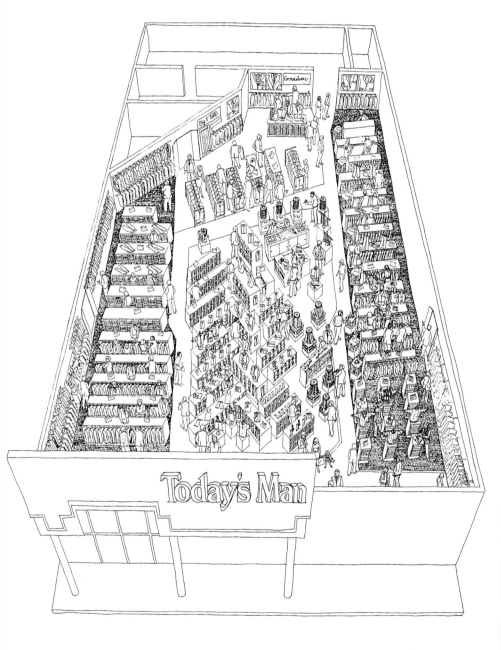

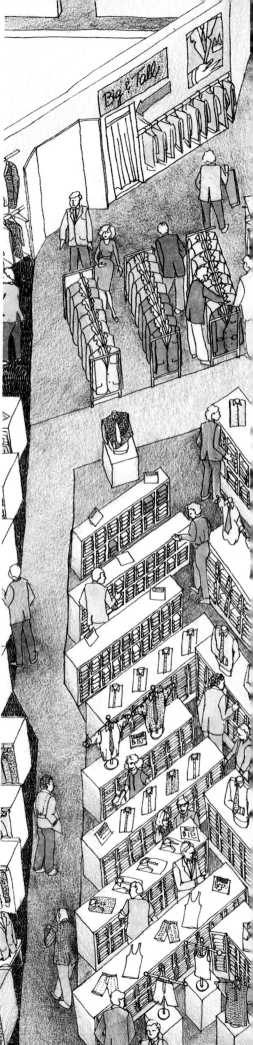

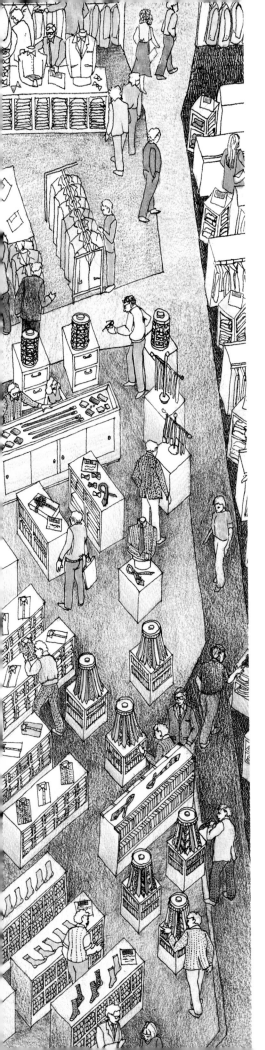

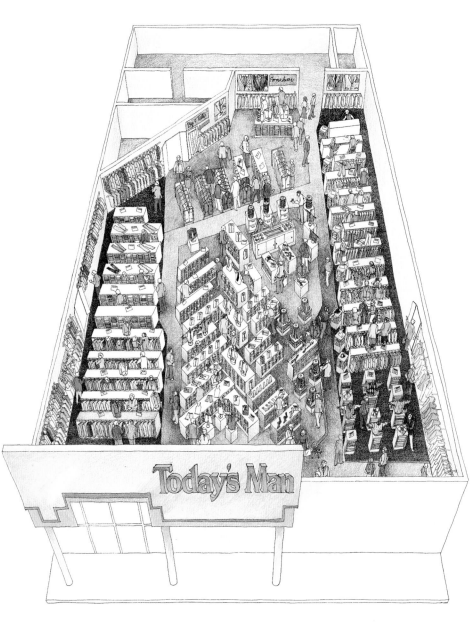

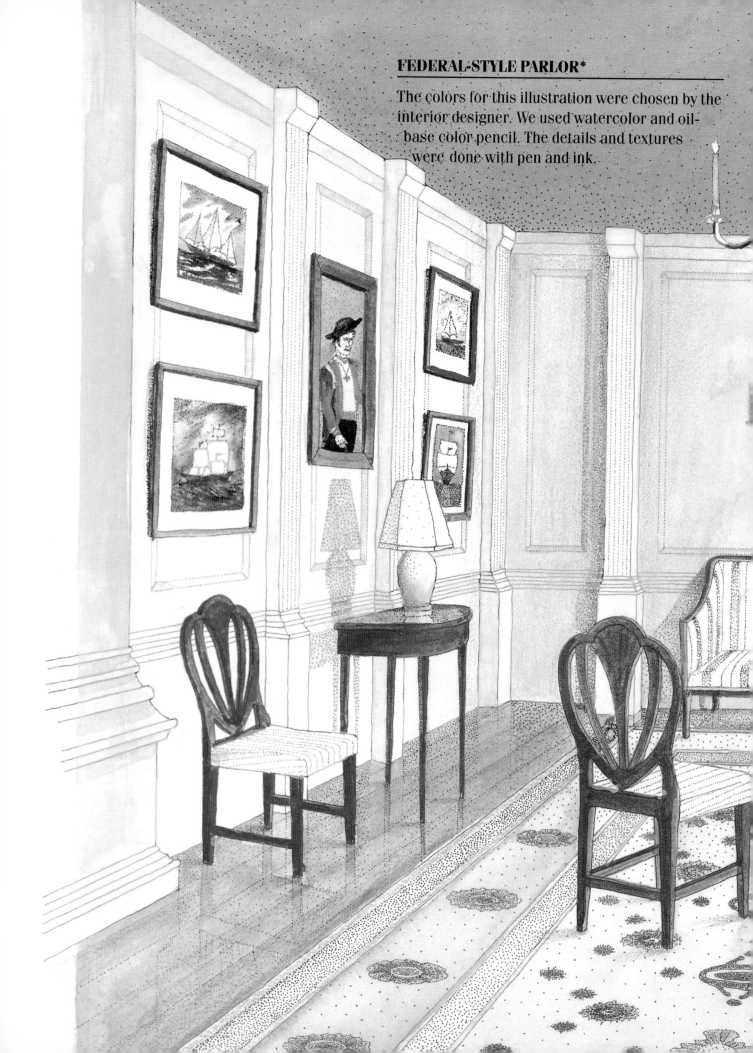

FEDERAL-STYLE PARLOR*

The colors for this illustration were chosen by the interior designer. We used watercolor and oil-base color pencil. The details and textures were done with pen and ink.

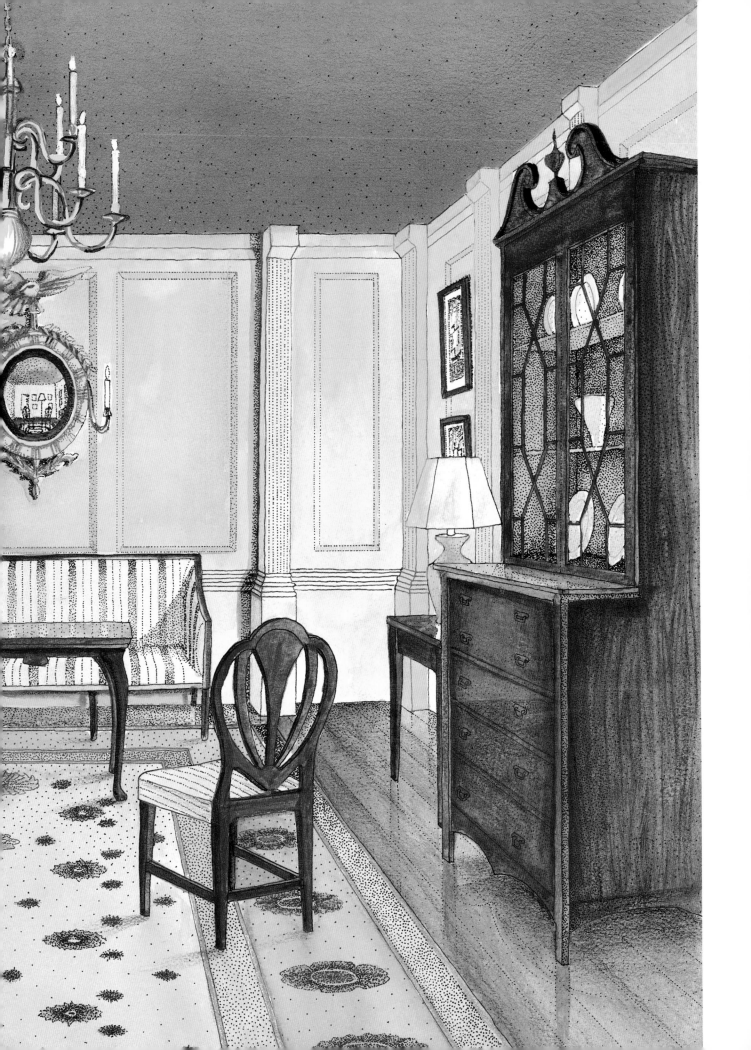

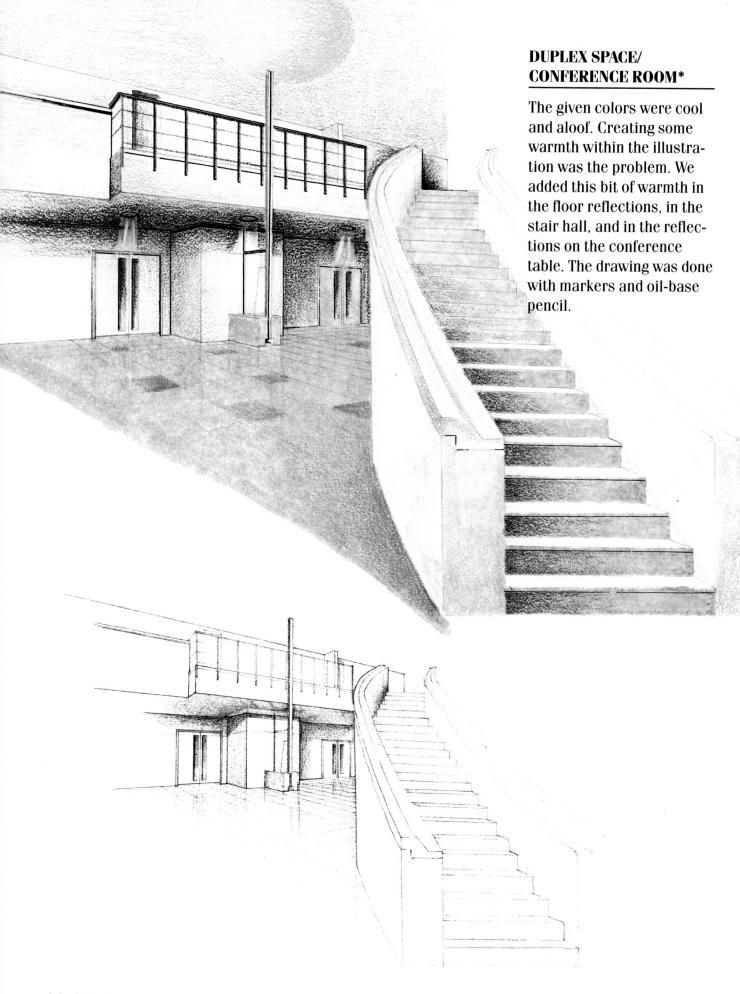

DUPLEX SPACE/ CONFERENCE ROOM*

The given colors were cool and aloof. Creating some warmth within the illustration was the problem. We added this bit of warmth in the floor reflections, in the stair hall, and in the reflections on the conference table. The drawing was done with markers and oil-base pencil.

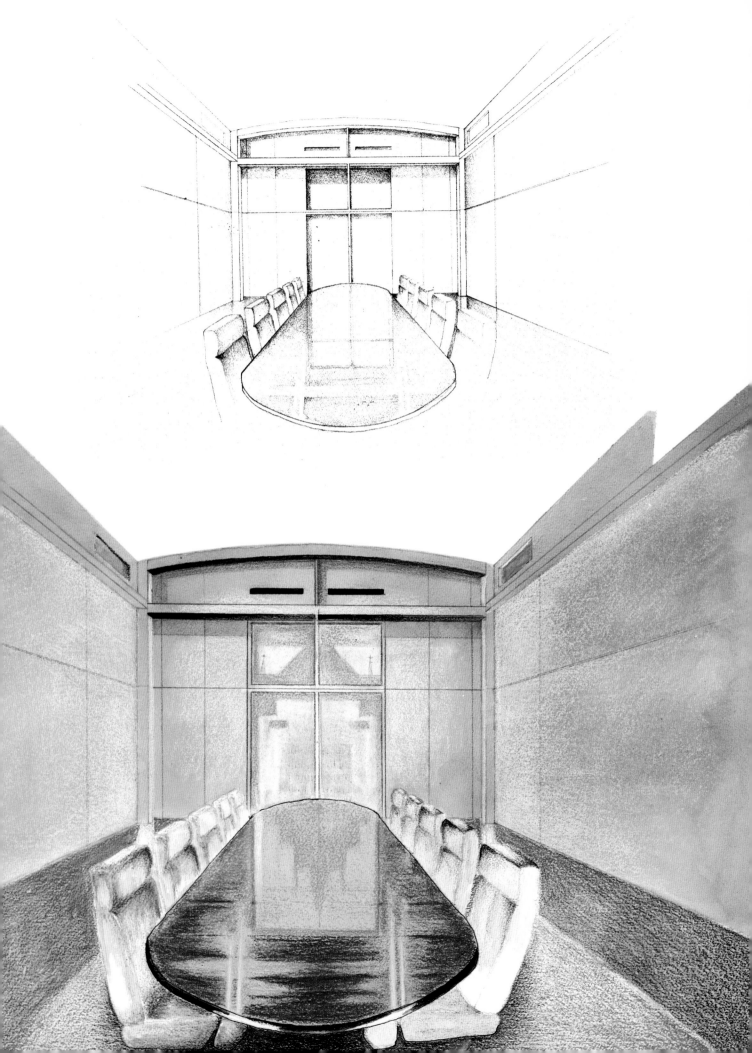

MEETING ROOM*

The challenge in this illustration was the replication of the reflections caused by semi-recessed lights in a mirrored ceiling. These reflections are further complicated by the wall washers and the pendant fixtures. The suede-like carpet was airbrushed. The ceiling was rendered with color pencils. The walls, tables, and chairs are watercolor and oil-base color pencil.

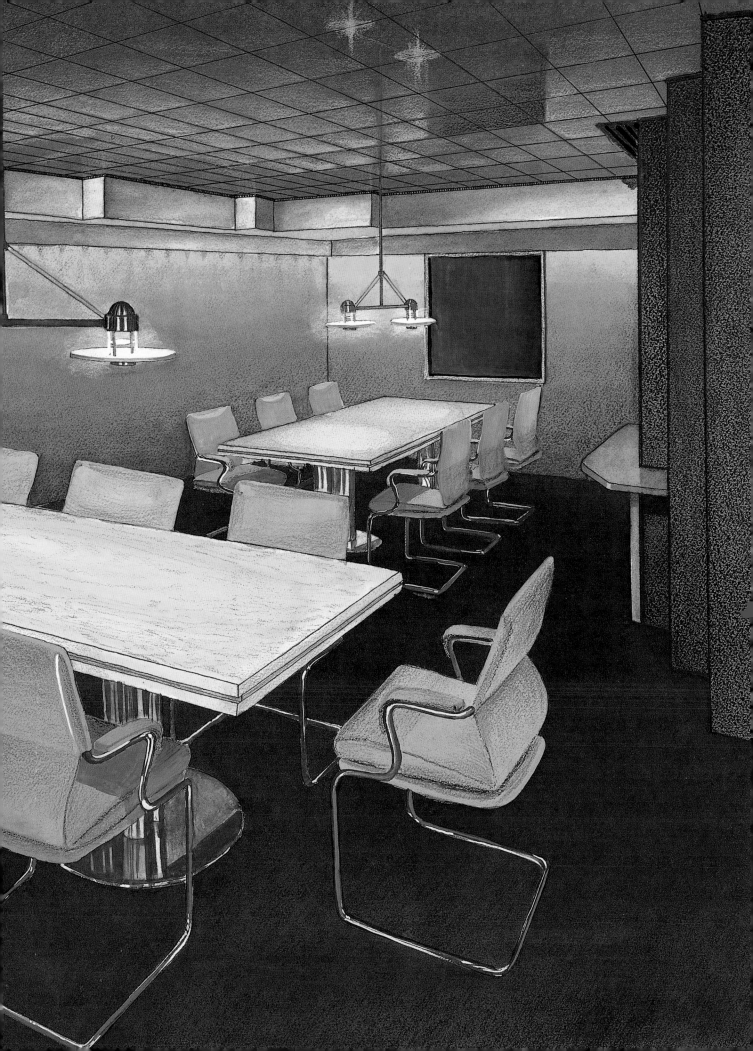

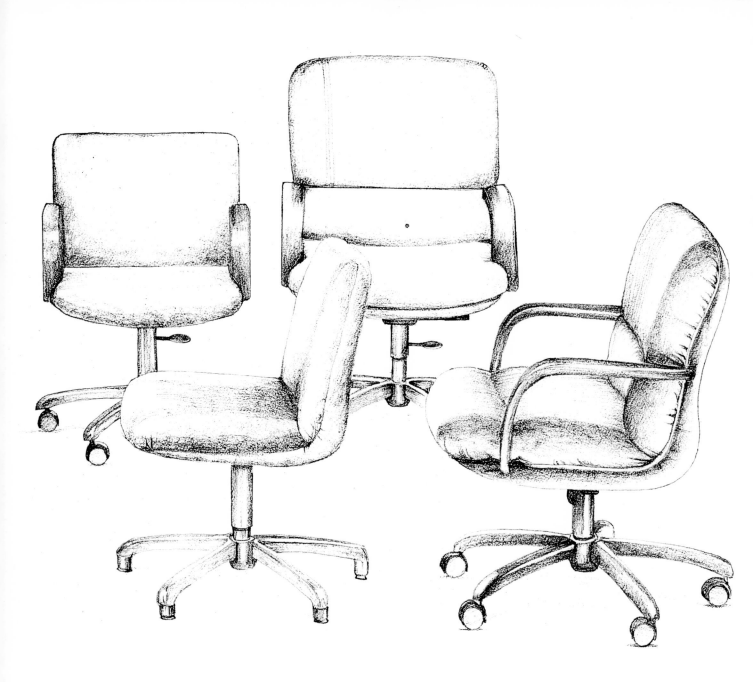

FOUR CHAIRS*

A furniture designer asked us to prepare a draw-
ing of his line of commercial furniture. The
unupholstered sections of the chairs are alumin-
um finished in glossy black. We stippled black
ink to illustrate this finish. The upholstery is
water-base color pencil. We chose this medium
to demonstrate the texture of the fabric. This is
further textured with stippled ink. We tied the
complex composition with a monochromatic color
scheme that is cool and low in energy. We further
tied the drawing with a neutral airbrush back-
ground.

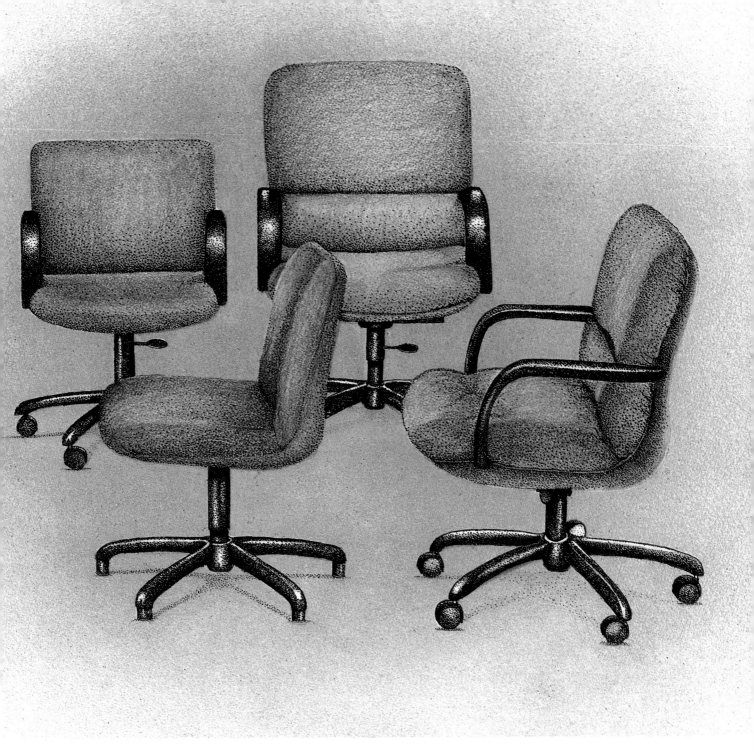

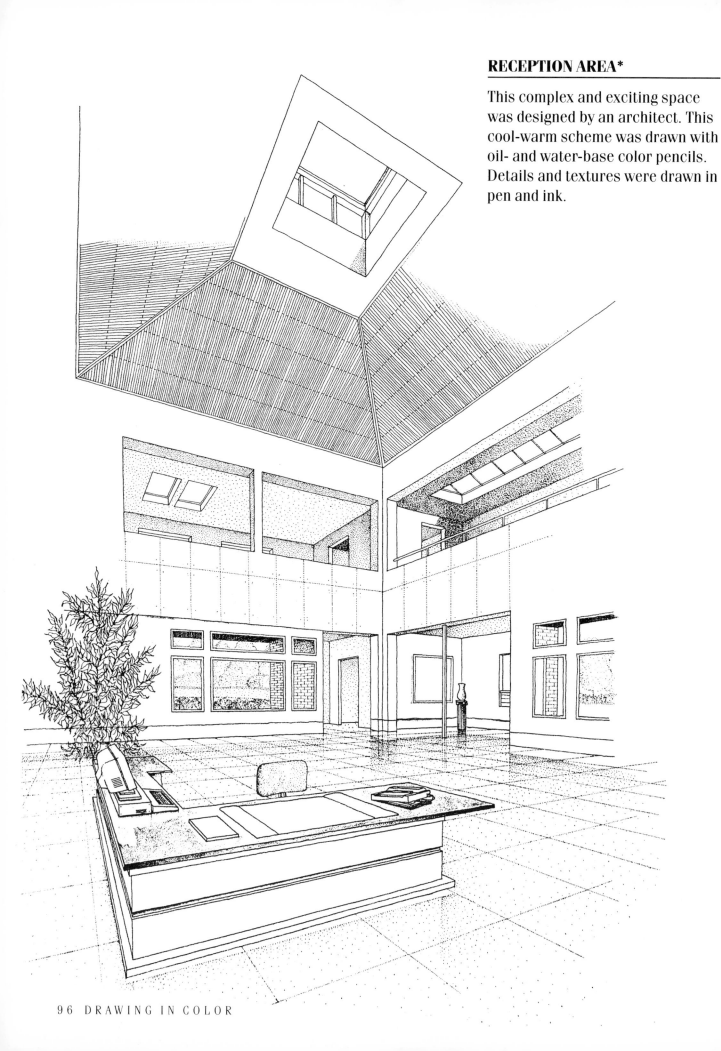

This complex and exciting space was designed by an architect. This cool-warm scheme was drawn with oil- and water-base color pencils. Details and textures were drawn in pen and ink.

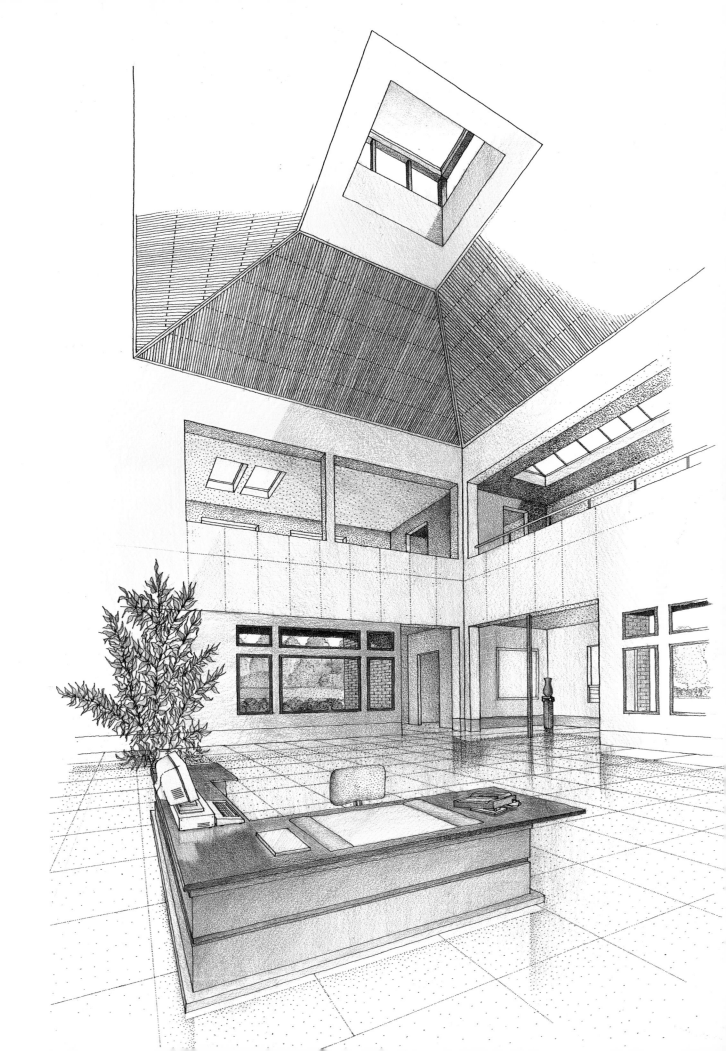

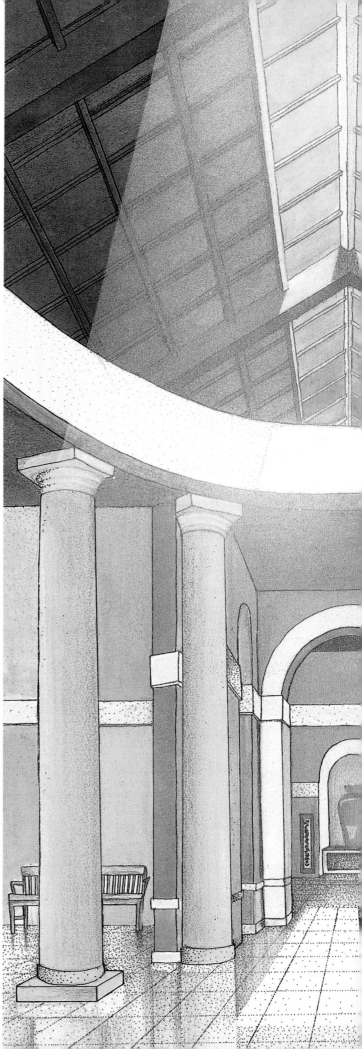

ENTRANCE HALL*

An architect commissioned this illustration. The space provides entry to a series of elegant specialty shops. We chose a monochromatic scheme of grays. The drawing is basically watercolor with touches of water-base color pencil.

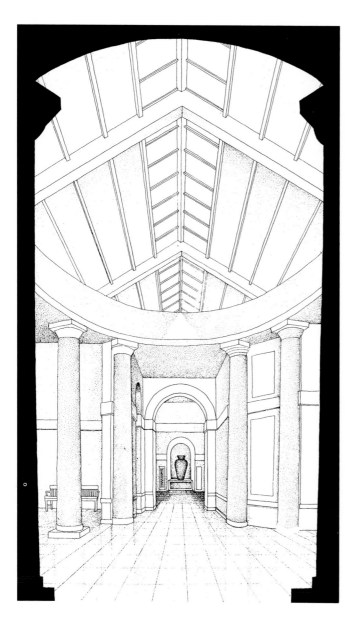

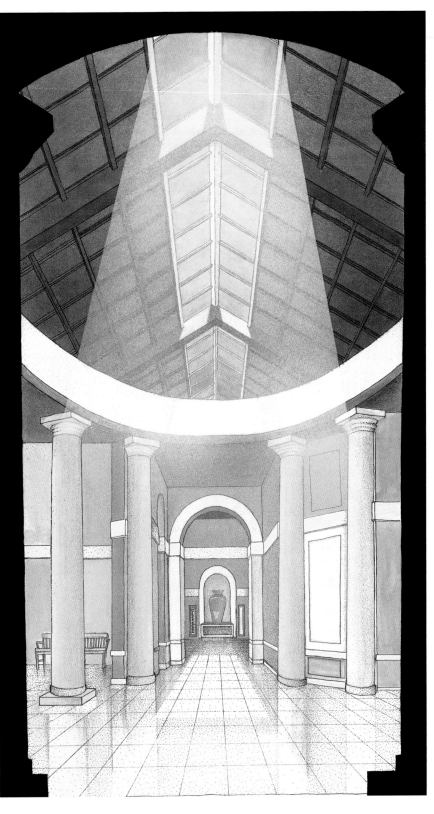

VICE-PRESIDENT'S OFFICE*

This illustration was ordered by an interior de-
signer, who gave us the color scheme. We used
watercolor, oil- and water-base color pencils.
The variety of textures were drawn with pen
and ink.

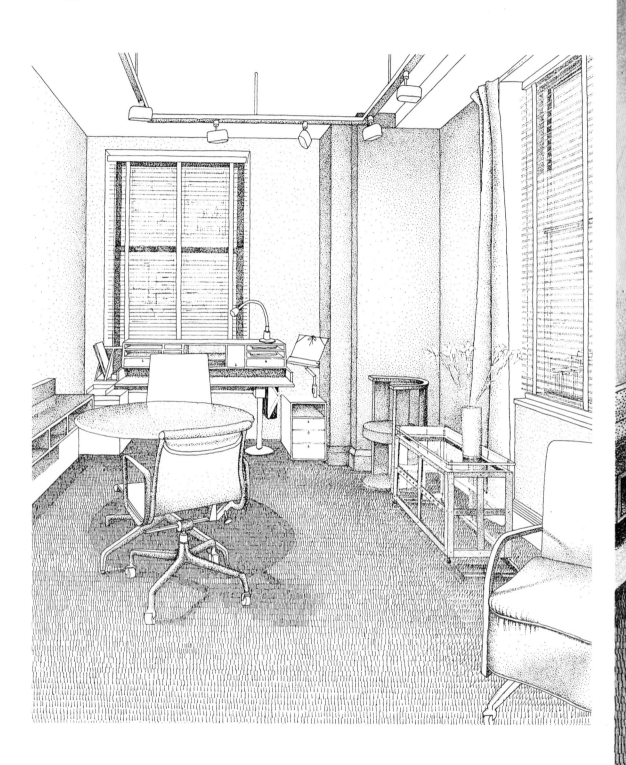

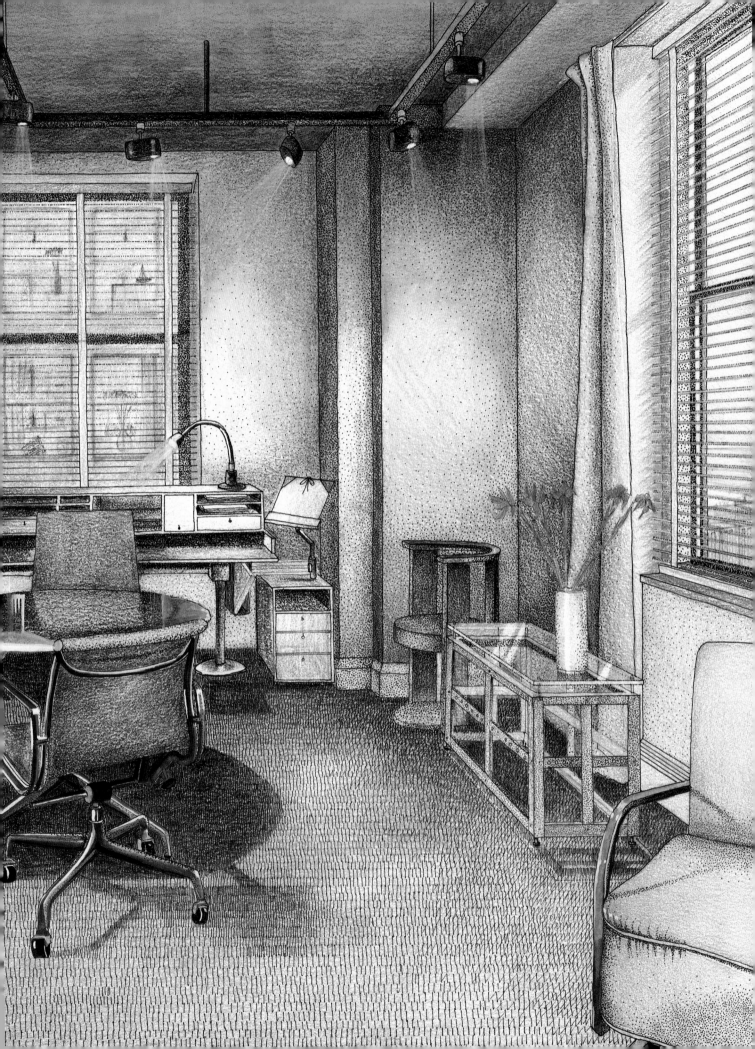

EXHIBITION SPACE*

An architect designed this exhibition space in a
high-tech environment. The colors are warm to
contrast the cool glass and greenery. The warm
colors, built around yellow, are analogous. We
used watercolor, water-base color pencil.
and pen and ink.

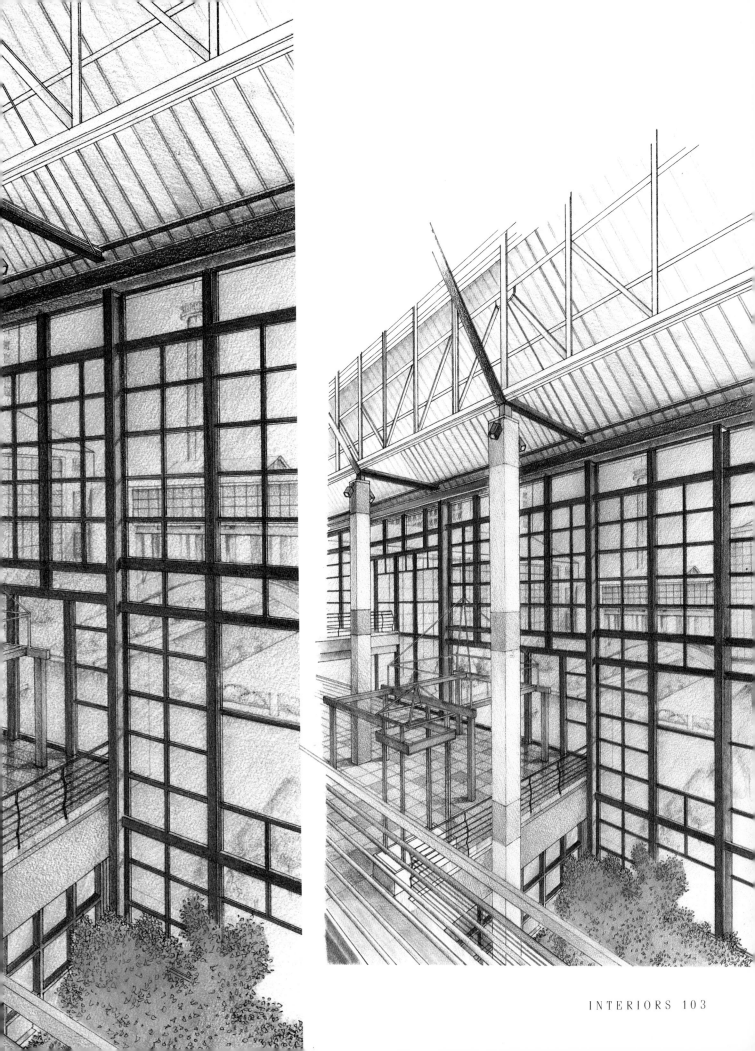

EXTERIORS

THE ARCHITECT, LIKE THE DE-SIGNER, PROVIDES THE ILLUSTRATOR WITH BASIC INFORMA-TION: THE VOLUMES, THE MATERIALS, THE COLORS, AND THE ENVIRONMENT OF THE BUILDING. THE MOOD OF THE ILLUS-TRATION, LIKE THE INTERIORS, DEPENDS ON THE ILLUSTRA-TOR'S CHOICE OF THE ANGLE OF THE PERSPECTIVE, LIGHT, TEXTURES, AND MEDIA. ADDITIONAL CONSIDERATIONS FOR THE ILLUSTRATOR ARE THE TIME OF DAY, THE SEASON, THE WEATHER, OPACITY, TRANSPARENCY, AND THE ENTOURAGE. THE UNDER-STANDING OF LIGHT, SHADE, AND SHADOW IS IMPERATIVE TO THE ESTABLISHMENT OF THESE CONSIDERATIONS AND TO EF-FECTIVELY USE THEM TO BEST SUPPORT THE BUILDING.

 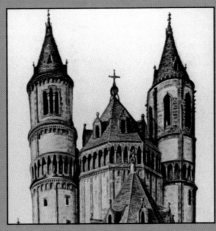 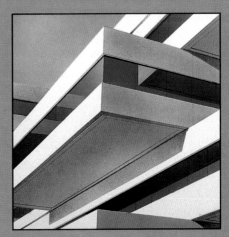

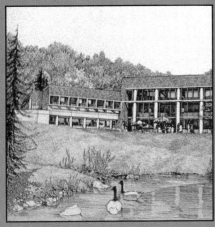 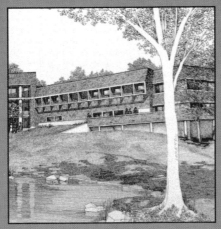 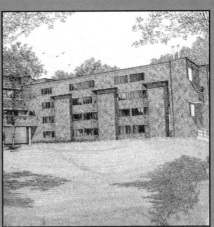

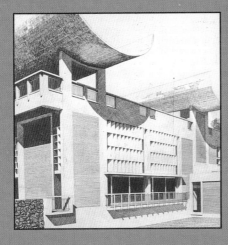 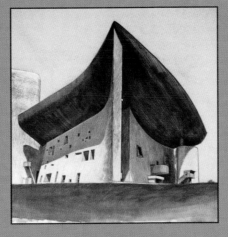 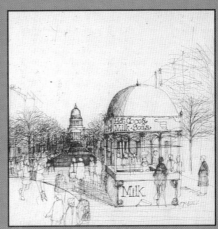

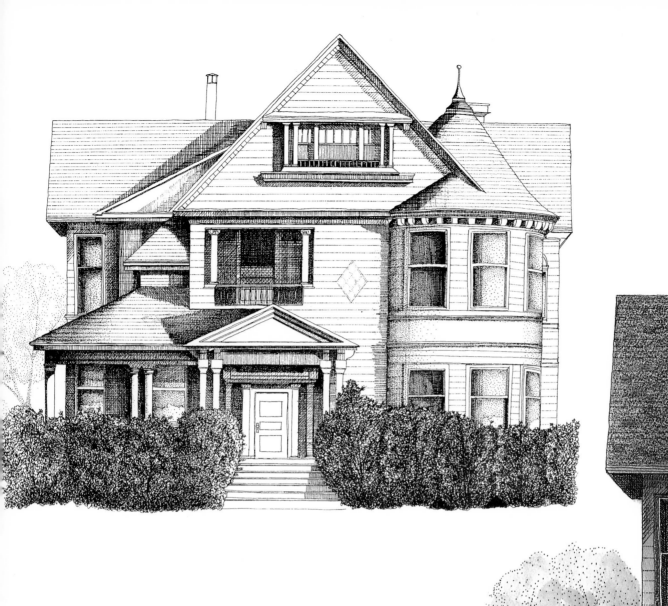

SHINGLE-STYLE HOUSE*

This whimsical house of shingles was detailed
with pen-and-ink stippling. The roofs are warm
brown, and the walls are warm beige. Contrast
is created by the cool sky and the greenery. We
tried to capture the amusing forms and details of
the shingle style.

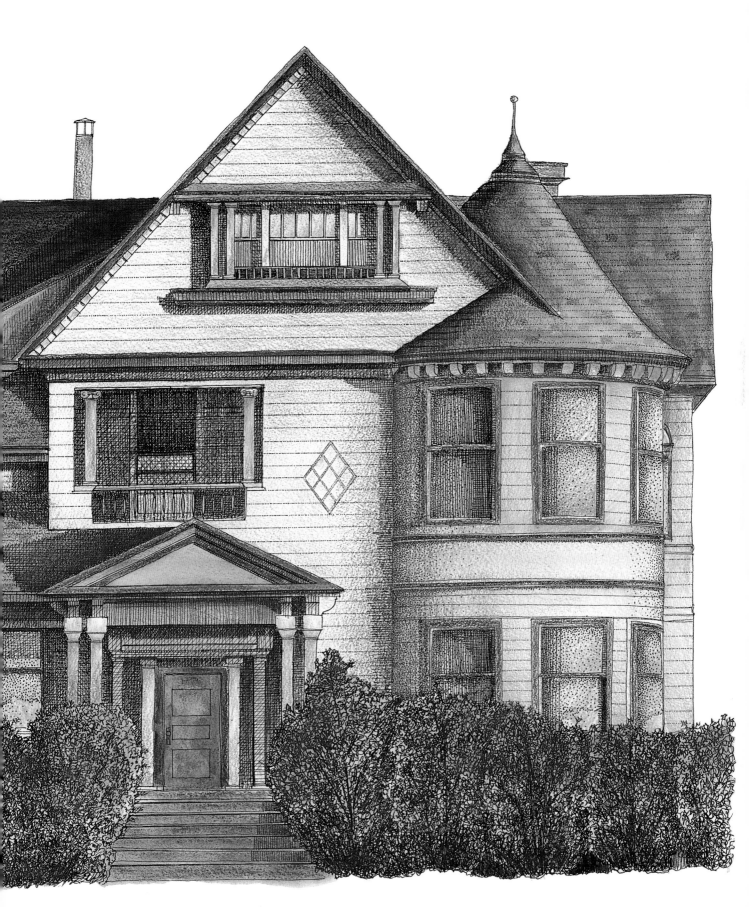

SUBURBAN INSURANCE COMPLEX*

Materials and details were our primary concern in this illustration. The materials are concrete, precast concrete, aluminium, glass, and glass block. Reflections were very difficult. We used two triadic color schemes: primary and secondary. Although three colors are cool and three colors are warm, the cool areas of color are dominant. Except for the airbrushed sky, all colors are transparent.

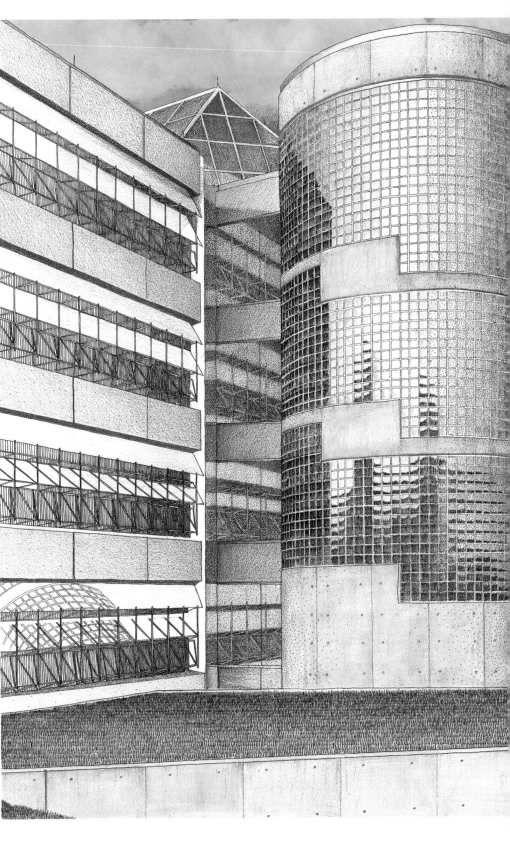

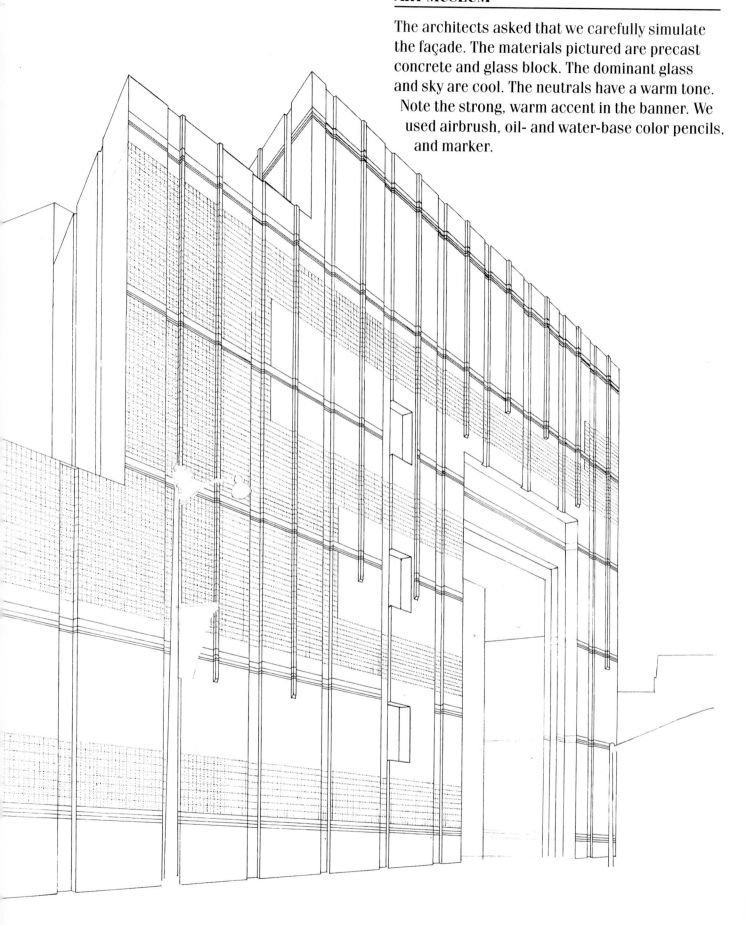

ART MUSEUM*

The architects asked that we carefully simulate the façade. The materials pictured are precast concrete and glass block. The dominant glass and sky are cool. The neutrals have a warm tone. Note the strong, warm accent in the banner. We used airbrush, oil- and water-base color pencils, and marker.

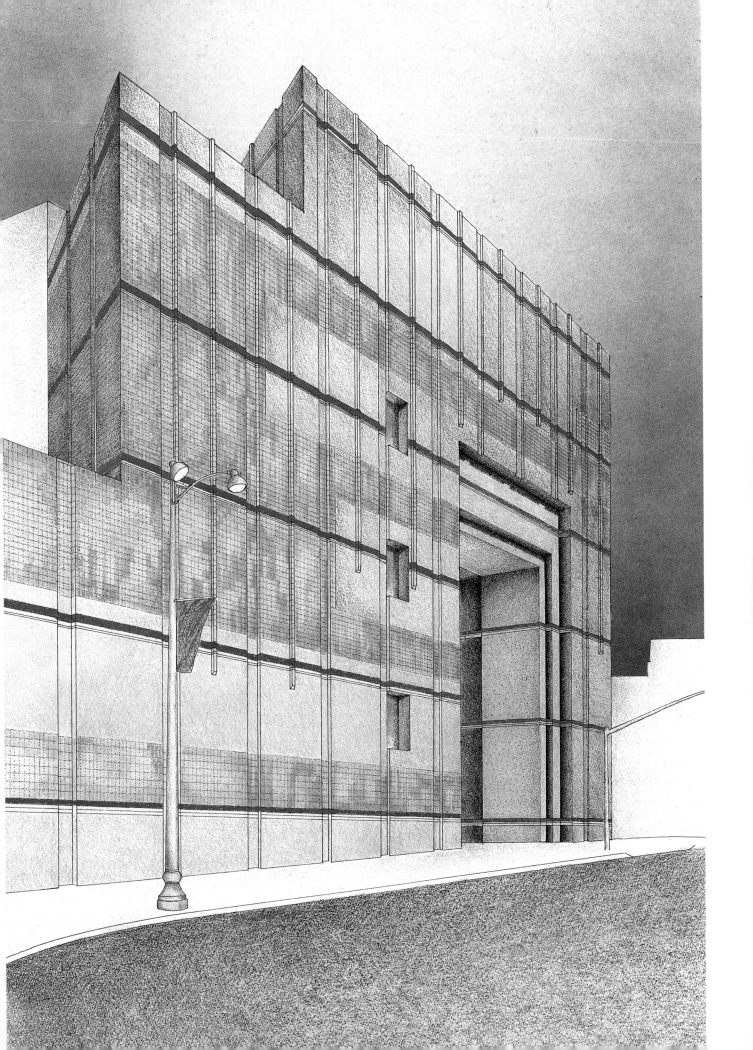

SMALL TOWN IN NEW ENGLAND*

Here are two illustrations that were prepared for
a developer. The vivid airbrushed sky adds a cool
note to an essentially warm color scheme. The
brick tones reflect the architectural traditions of
New England.

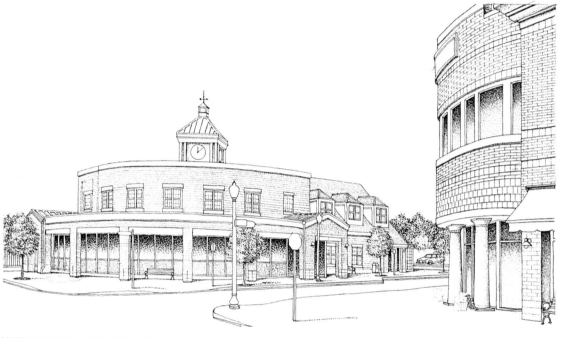

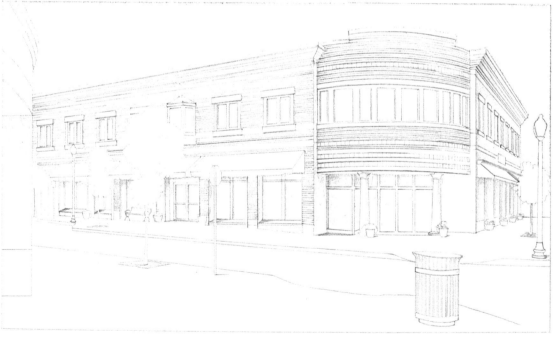

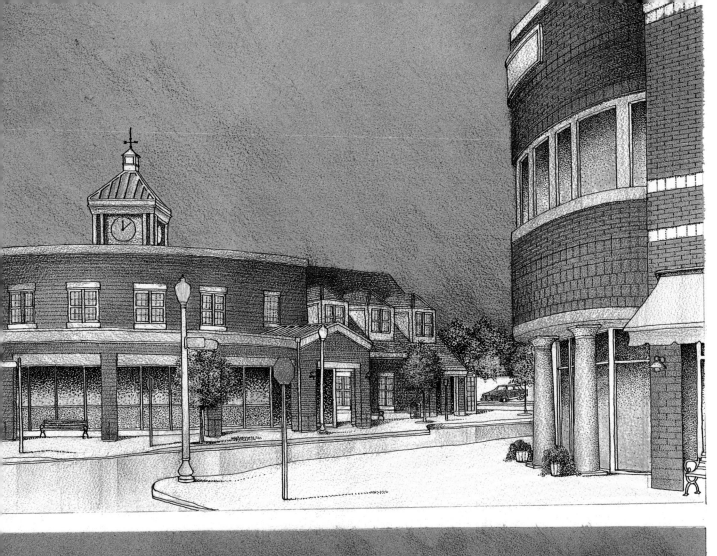

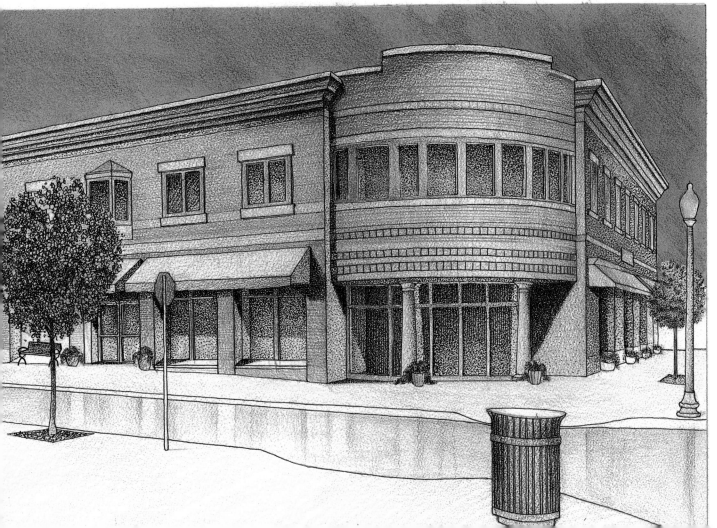

SMALL MUSEUM*

The architect was afraid that the client might
think this design too severe. The materials, pre-
cast concrete and glass, are harsh. We designed
this illustration as an early evening scene to
contrast the transparent glass and opaque con-
crete. We softened the concrete by accenting the
texture, and we used a soft analogous color
scheme. The media are pencil, oil- and water-
base color pencils, and watercolor.

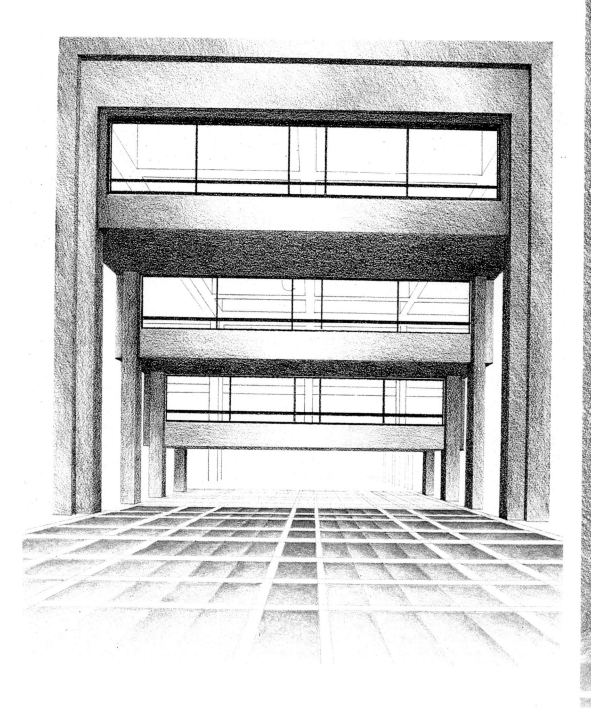

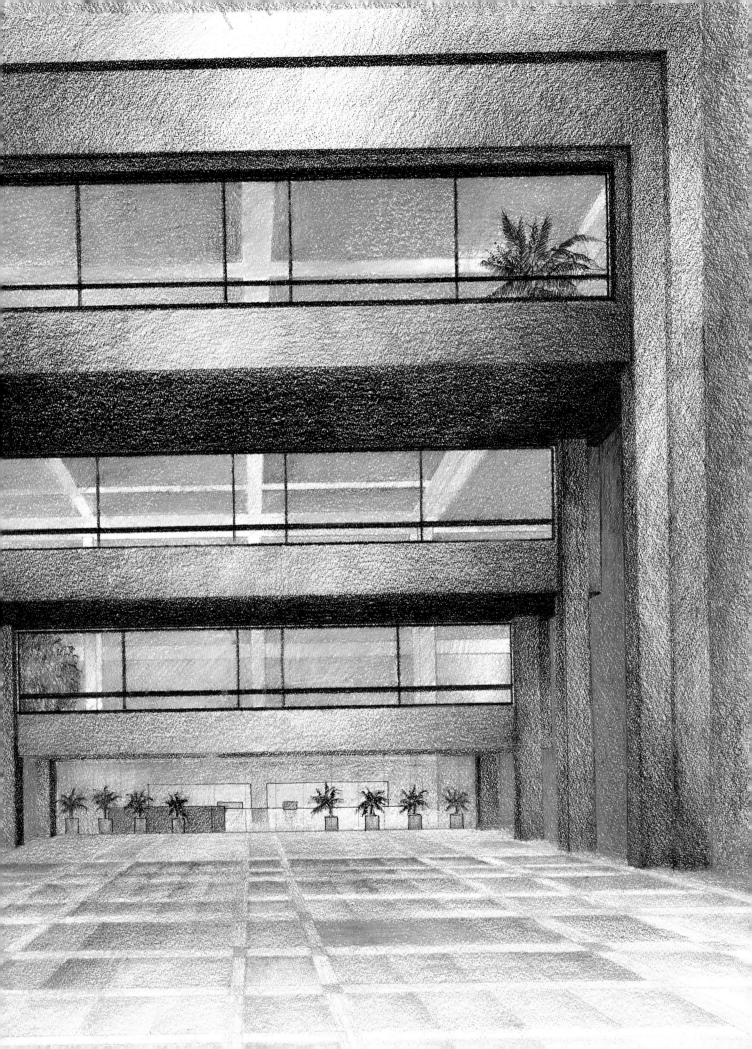

SCHOOL*

Many of our architect clients fear that their designs are too radical for their clients. This deconstructed building explodes a variety of forms. To unite this composition, we used a monochromatic color scheme. We added sparkle to the drawing by concentrating on the transparency of the "greenhouse." The media are primarily transparent to keep the illustration soft. The transparent media also allow the base textures to be visible.

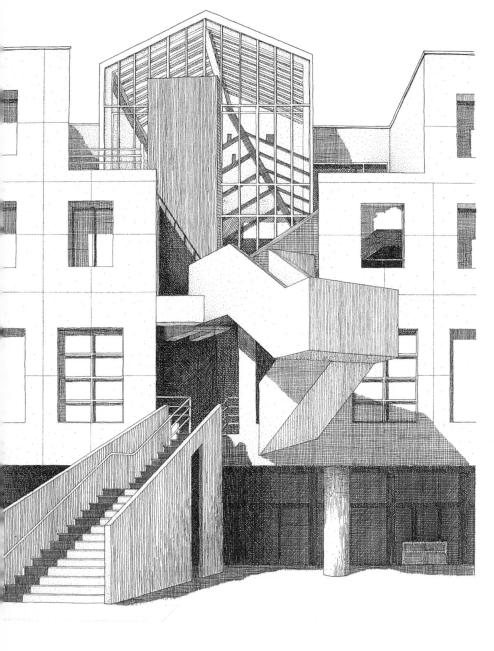

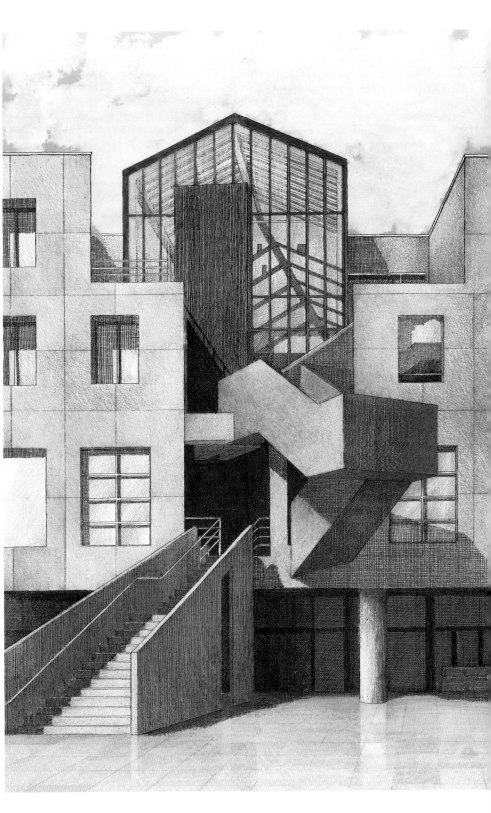

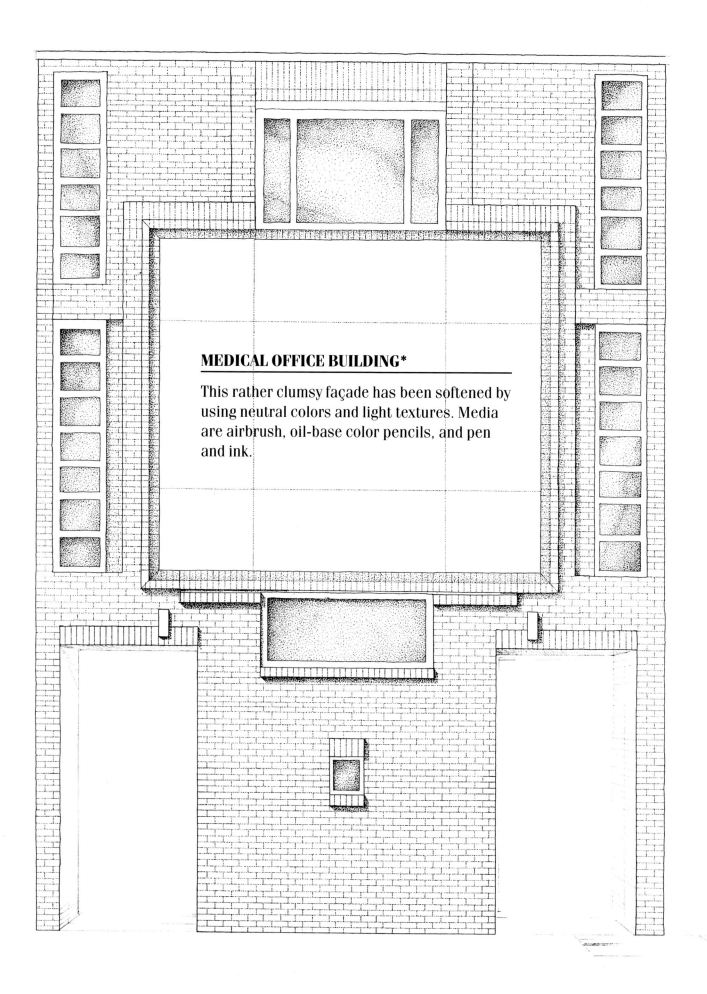

MEDICAL OFFICE BUILDING*

This rather clumsy façade has been softened by using neutral colors and light textures. Media are airbrush, oil-base color pencils, and pen and ink.

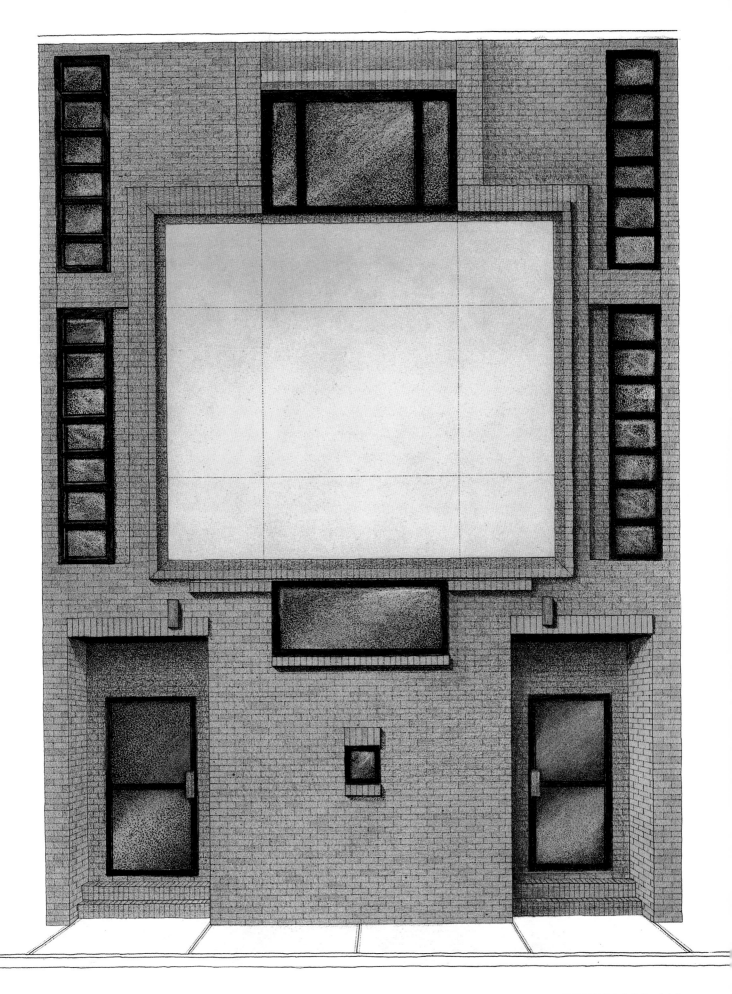

SMALL HOUSE*

There are times when we must help a designer to make the project look better than it really is. Certainly, the angle of the perspective, the material on which it is drawn, the material simulation, textures, and entourage affect the way that the project looks. There are more media used in this drawing than most. We used airbrush, watercolor, oil- and water-base color pencil, and a variety of pen-and-ink textures.

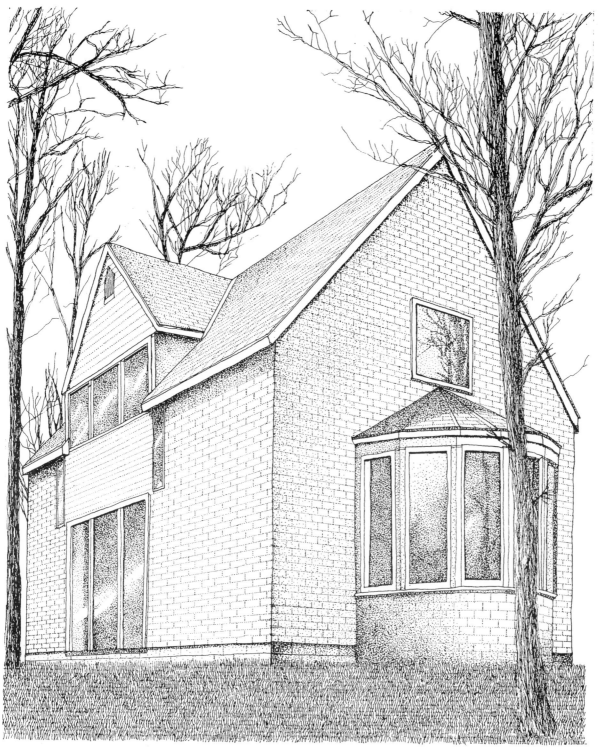

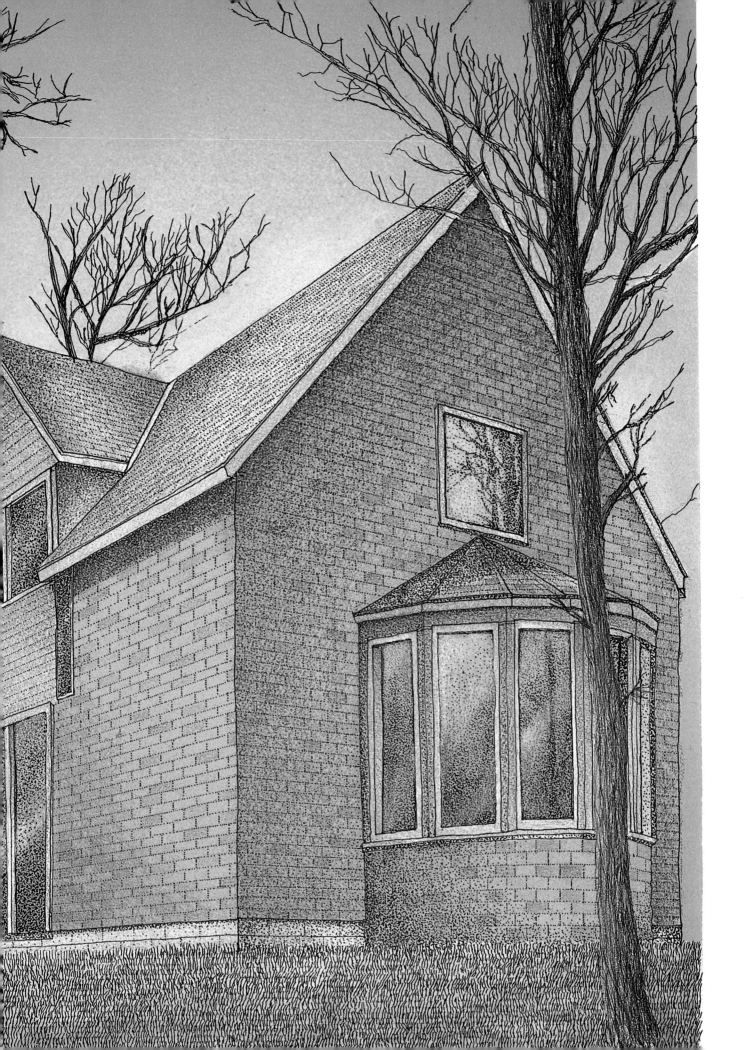

SCIENCE LABORATORY*

The architect asked us to contrast the base of
limestone and the reflective nature of the glass
and aluminum. To project the simplicity and
sobriety of this design, we drew a perspective
that is almost an elevation. The glass and alumin-
um are cool in color and the masonry is warm.
The media are watercolor and oil-base color
pencil. The sky is airbrushed.

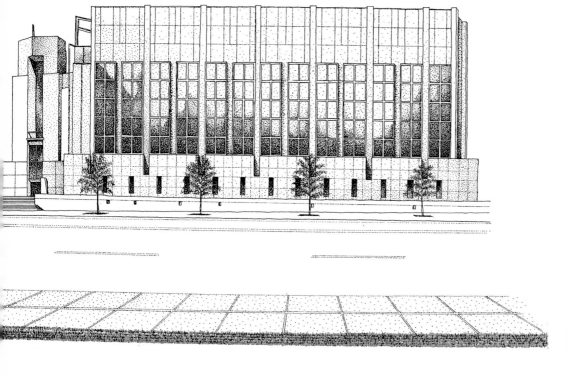

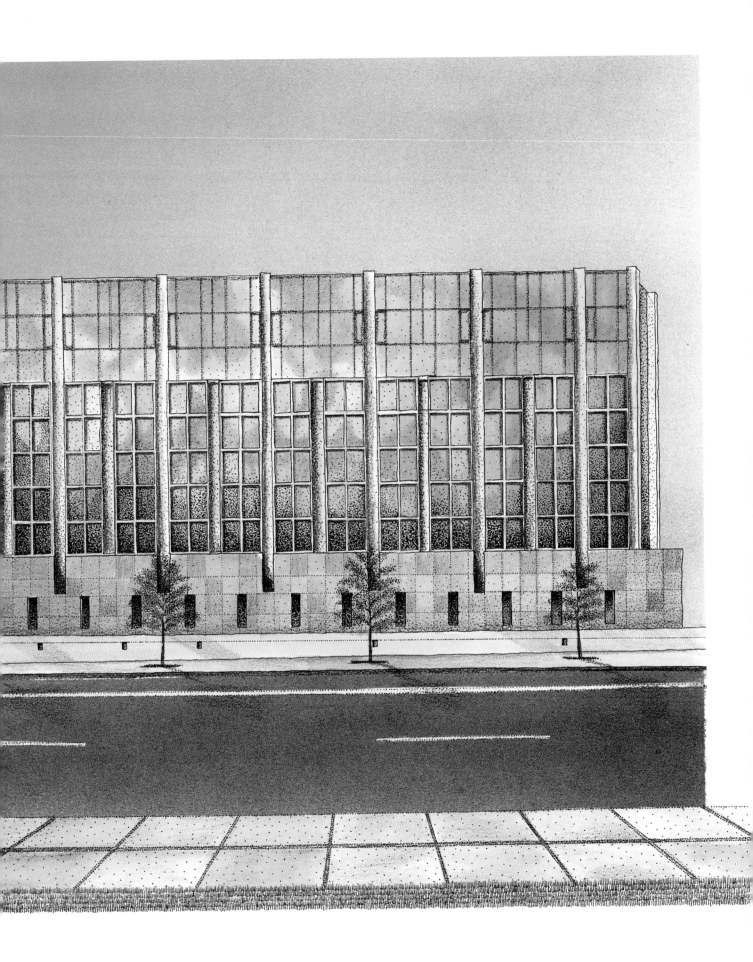

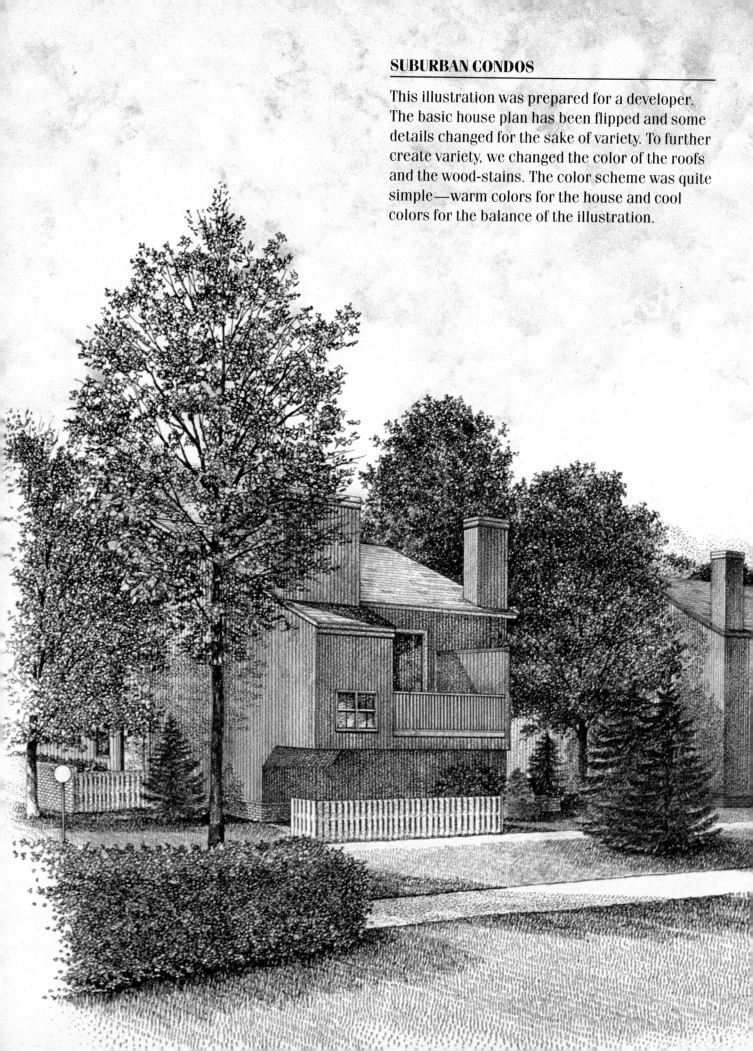

SUBURBAN CONDOS

This illustration was prepared for a developer. The basic house plan has been flipped and some details changed for the sake of variety. To further create variety, we changed the color of the roofs and the wood-stains. The color scheme was quite simple—warm colors for the house and cool colors for the balance of the illustration.

ISLAND OF BUILDINGS

A large Manhattan real estate firm asked us to "create" a city, consisting of nothing but the company's holdings. We chose to draw elevations, because it allowed for the overlapping of the buildings and made it easy to identify each building. Light, shade, and shadow were delineated with pen and ink. The color was done with oil- and water-base pencil. The unevenness of the application of color allows us to move the viewer's eye around the drawing.

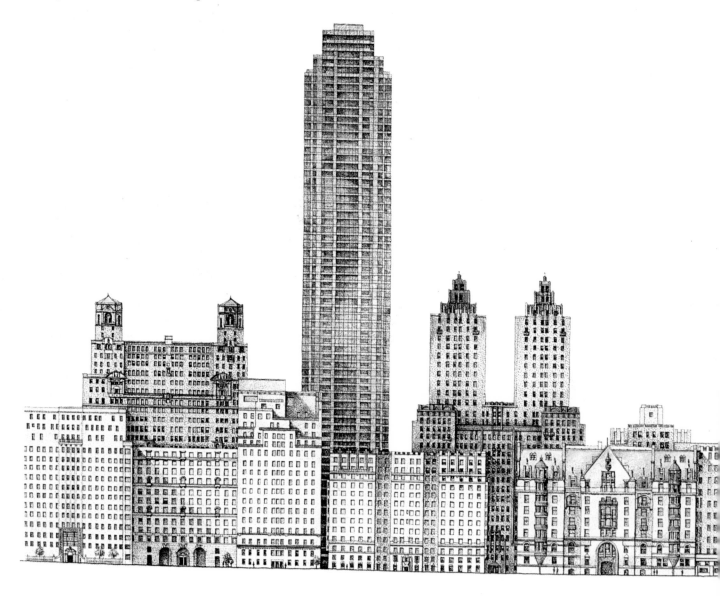

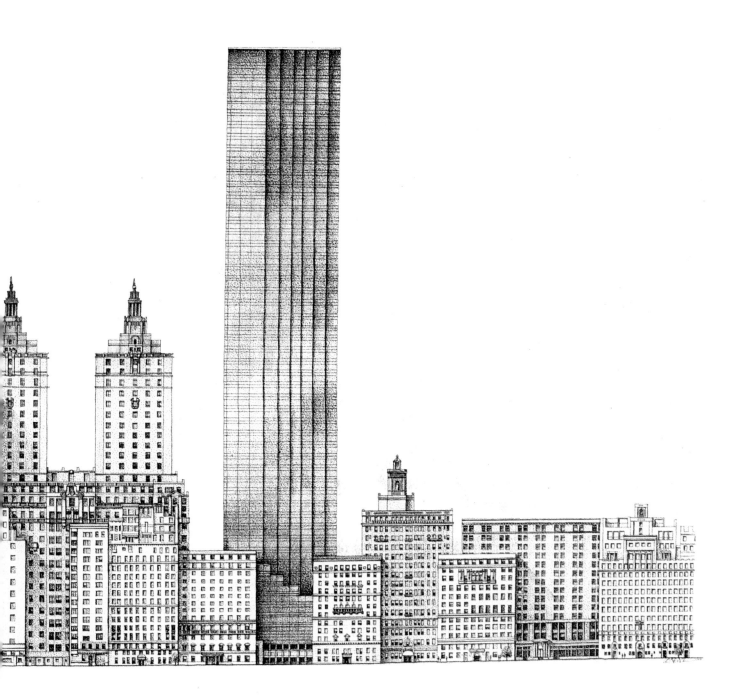

VIEW OF DALLAS, TEXAS

The most interesting buildings in Dallas were grouped to create this illustration for a Dallas newpaper. The drawing was done in a bold way to enable it to be reproduced easily and legibly. The color media used were dye and watercolor, both applied with brush.

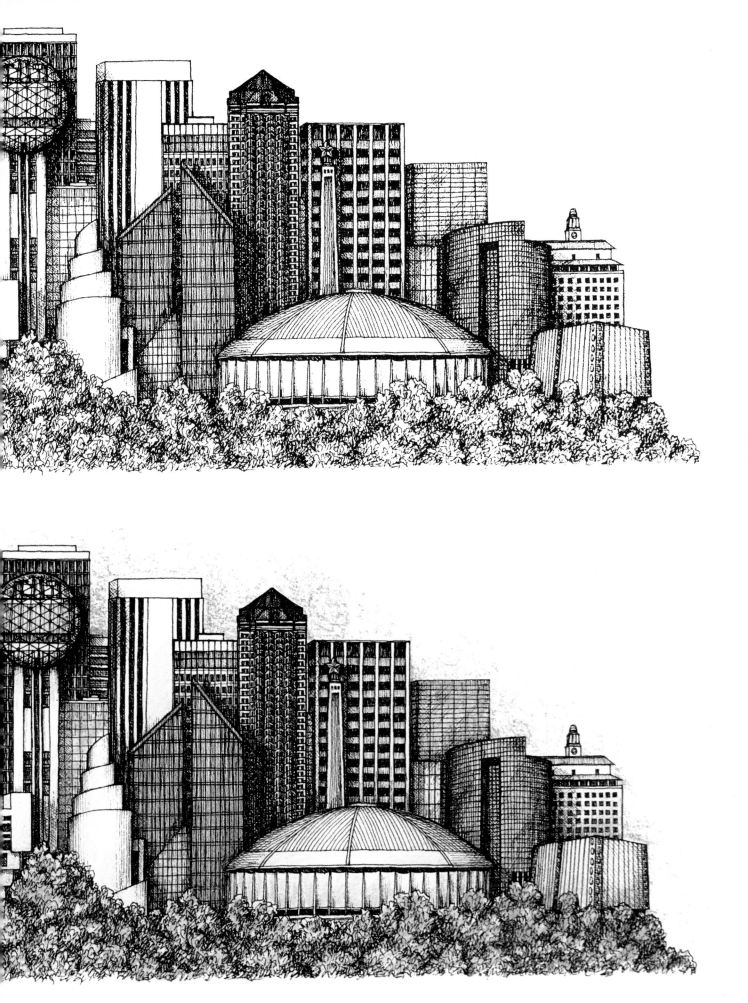

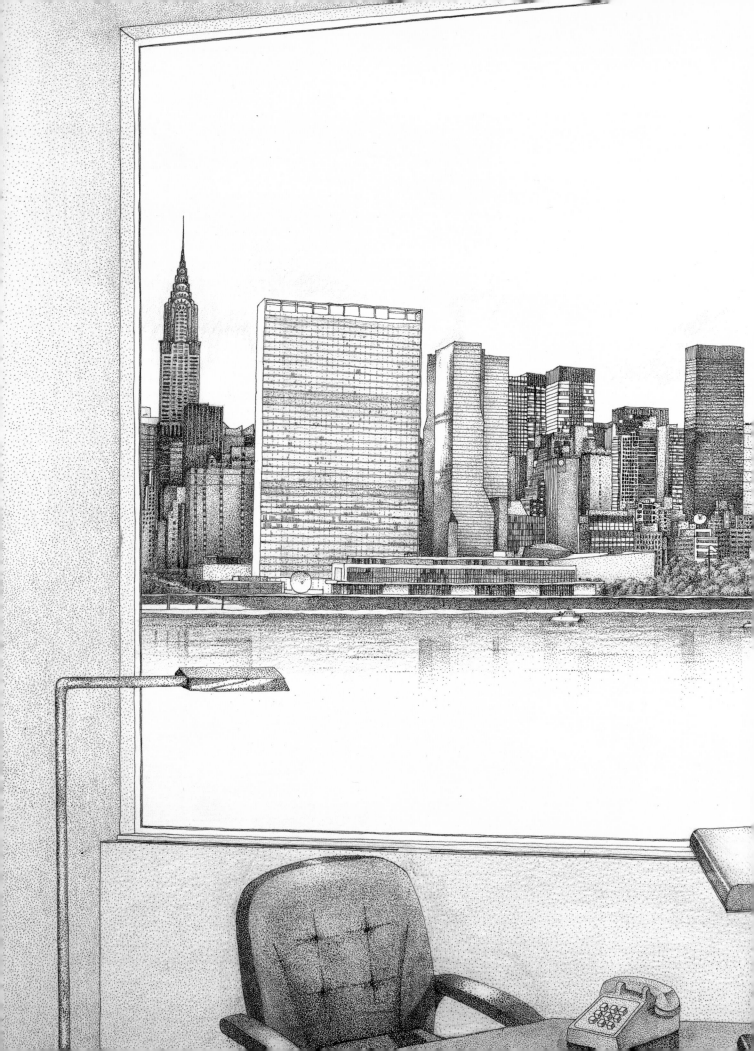

MIDTOWN MANHATTAN

A large city agency hired us to draw these views
of Manhattan to interest buyers in the property
that offered these views. The drawings are clean,
quiet, and detailed. They are meant to let Man-
hattan supply the excitement for the viewer. The
colors, done using airbrush and watercolor, are
subdued and supportive.

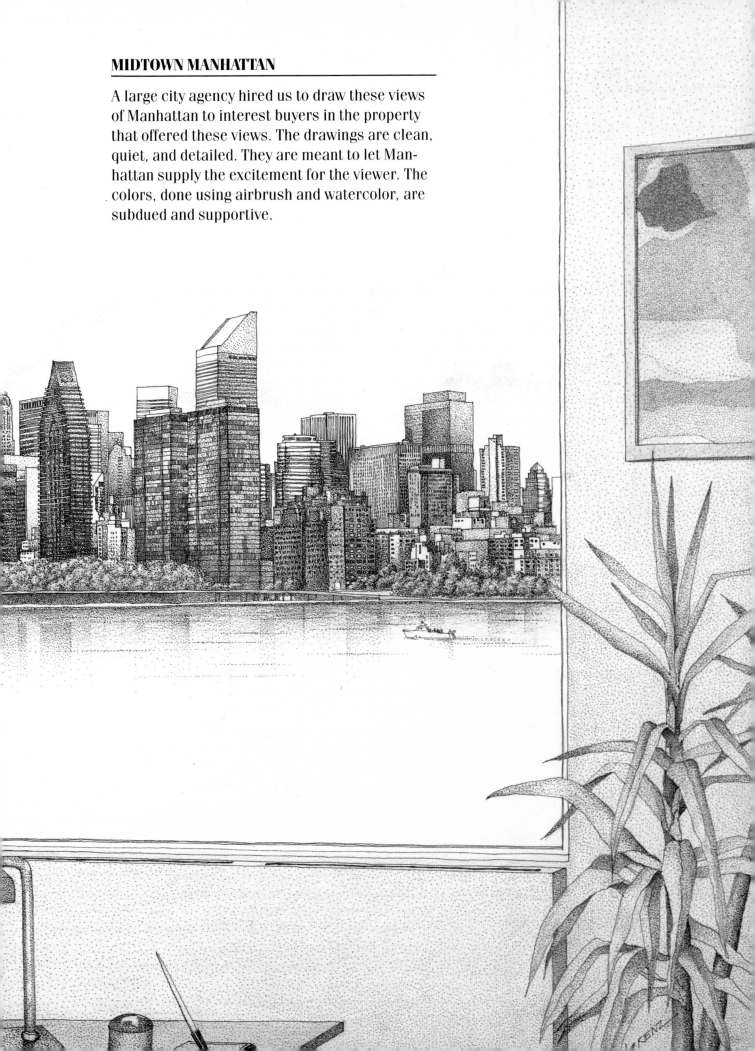

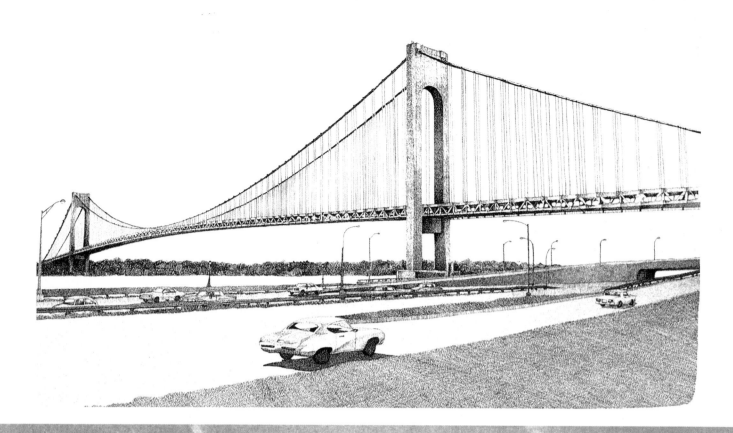

VERRAZANO BRIDGE, NEW YORK

A city agency commissioned this illustration. It was drawn on textured watercolor board. The base drawing is freehand pen and ink and richly textured. Additional textures are crosshatched colored inks. The drawing is basically colored with watercolor and water-base color pencil. The sky is airbrushed, water-base dyes. The clouds were first shaded with oil-base color pencil. They were then bleached out with cotton dipped in bleach. Fixative was applied to blend the water-base colors. Again, we used a cool-warm color scheme with cool as dominant.

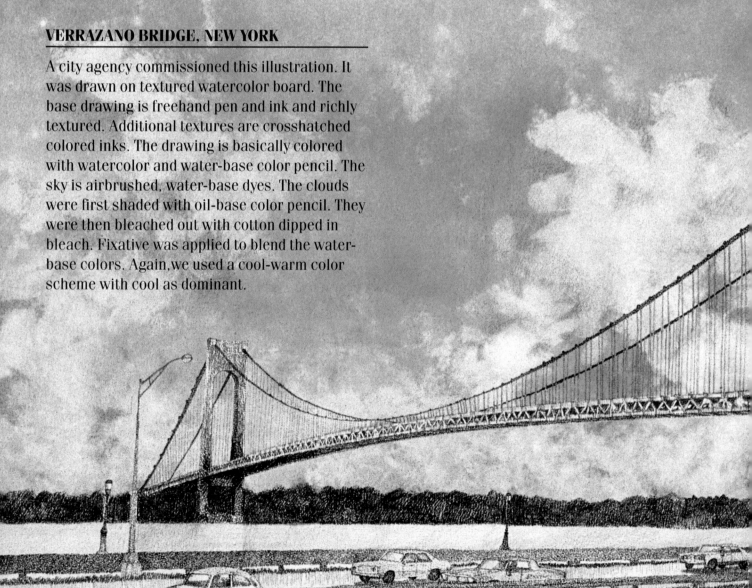

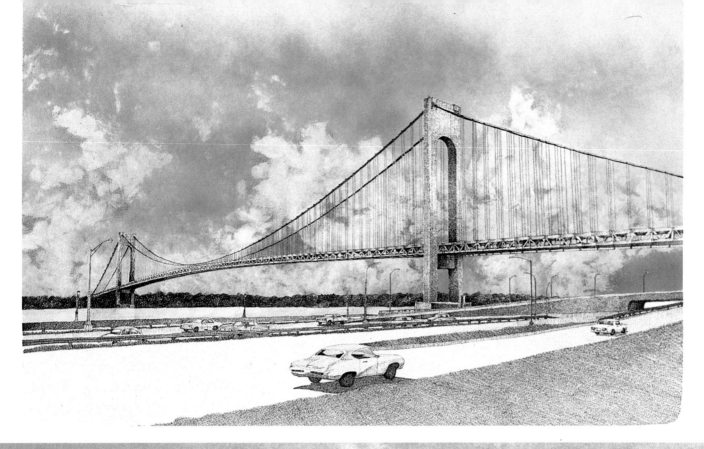

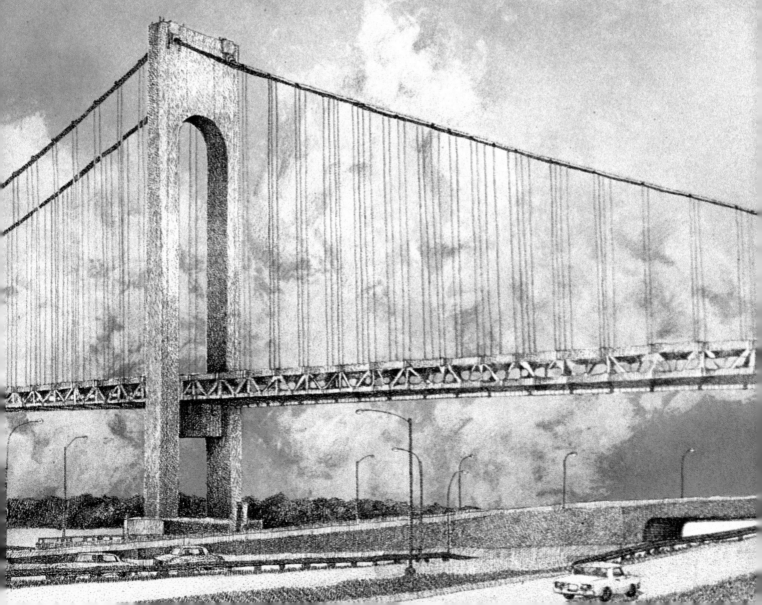

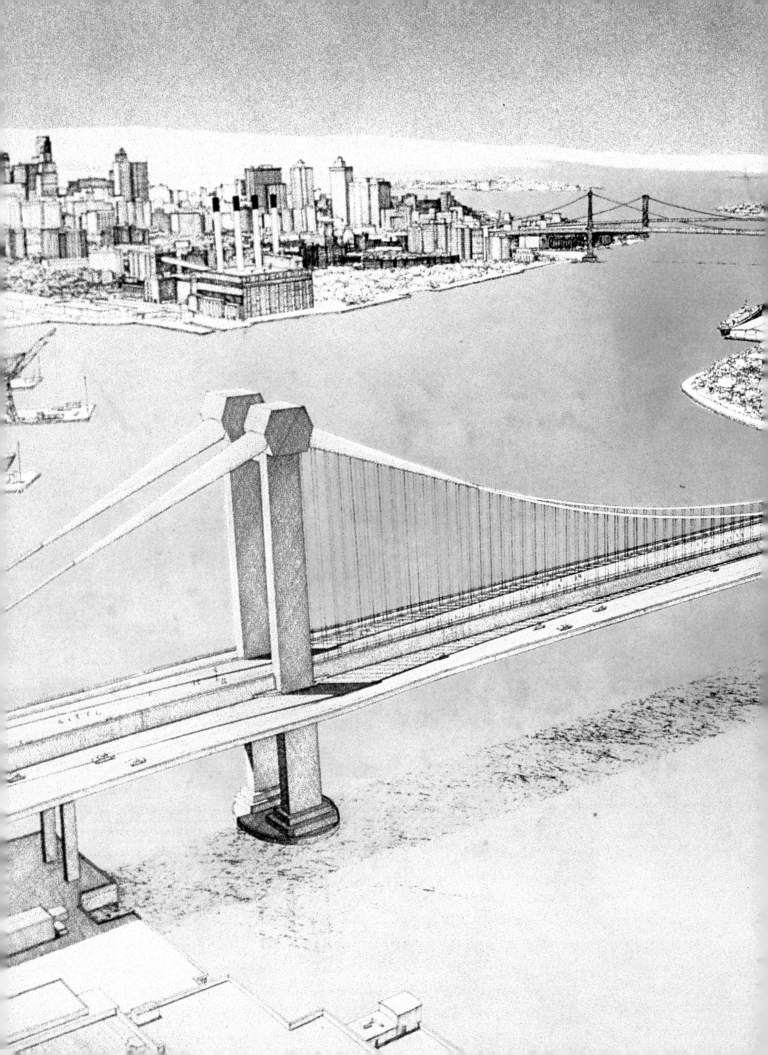

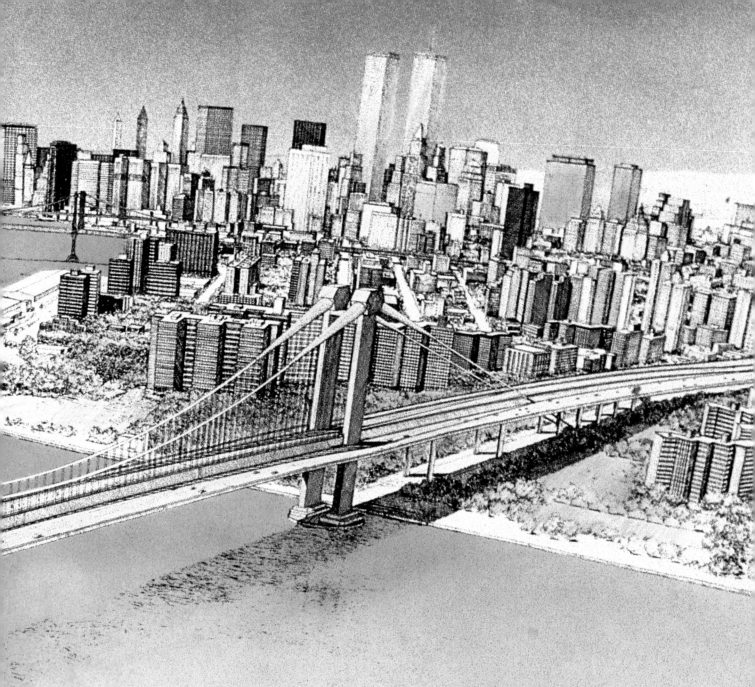

MANHATTAN BRIDGE COMPETITION, NEW YORK

Here we had a difficult assignment. The color had to be applied to a photograph. In order to apply watercolor or airbrush to a slick surface, Flex Opaque must be added to whatever color is being used. This chemical permits the application of the color to photographs. The color scheme was basically a cool one to contrast with the bridge, the only component of the drawing done in a warm tone.

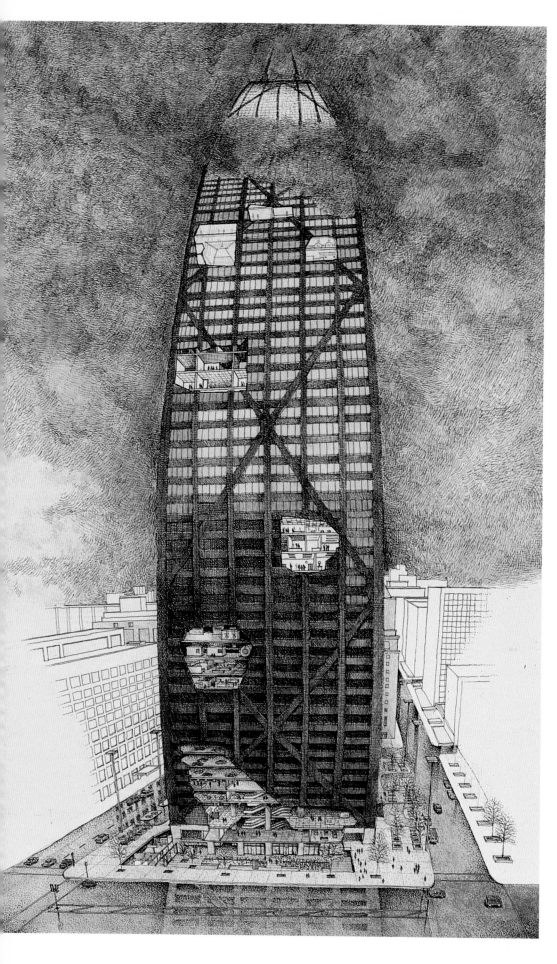

JOHN HANCOCK BUILDING, CHICAGO

This illustration was commissioned by *National Geographic* magazine. This perspective was used to simulate a photograph taken with a fish-eye lens. The pen-and-ink texture of the sky set the somber and stormy mood of the drawing. The media were watercolor, oil- and water-base color pencils, and gouache.

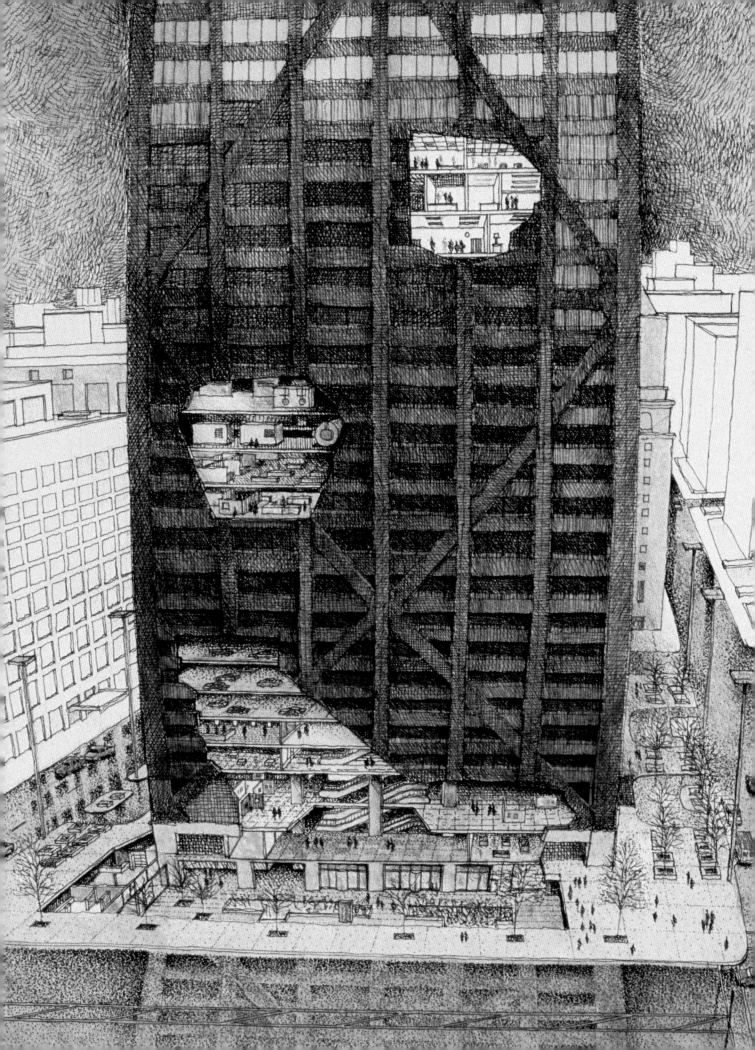

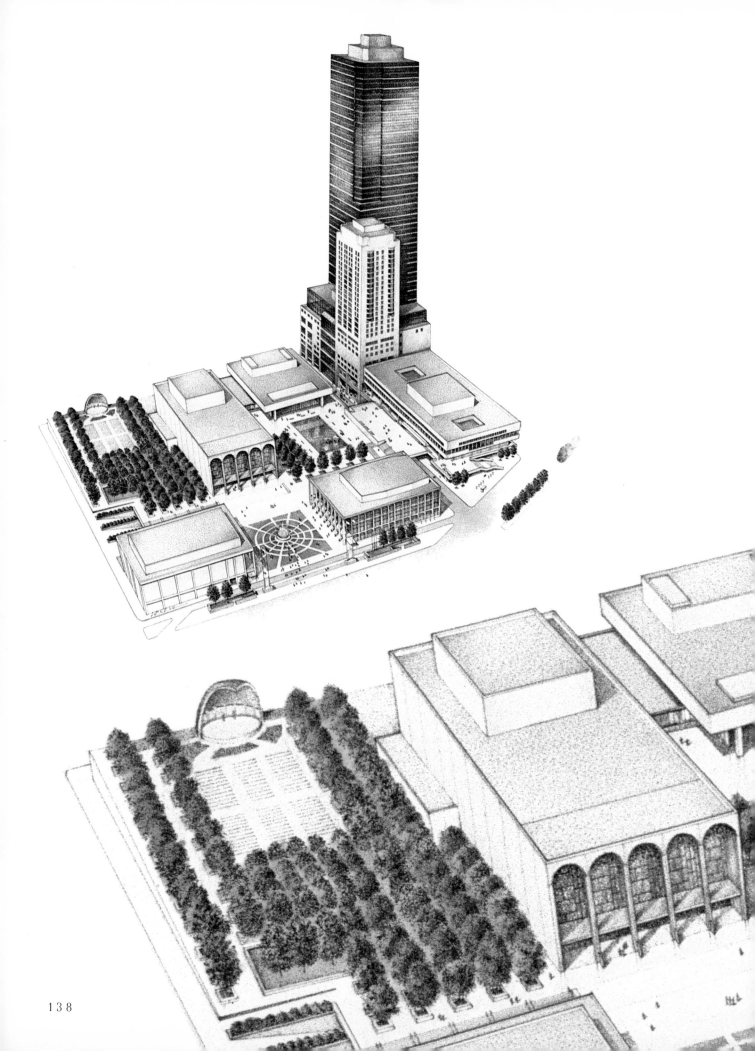

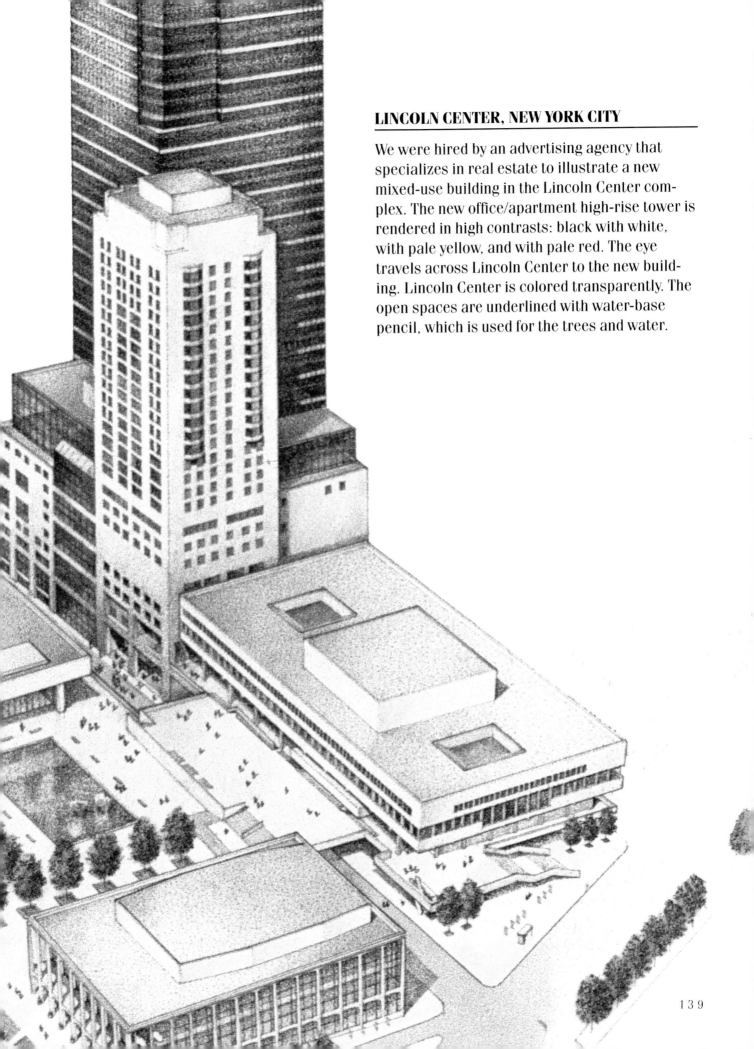

LINCOLN CENTER, NEW YORK CITY

We were hired by an advertising agency that specializes in real estate to illustrate a new mixed-use building in the Lincoln Center complex. The new office/apartment high-rise tower is rendered in high contrasts: black with white, with pale yellow, and with pale red. The eye travels across Lincoln Center to the new building. Lincoln Center is colored transparently. The open spaces are underlined with water-base pencil, which is used for the trees and water.

139

EAST RIVER PANORAMA

This is an eye-level perspective done for a sales brochure for the Port Authority of New York and New Jersey. In order to enhance the view, we increased the drama of the site by taking the view one would have looking at the buildings from the middle of the East River. The drawing was done freehand and colored with a mixture of watercolor and water-base color pencil.

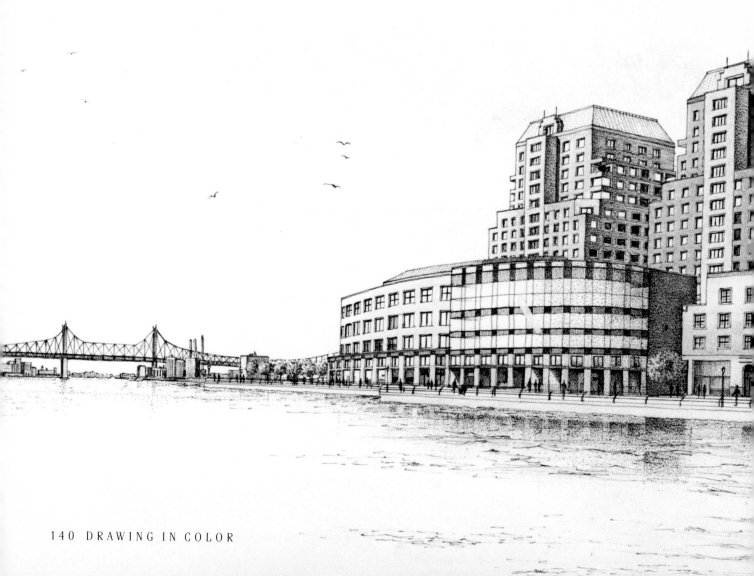

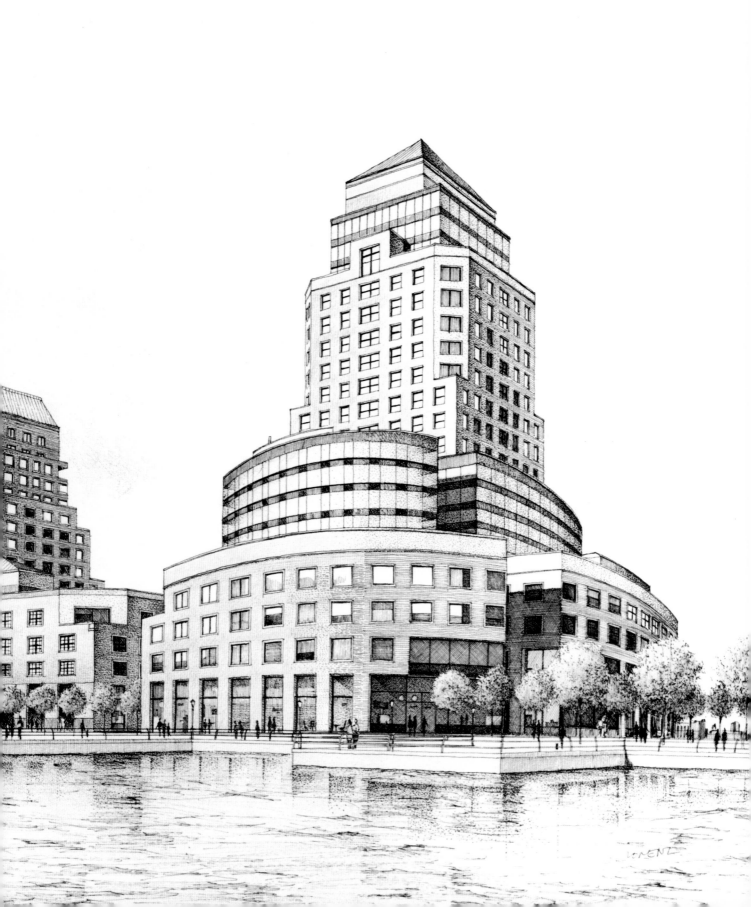

AERIALS

IF THE BEST WAY TO SEE THE VALLEY IS FROM THE MOUNTAIN, CERTAINLY THE BEST WAY TO SEE THE CITY OR OTHER ARCHITECTURE ENSEMBLES IS THE BIRD'S-EYE OR AERIAL PERSPECTIVE. NOTICE THAT SOME PERSPECTIVES ARE DISTORTED TO FOCUS ON A CENTER OF INTEREST. COLOR AND TEXTURE CAN SUPPORT THIS FOCUS. THE ILLUSTRATOR MUST KEEP THE VIEWER'S EYE MOVING WITH AN INTELLIGENT AND EXCITING USE OF COLOR AND DETAIL.

GRAND BAY HOTEL, COCONUT GROVE, FLORIDA

This drawing was done for the firm Robinson, Yesawich & Pepperdine. We concentrated on the surroundings of this new hotel: the sea, the greenery, and the sky. Note the use of red to complement the verdure. The color and detail become less concentrated as we move away from the visual center of the drawing.

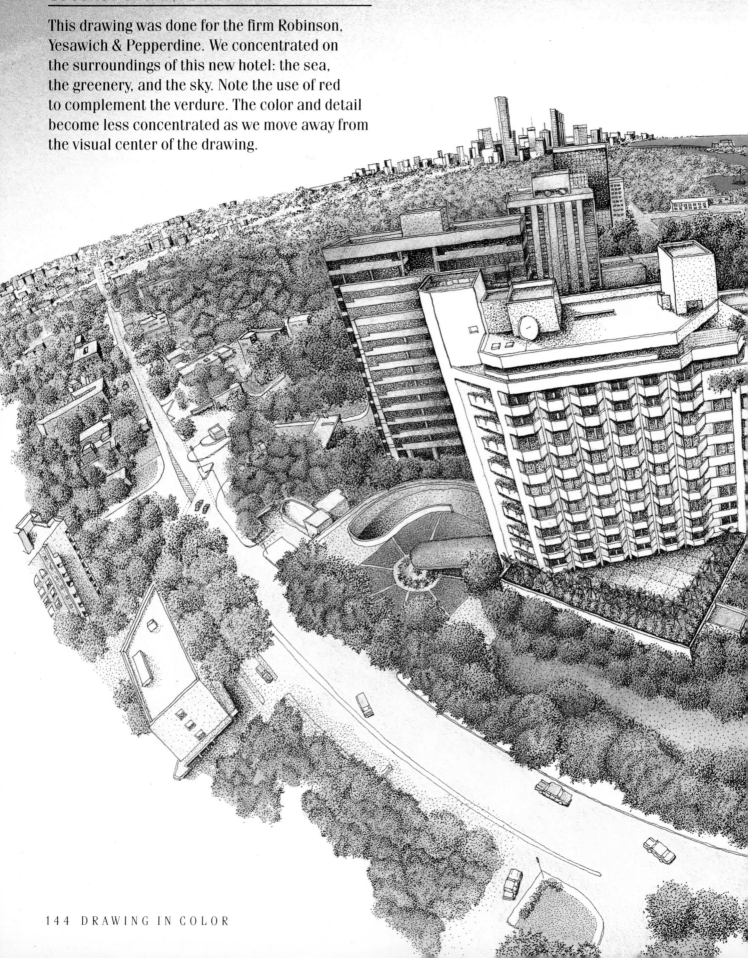

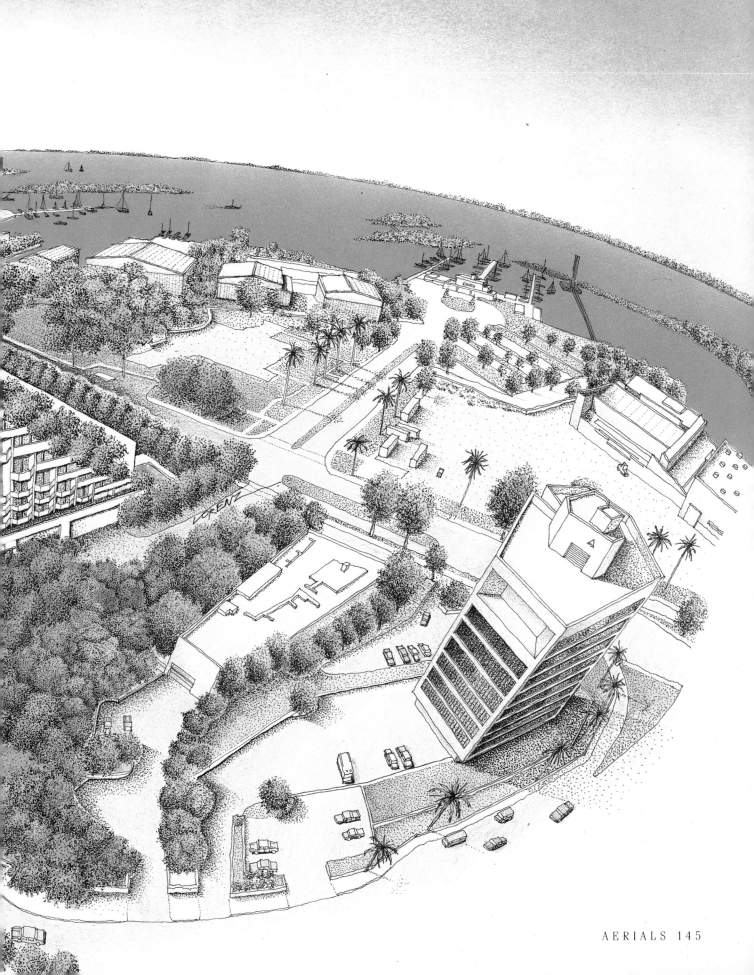

LORENZ

GRAND BAY HOTEL, NEW YORK CITY

This illustration of the renovation of this New
York City hotel was done for the firm Robinson,
Yesawich & Pepperdine. We accented the hotel in
this low-key perspective by strongly coloring the
surrounding buildings. The sky was airbrushed.
The colors were very transparent, allowing the
pen-and-ink work to read.

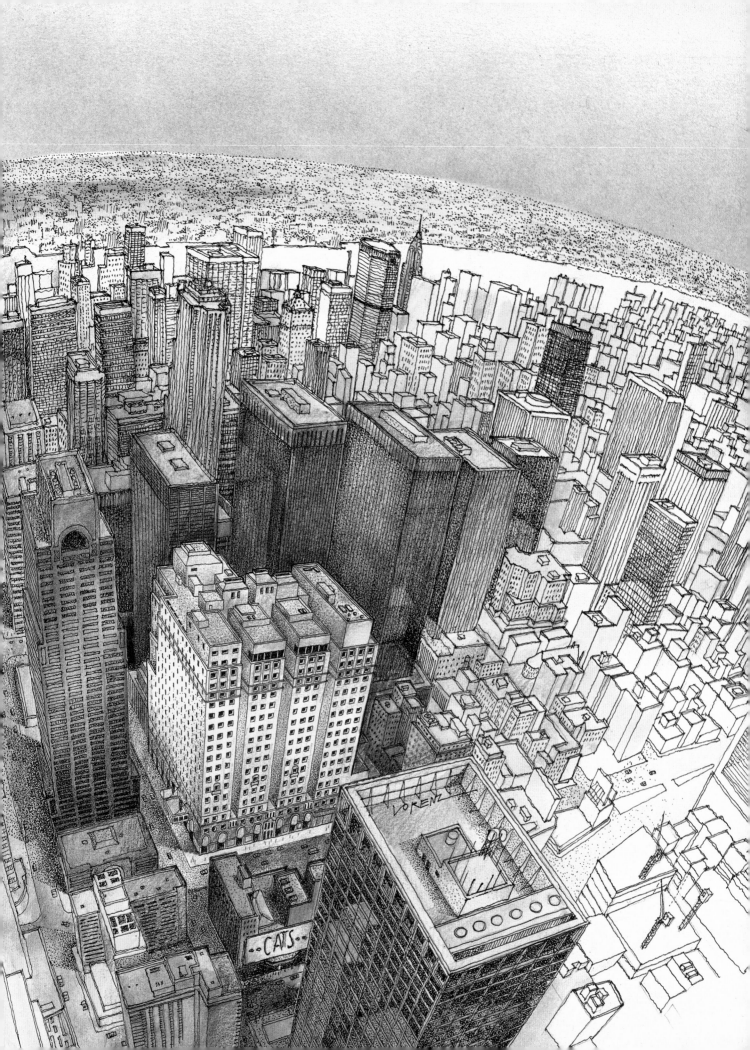

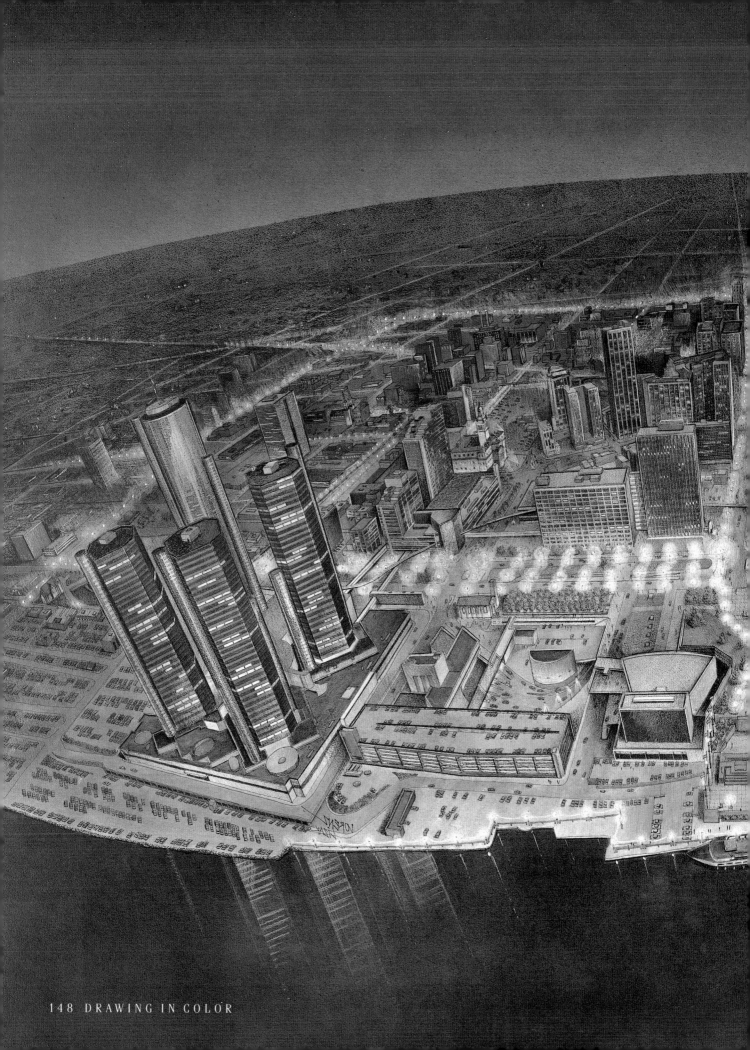

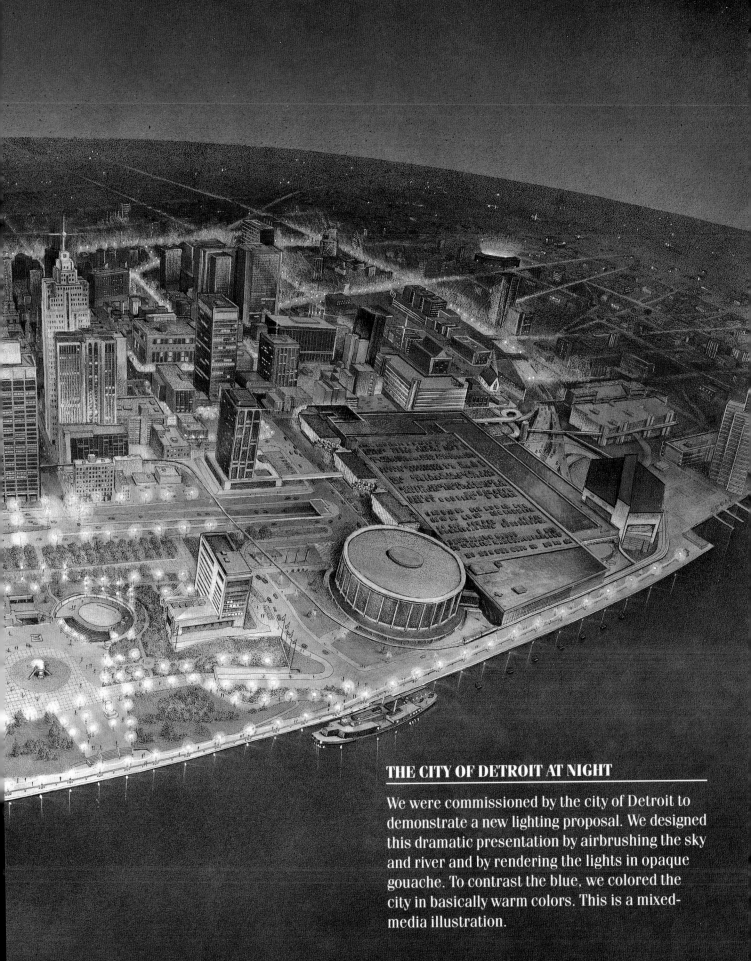

THE CITY OF DETROIT AT NIGHT

We were commissioned by the city of Detroit to demonstrate a new lighting proposal. We designed this dramatic presentation by airbrushing the sky and river and by rendering the lights in opaque gouache. To contrast the blue, we colored the city in basically warm colors. This is a mixed-media illustration.

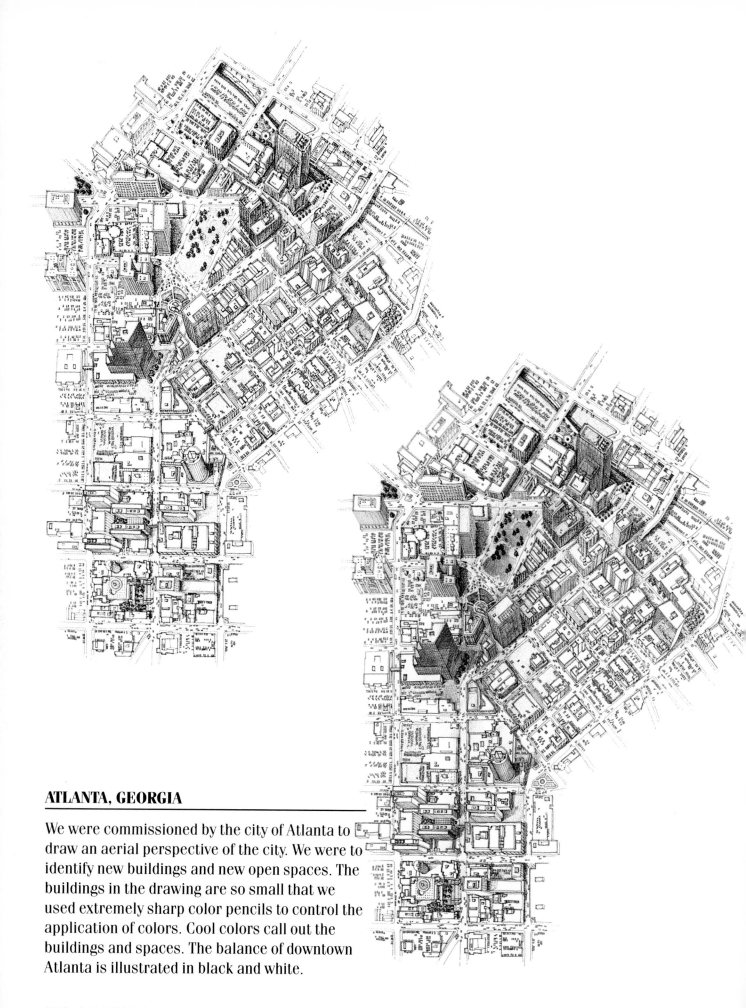

ATLANTA, GEORGIA

We were commissioned by the city of Atlanta to
draw an aerial perspective of the city. We were to
identify new buildings and new open spaces. The
buildings in the drawing are so small that we
used extremely sharp color pencils to control the
application of colors. Cool colors call out the
buildings and spaces. The balance of downtown
Atlanta is illustrated in black and white.

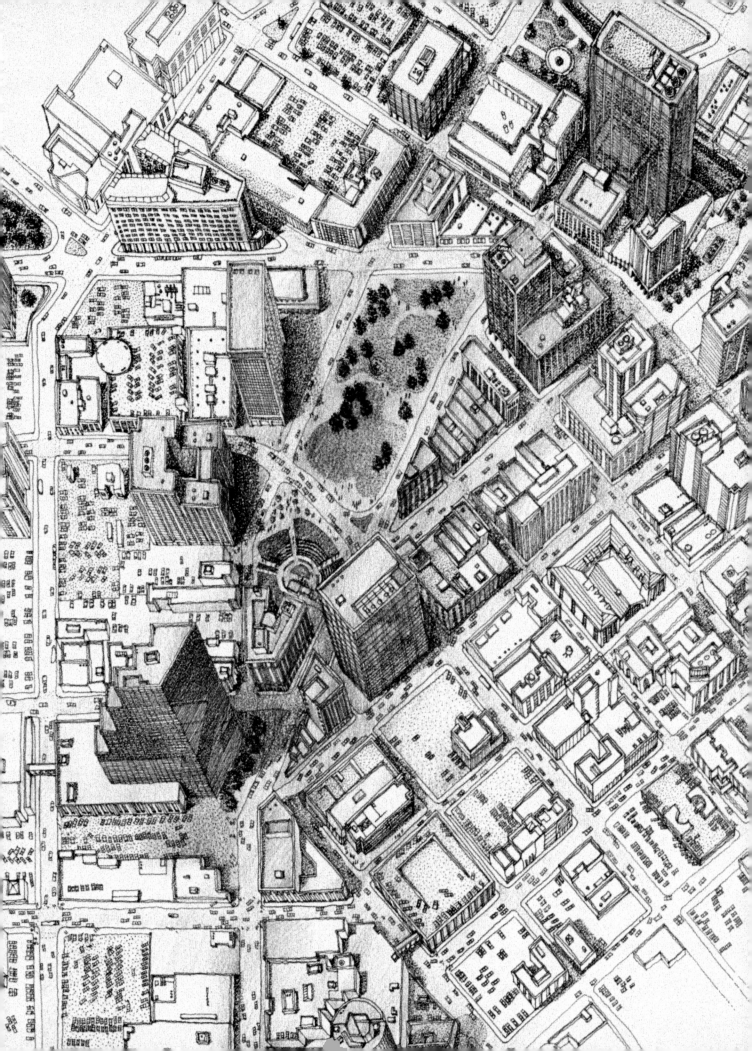

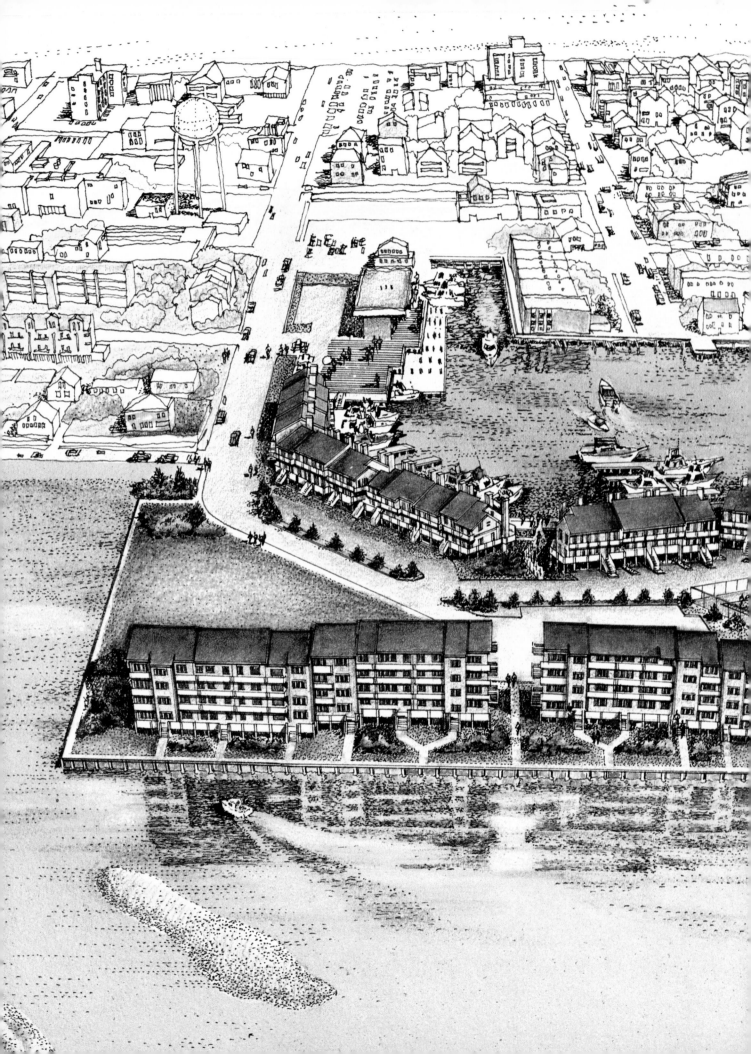

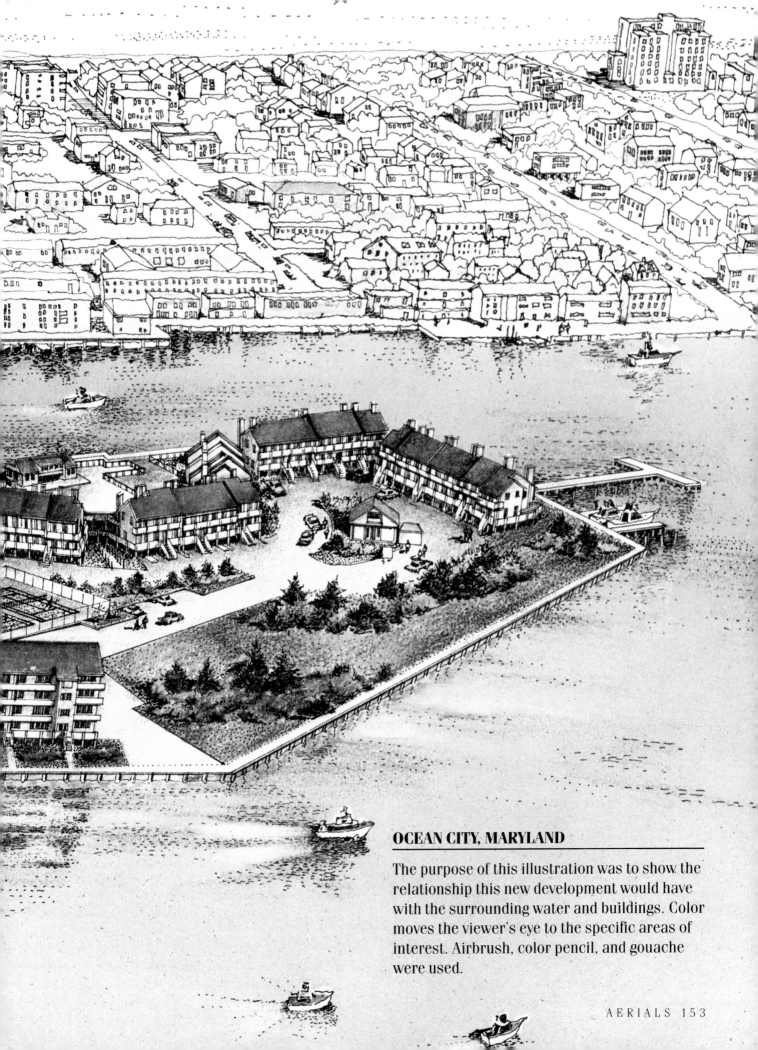

OCEAN CITY, MARYLAND

The purpose of this illustration was to show the relationship this new development would have with the surrounding water and buildings. Color moves the viewer's eye to the specific areas of interest. Airbrush, color pencil, and gouache were used.

VIEW FROM THE WORLD TRADE CENTER, NEW YORK CITY

This illustration was used to promote tourism. The colors in this aerial perspective call out the great views from the roof of the World Trade Center. The roof in the foreground was drawn with a straight-edge, while the rest of the drawing is freehand. We used watercolor and oil- and water-base color pencils.

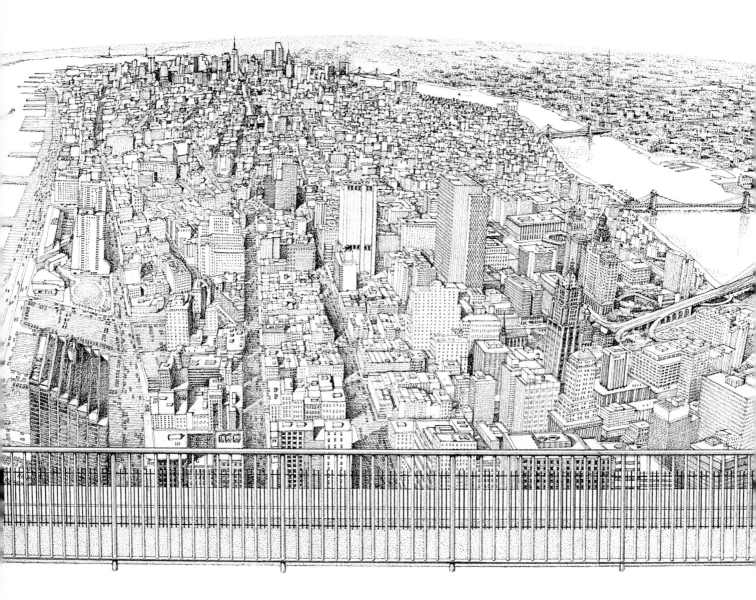

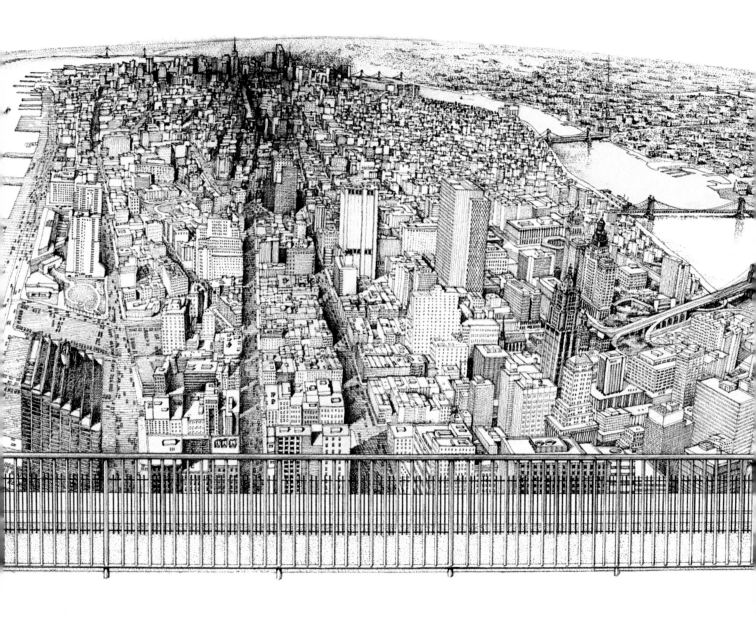

NATIONAL TENNIS CENTER, QUEENS, NEW YORK

This illustration was commissioned by *Tennis* magazine. We deliberately chose the red-brown color to energize the greenery and the tennis courts. This was a mixed-media illustration.

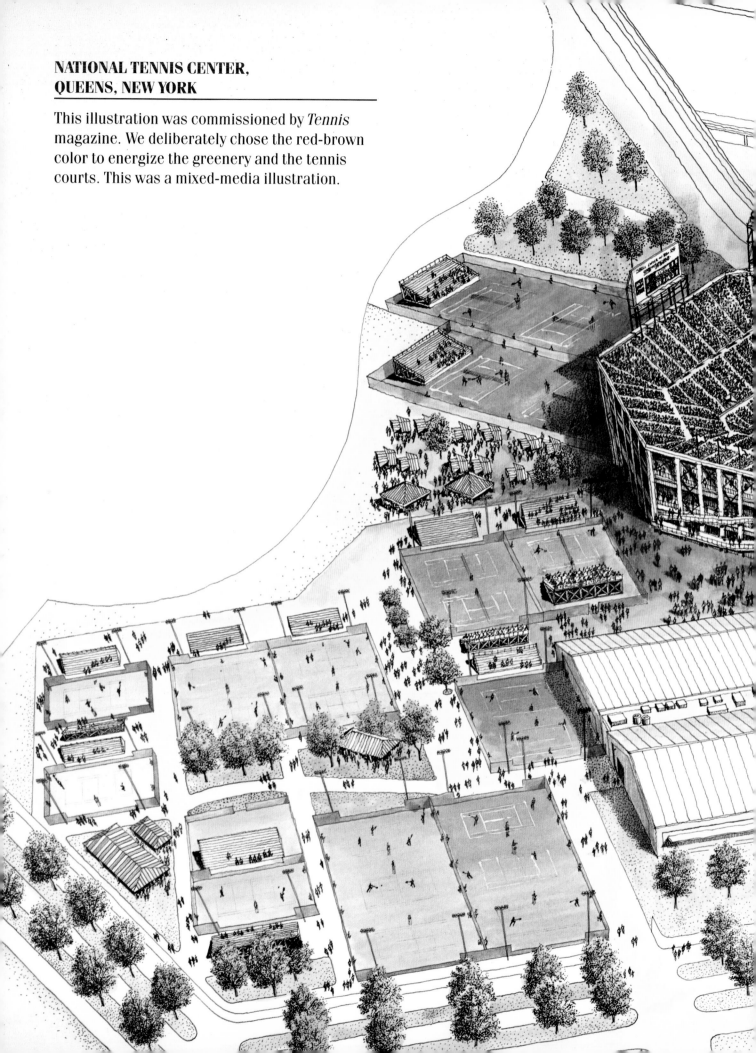

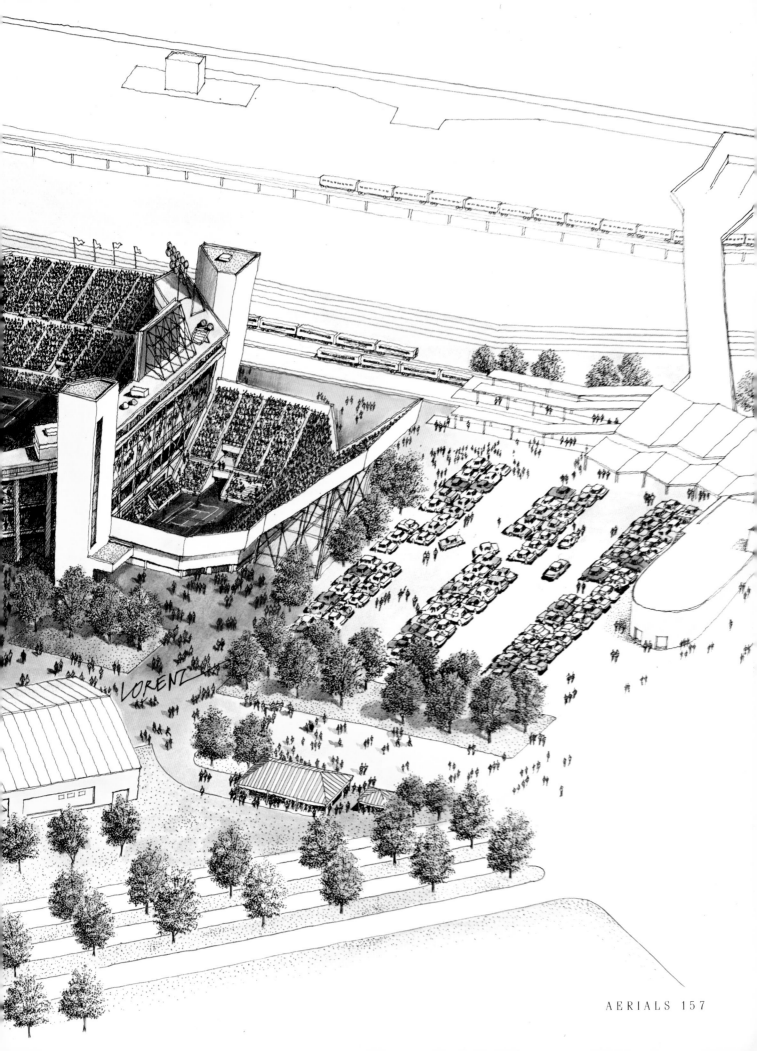

LORENZ

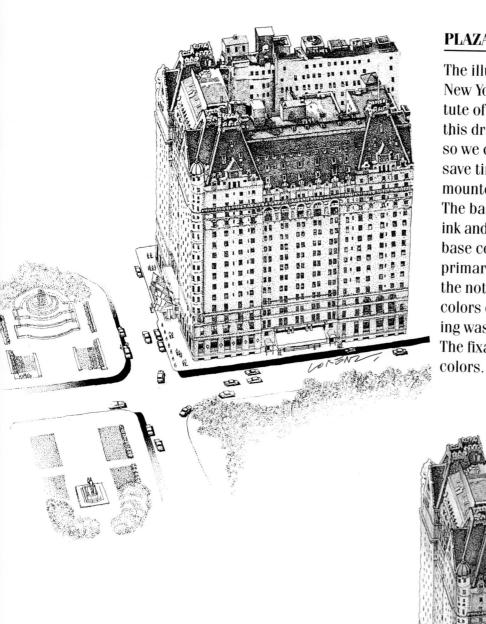

PLAZA HOTEL, NEW YORK CITY

The illustration was commissioned by the New York chapter of the American Institute of Architects. The chapter wanted this drawing in a hurry. We drew on vellum so we could trace over the mechanical to save time. The finished rendering was mounted on board with mounting tissue. The base drawing was freehand pen and ink and was stippled. Watercolor and water-base color pencil were used to create a primarily warm-cool color scheme. Notice the note of energy that the high-intensity colors of the flags add. The finished drawing was *fixed*, that is, sprayed with fixative. The fixative helps blend the water-base colors.

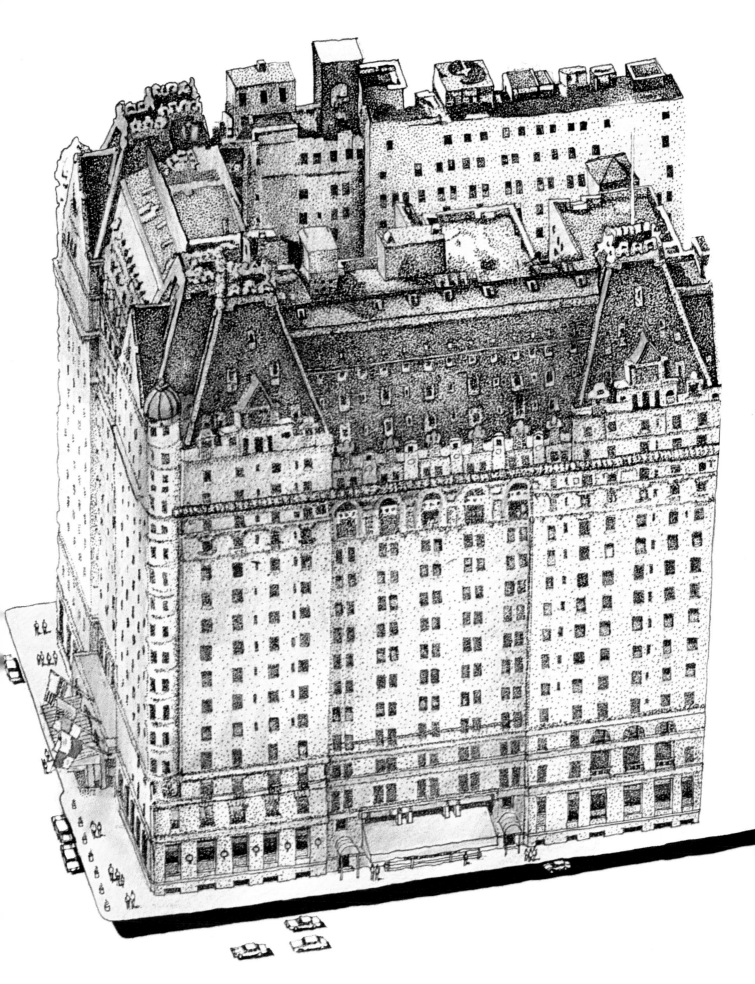

PARK AVENUE, NEW YORK CITY

This is a drawing that we did for a Park Avenue
real estate firm. Freehand pen and ink and color
pencil enabled us to finish the illustration
in one day.

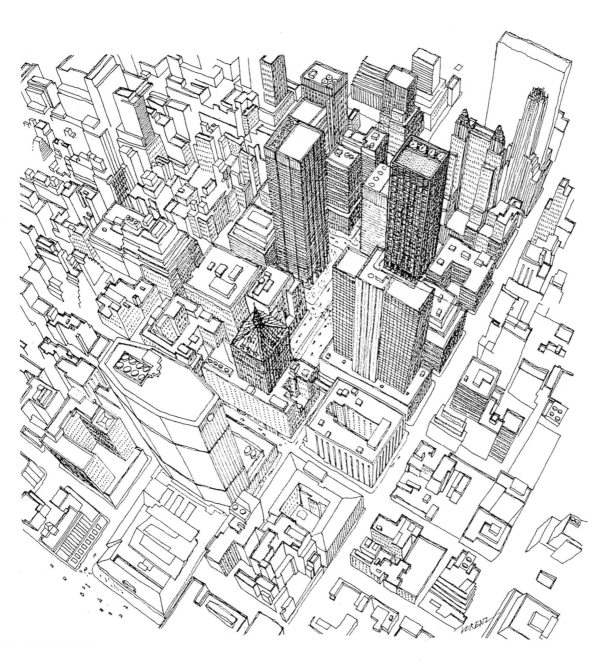

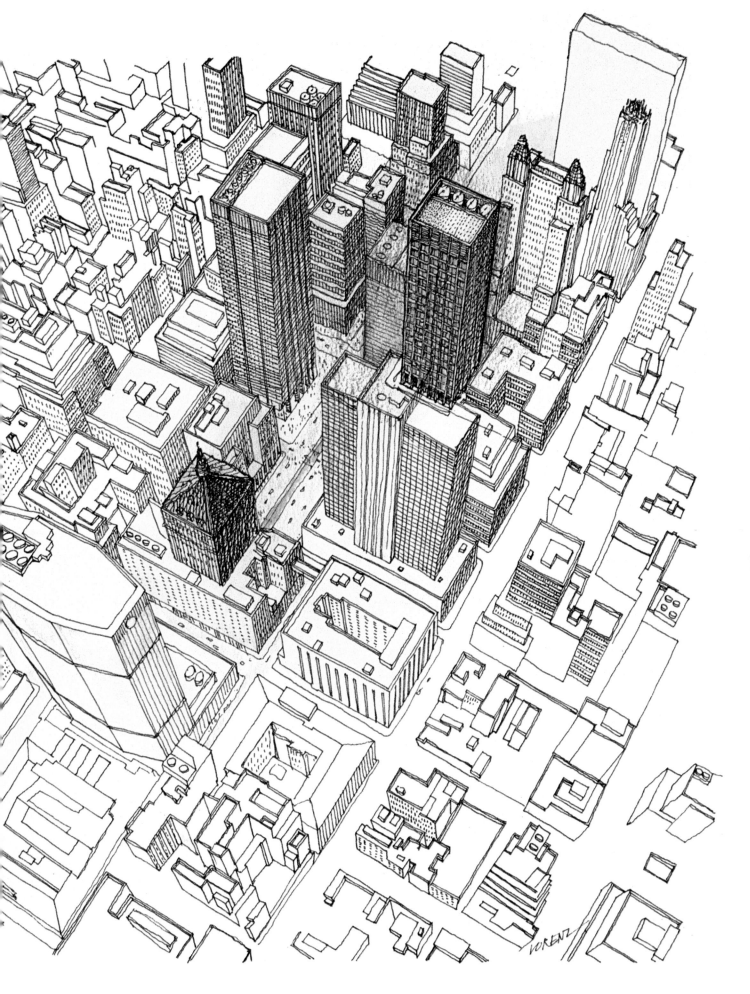

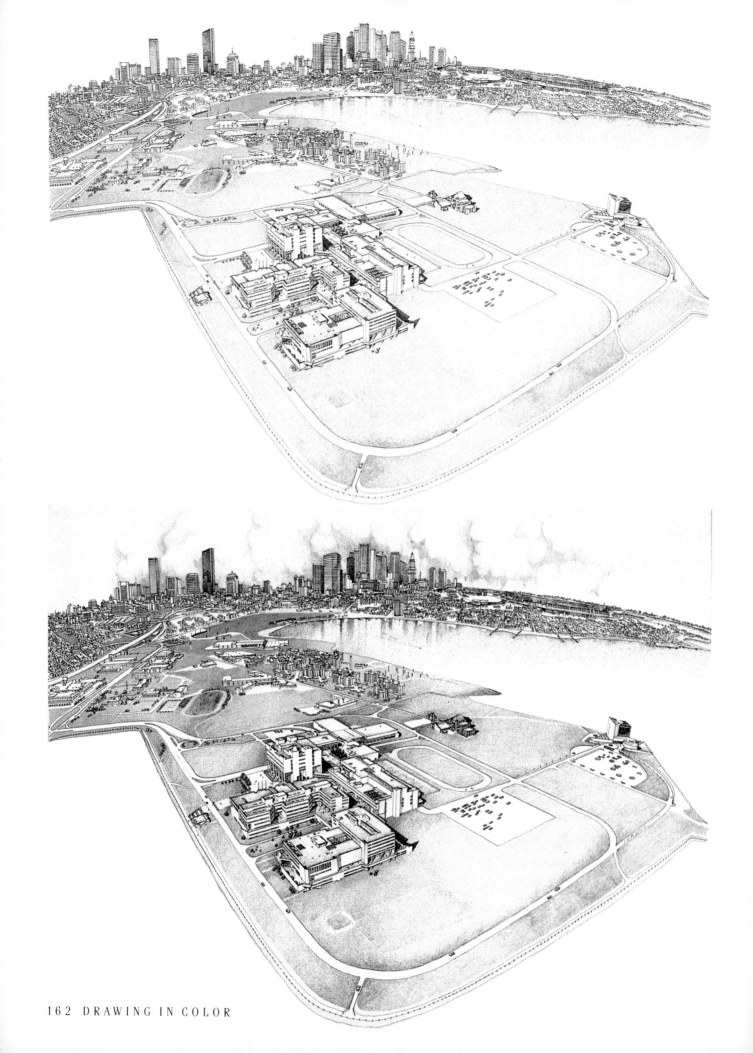

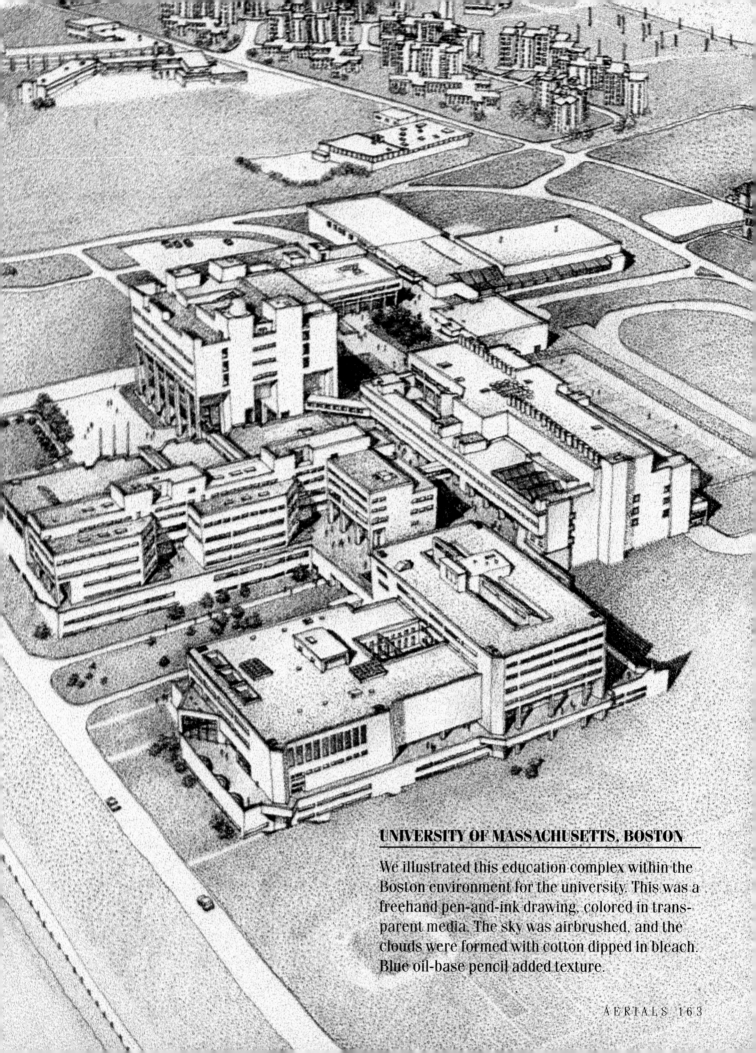

UNIVERSITY OF MASSACHUSETTS, BOSTON

We illustrated this education complex within the Boston environment for the university. This was a freehand pen-and-ink drawing, colored in transparent media. The sky was airbrushed, and the clouds were formed with cotton dipped in bleach. Blue oil-base pencil added texture.

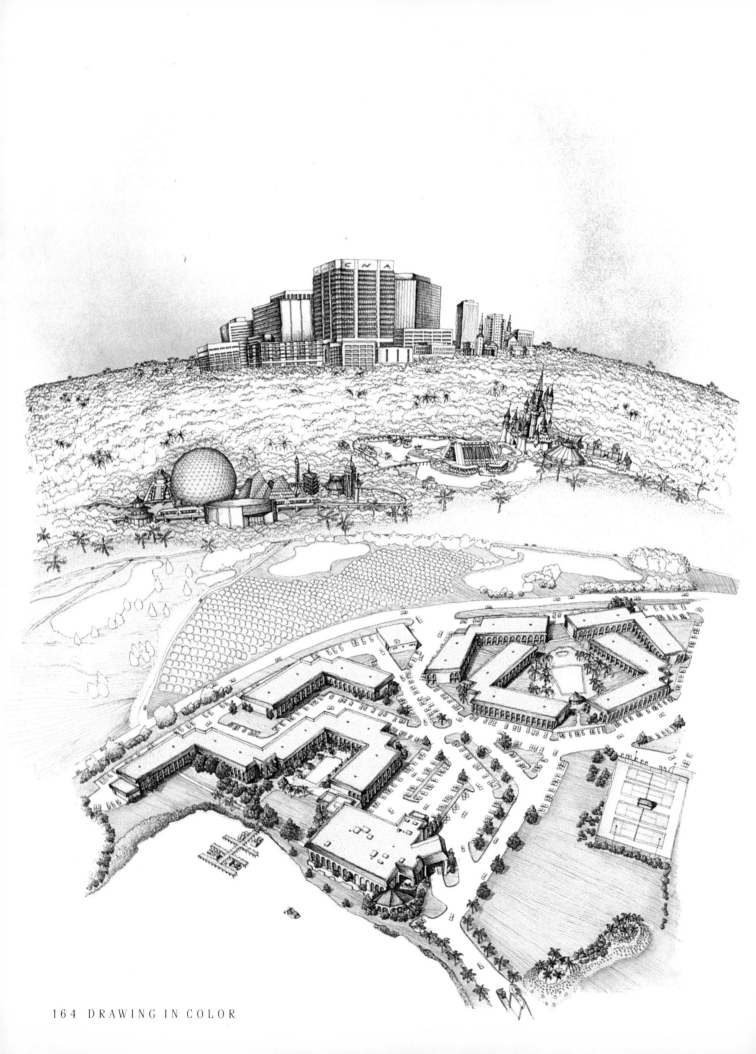

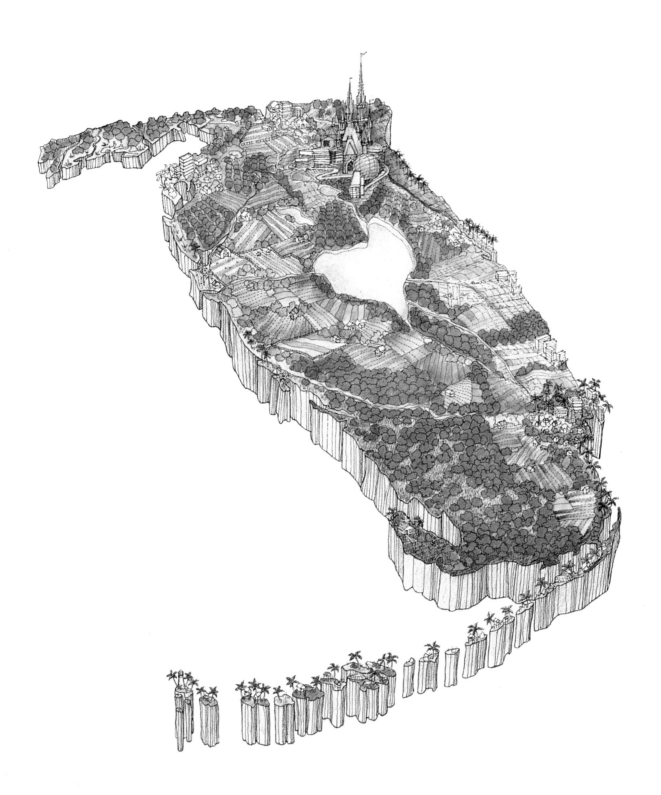

▲ **THE STATE OF FLORIDA**
◄ **TAMPA, FLORIDA**

This is part of a series of aerials we did for Bruce Elton Design. These drawings are obviously not in scale, yet the viewer is still able to understand certain architectural relationships. In the drawing of the entire state, locations are immediately evident. Both drawings were done in water-base color pencil only.

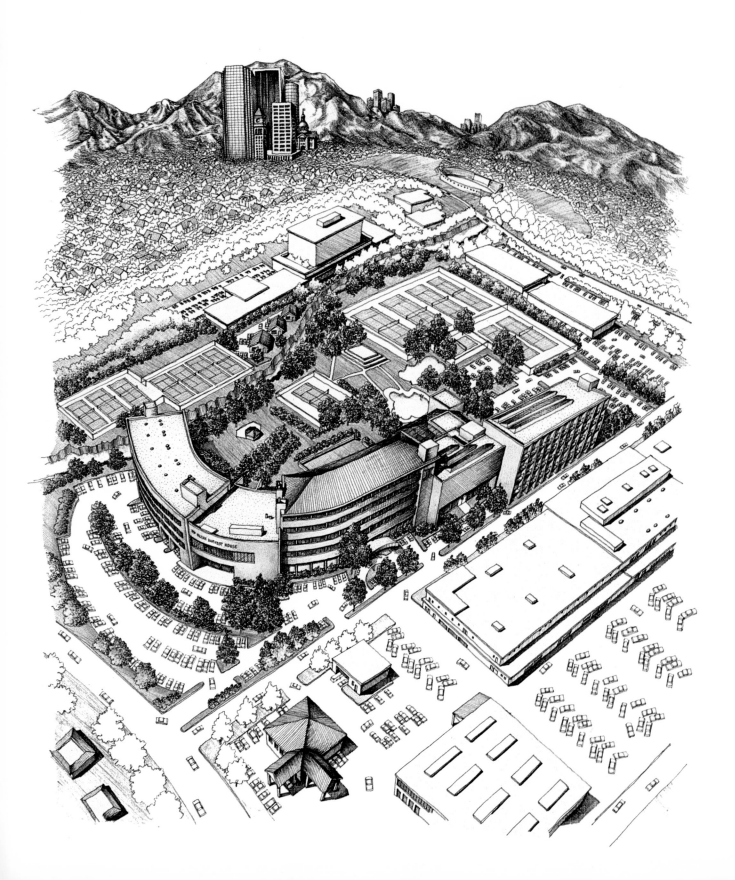

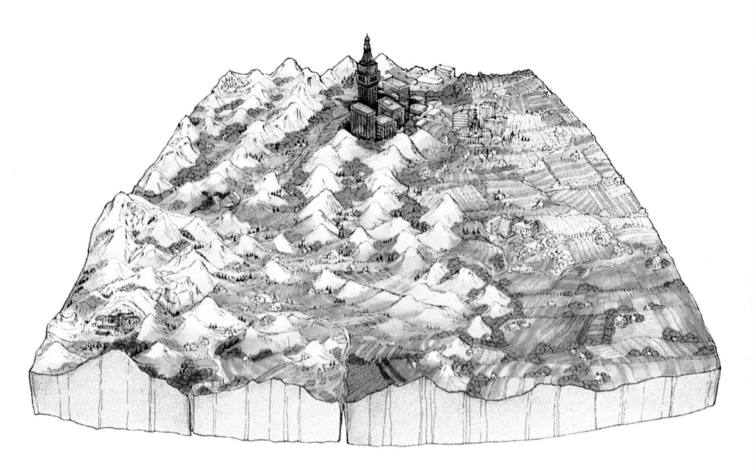

▲ **THE STATE OF COLORADO**
◄ **DENVER, COLORADO**

These drawings, part of the series for Bruce Elton Design, are almost cartoon-like, yet there is enough detail and geography to make us believe that these illustrations are factual. The viewer's interest in the drawing is heightened by the opposition of warm and cool colors. This was done completely in water-base pencil.

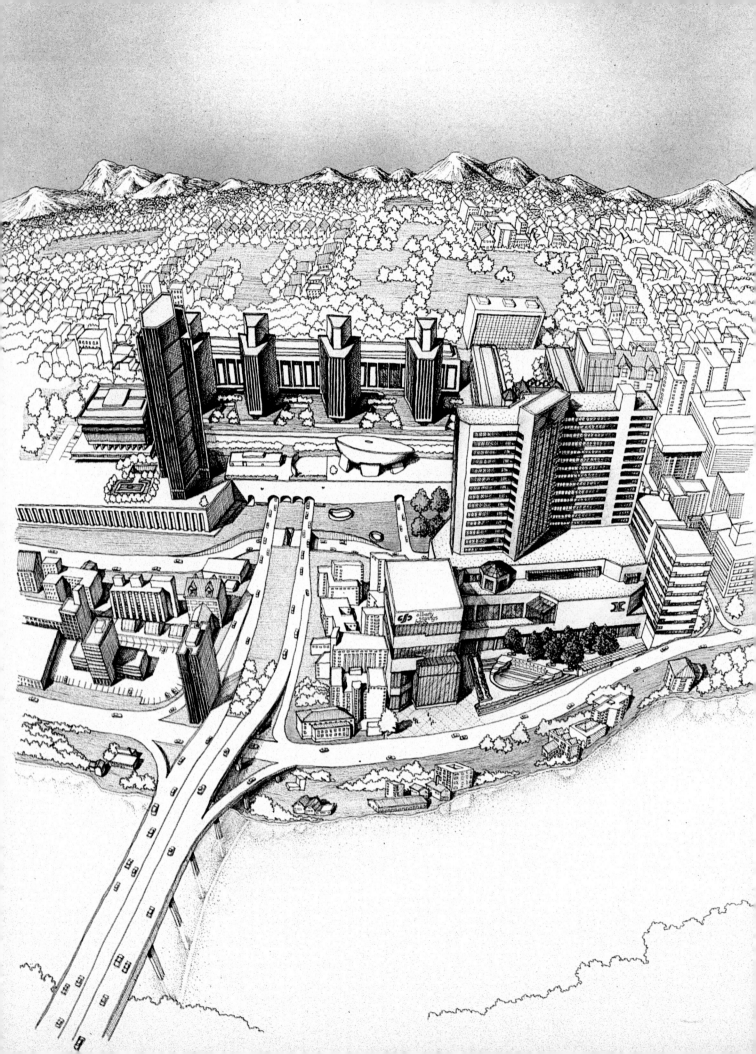

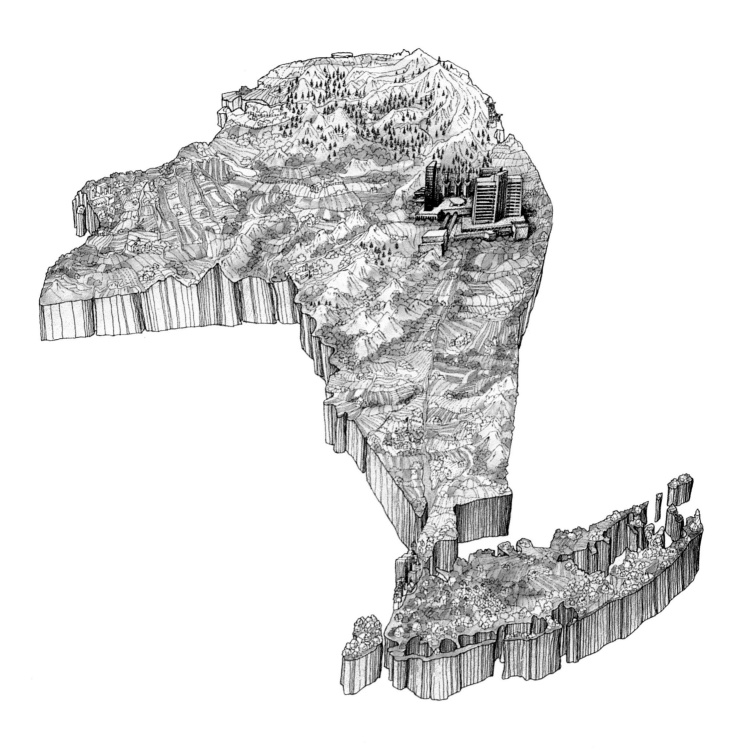

▲ THE STATE OF NEW YORK
◀ ALBANY, NEW YORK

These fun illustrations, part of the Bruce Elton Design series, rely on the pen-and-ink base drawing to outline the simplistic rendering of an entire state. The delicate use of water-base pencil easily brings the viewer's eye to the points of interest.

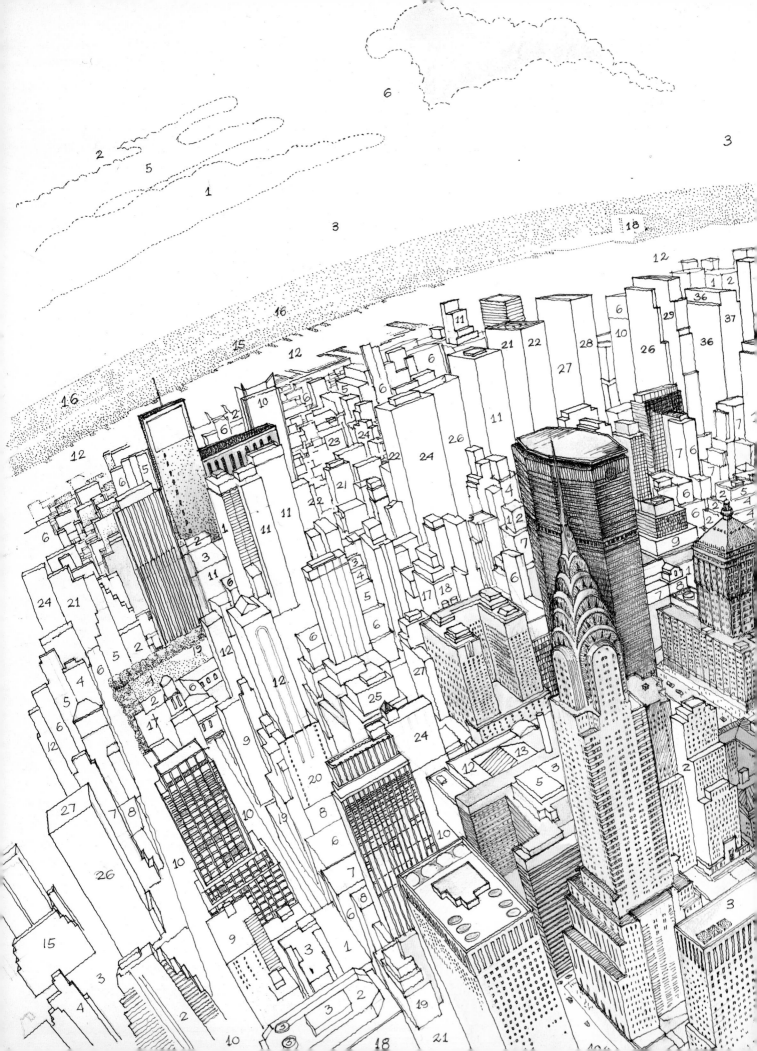

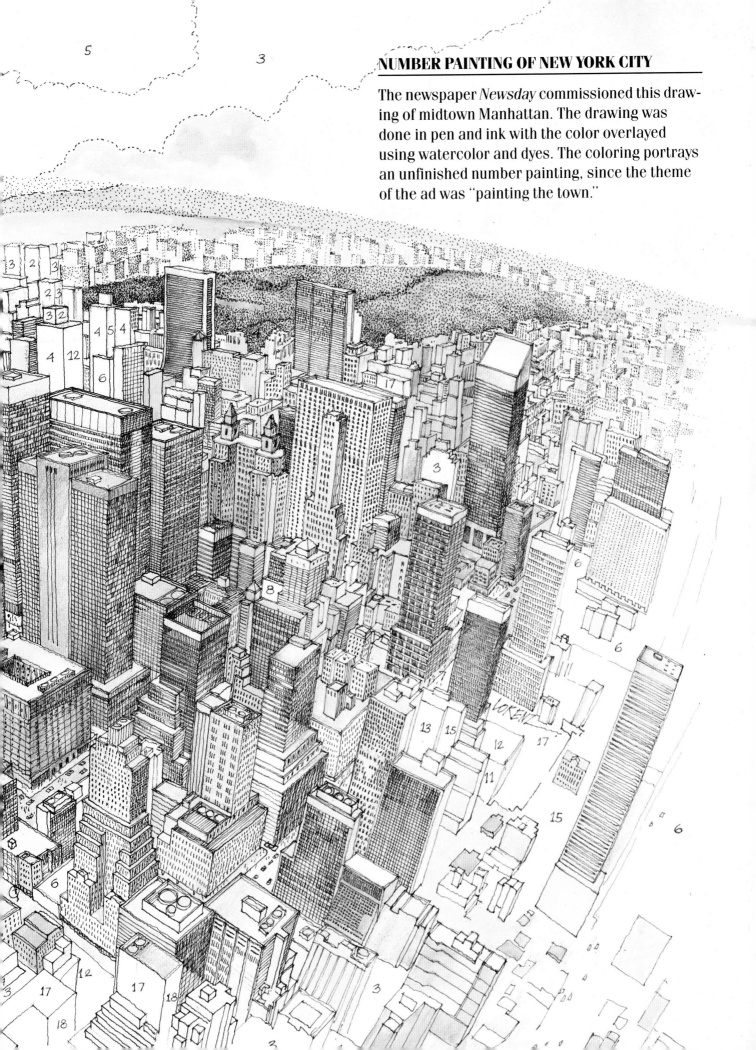

NUMBER PAINTING OF NEW YORK CITY

The newspaper *Newsday* commissioned this drawing of midtown Manhattan. The drawing was done in pen and ink with the color overlayed using watercolor and dyes. The coloring portrays an unfinished number painting, since the theme of the ad was "painting the town."

MANHATTAN

This drawing was commissioned by *National Geographic* magazine. Although obviously out-of-scale, every inch of Manhattan is covered with architecture. The areas of interest are then done in more detail, and color was overlayed using watercolor and water-base color pencil.

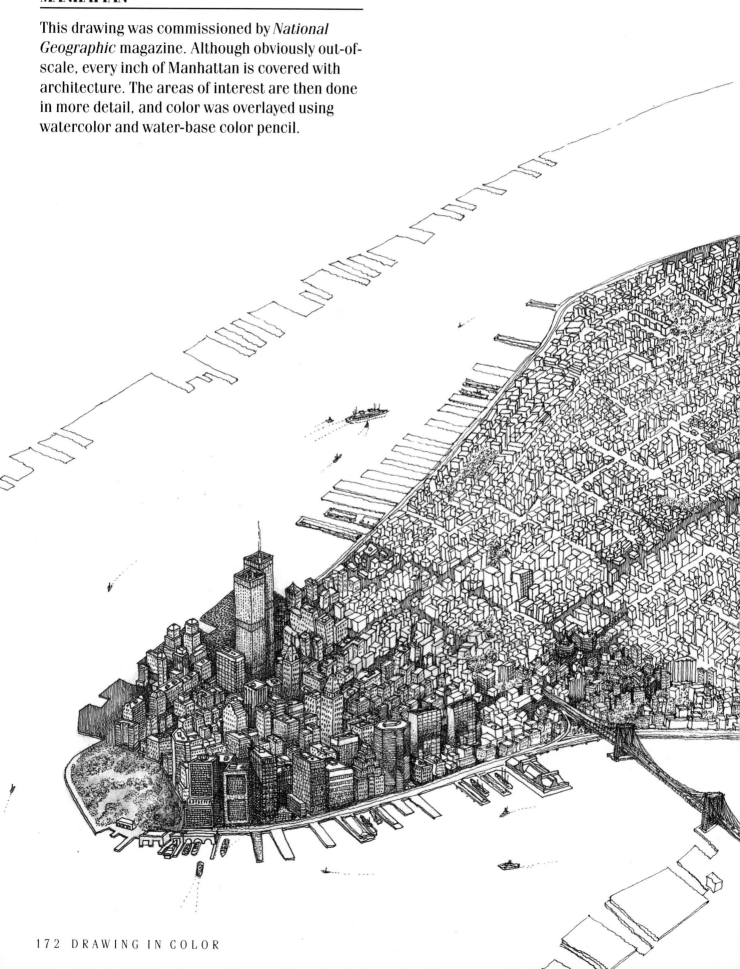

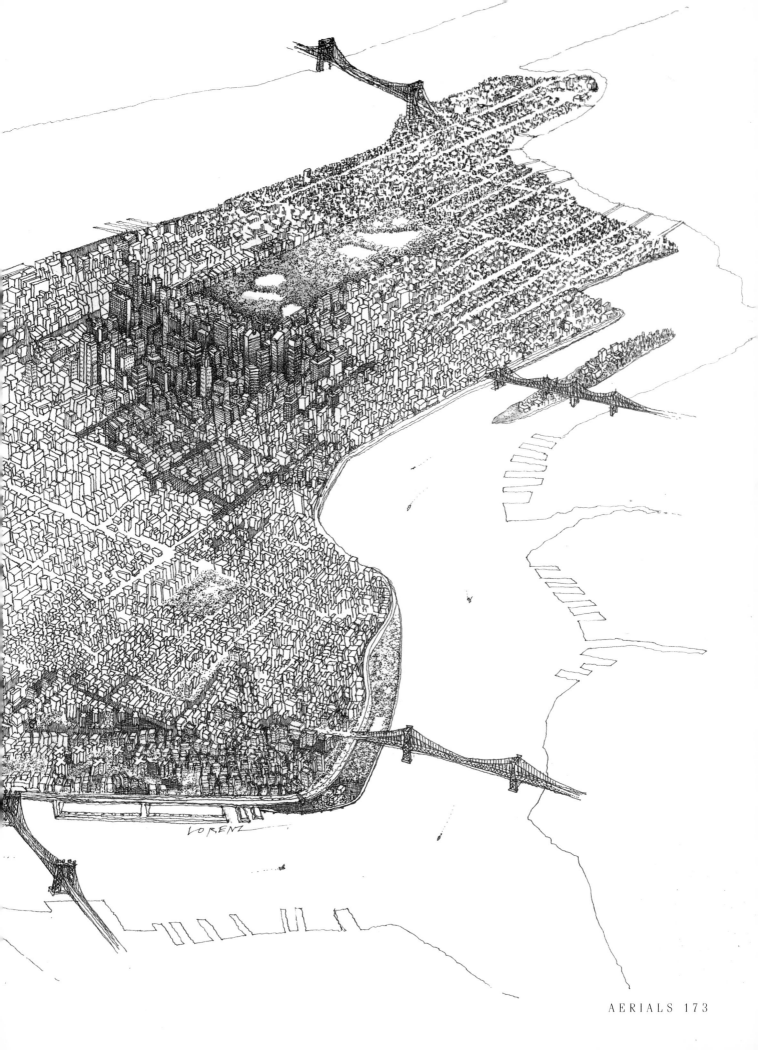

LORENZ

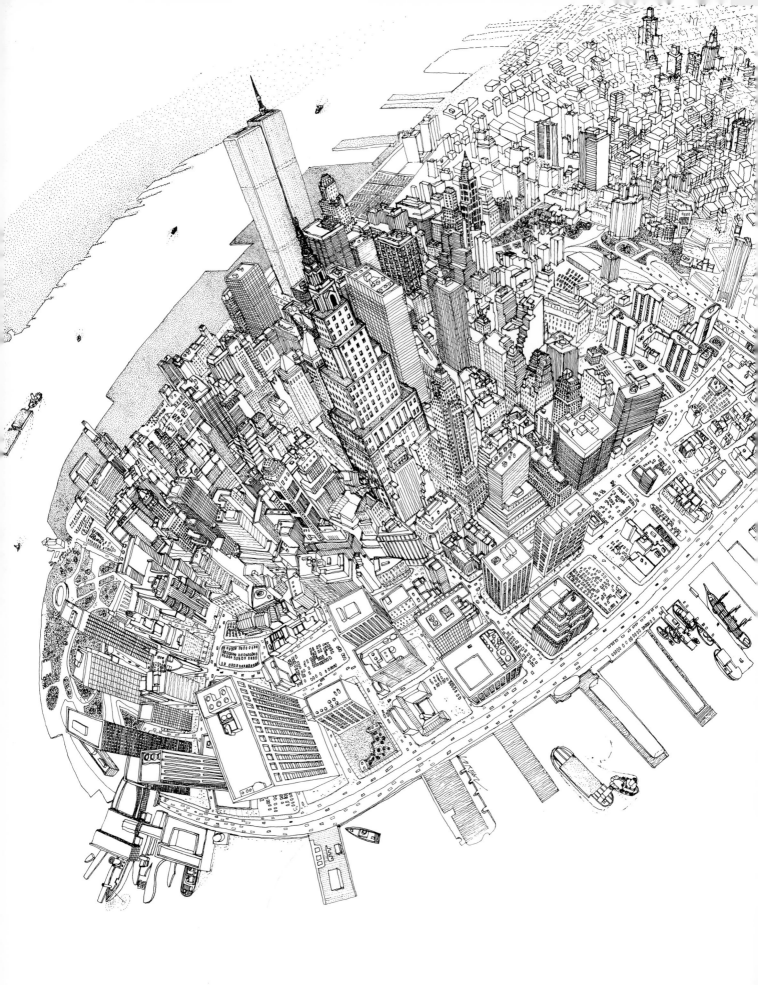

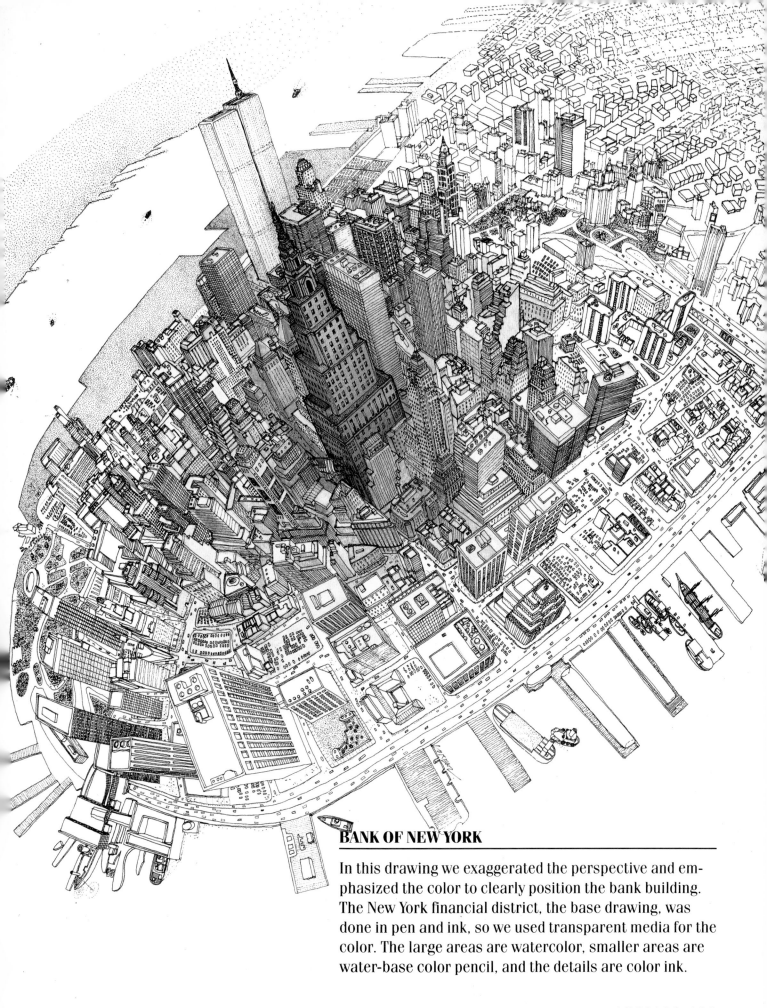

BANK OF NEW YORK

In this drawing we exaggerated the perspective and emphasized the color to clearly position the bank building. The New York financial district, the base drawing, was done in pen and ink, so we used transparent media for the color. The large areas are watercolor, smaller areas are water-base color pencil, and the details are color ink.

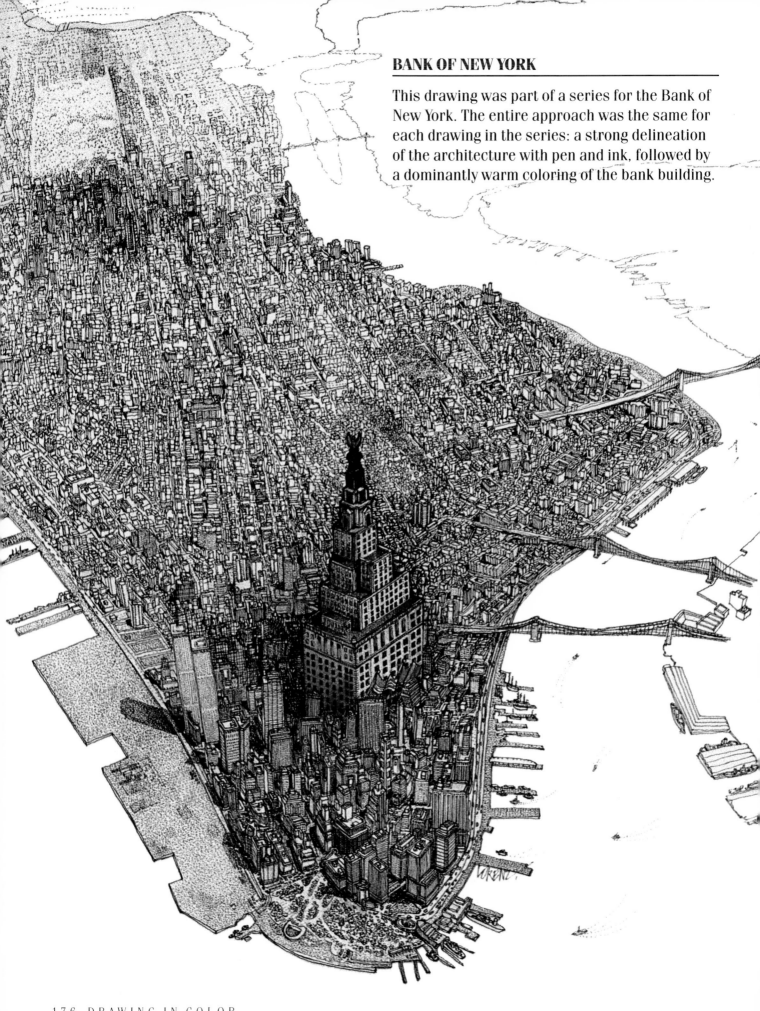

BANK OF NEW YORK

This drawing was part of a series for the Bank of New York. The entire approach was the same for each drawing in the series: a strong delineation of the architecture with pen and ink, followed by a dominantly warm coloring of the bank building.

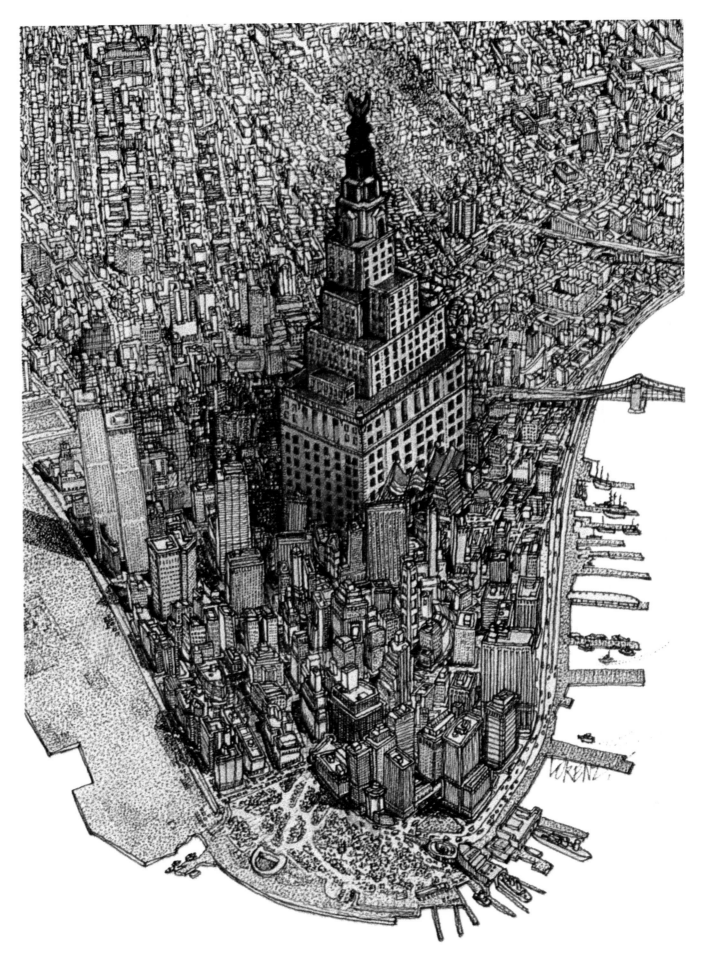

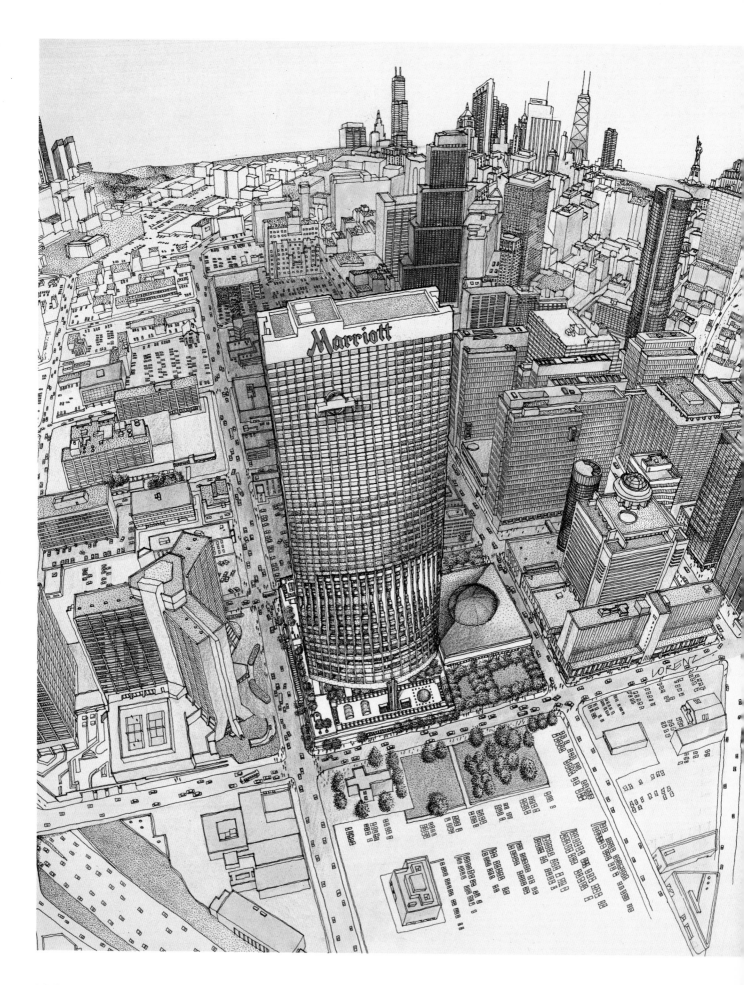

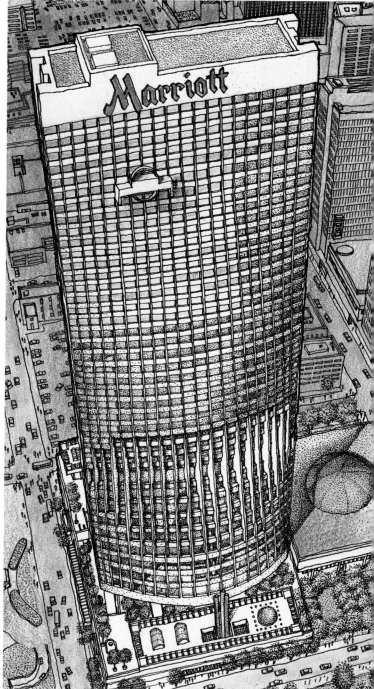

THE MARRIOT, ATLANTA, GEORGIA

This is a view of Atlanta centering on the flagship hotel of the Marriot chain. The exaggerated size makes the hotel almost overwhelm the surrounding buildings. Warm colors keep the building from fading out. The warm tones of the Atlanta cityscape are juxtaposed with the cool tones of the hotel. As with most of our aerials, a detailed pen-and-ink base drawing was overlayed with watercolor and water-base color pencil.

ETCHINGS

Etchings are produced by covering a zinc or copper plate with an acid-resistant chemical ground. The ground is removed line by line as the drawing is scratched onto the plate with a special tool. Once the ground is removed, the plate is put into an acid bath. The acid etches the lines into the plate. When all the lines have been etched, the ground is removed. The plate is then covered with ink. After the excess ink is carefully wiped off, the plate is placed in a press. With a tremendous amount of pressure, the image is transferred to paper. There is a characteristic indentation of the plate outline on the paper—the hallmark of an etching. Depending on the quality of paper, the image may be hand-colored.

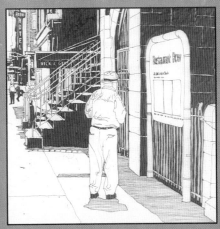 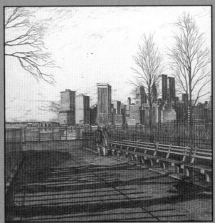

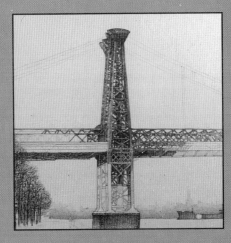

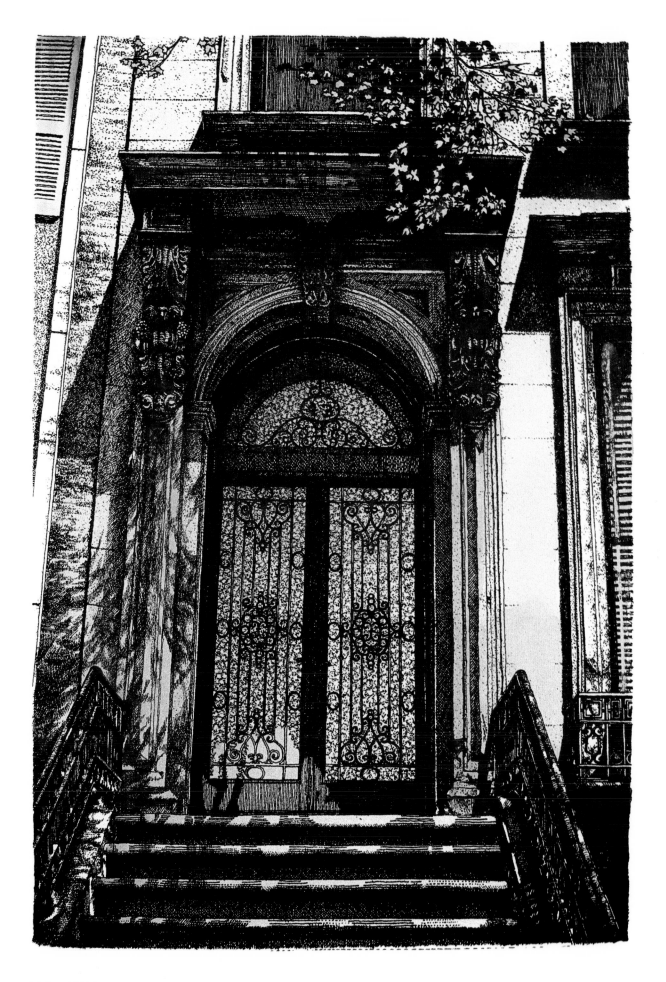

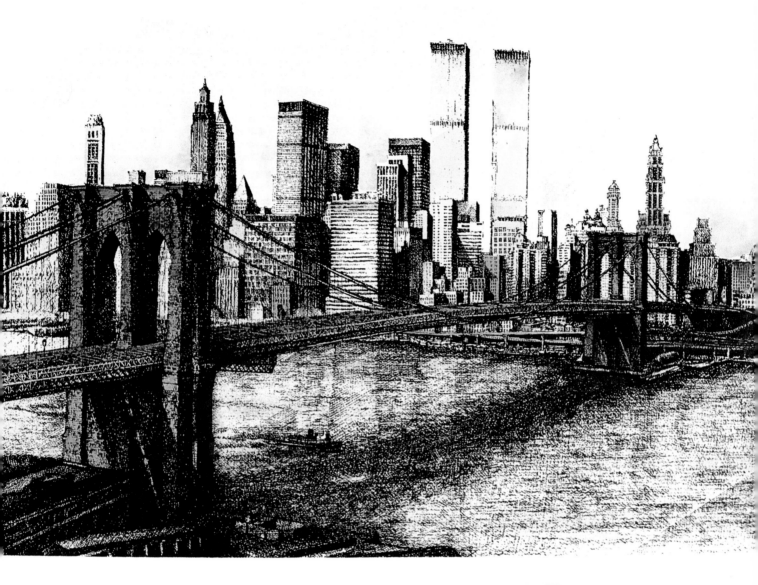

THE BROOKLYN BRIDGE

An etching can be done directly on a plate, or it can be done as a black-and-white drawing that is transferred to a plate by a photographic process. This etching was done using the latter process. The coloring was done using nonfading inks with warm tones, which produced a glow reflecting off the skyline.

BROOKLYN BROWNSTONE DOORWAY

This etching has been hand-colored using non-fading inks. It was printed on Arches paper, one of the highest-quality papers. The colors are uniformly warm and inviting.

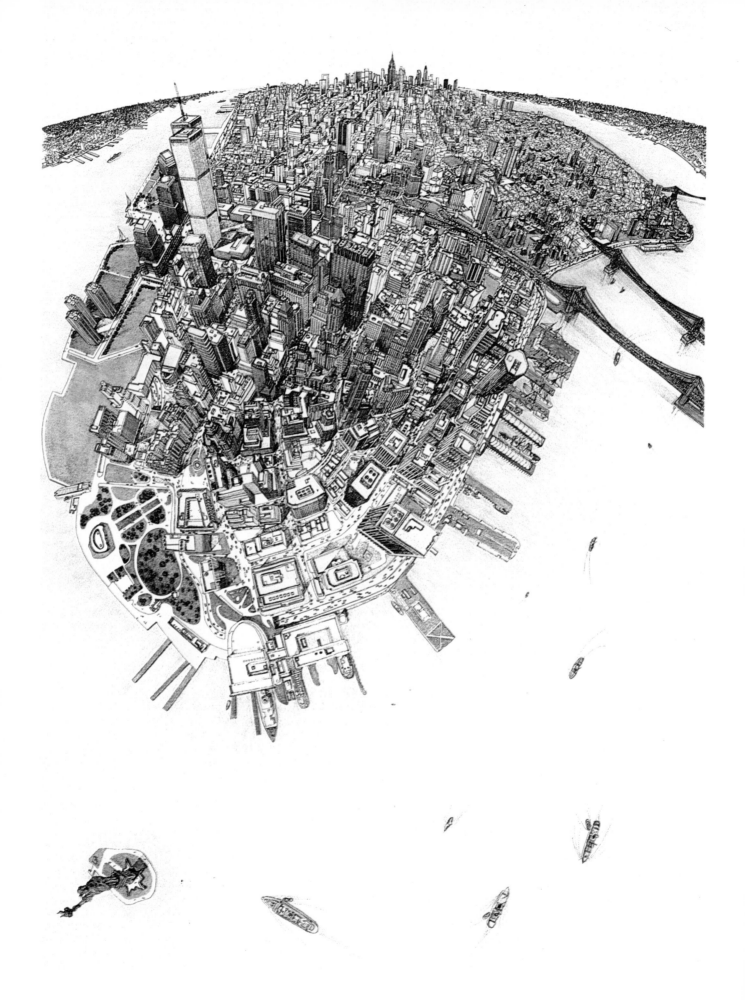

FINANCIAL DISTRICT, NEW YORK CITY

This is a complicated etching of lower Manhattan that was hand-colored using nonfading inks. These colors are intense and help convey the density and excitement of the Financial District.

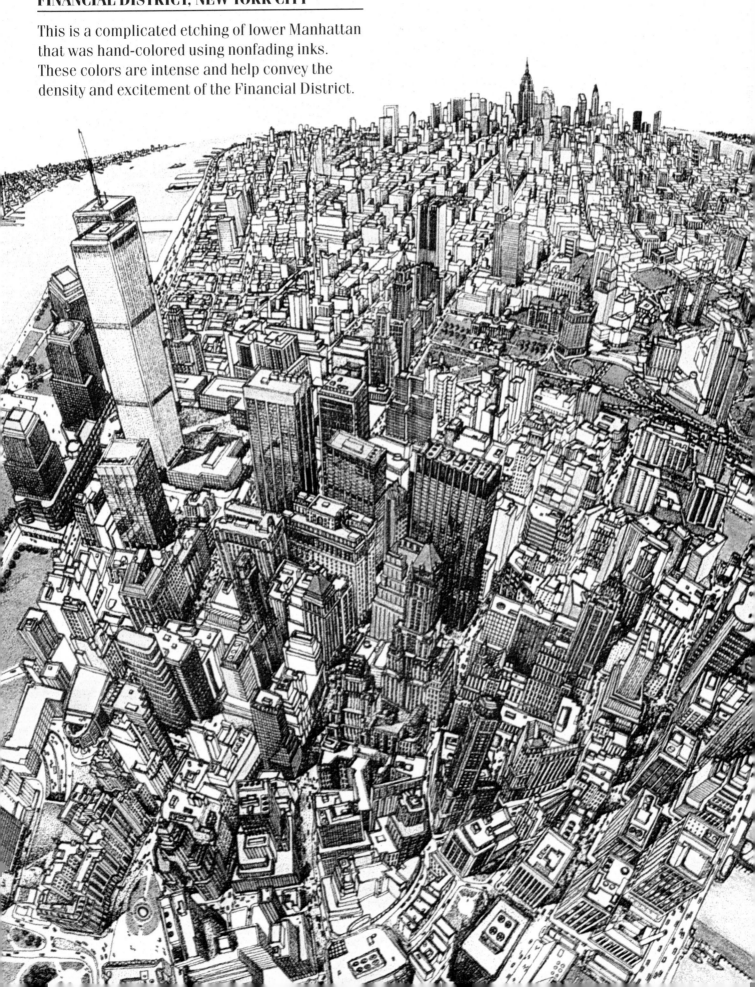

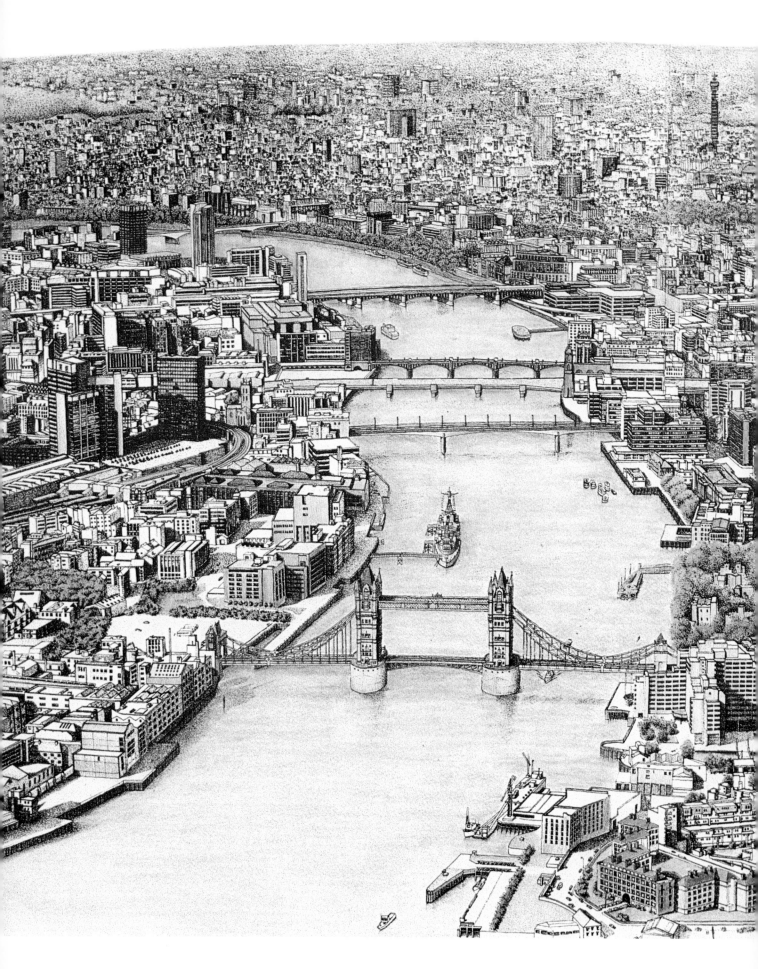

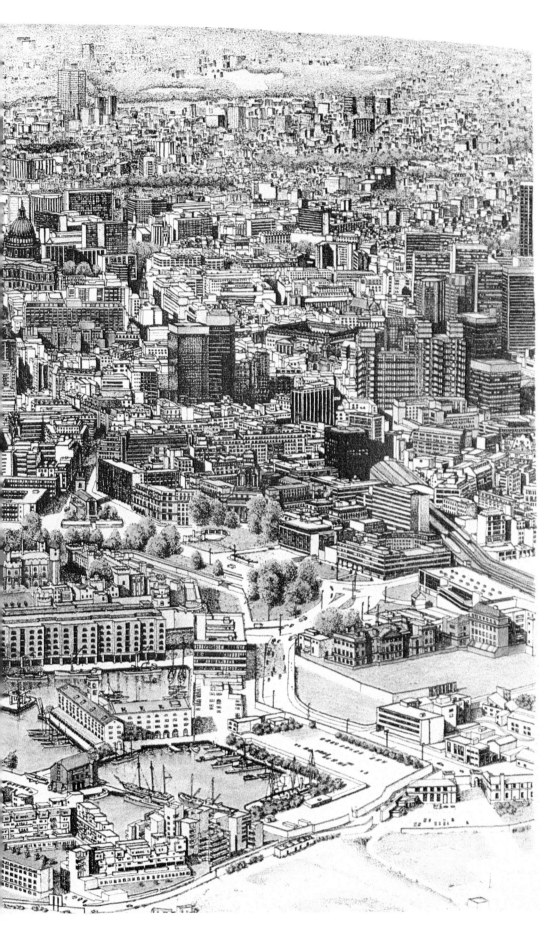

LONDON

This is an etching of the city of London using the same point of view as one of the first aerial drawings done in 1770. We used warm tones to create the overall mood of the late afternoon sun bathing London's bridges in a golden glow.

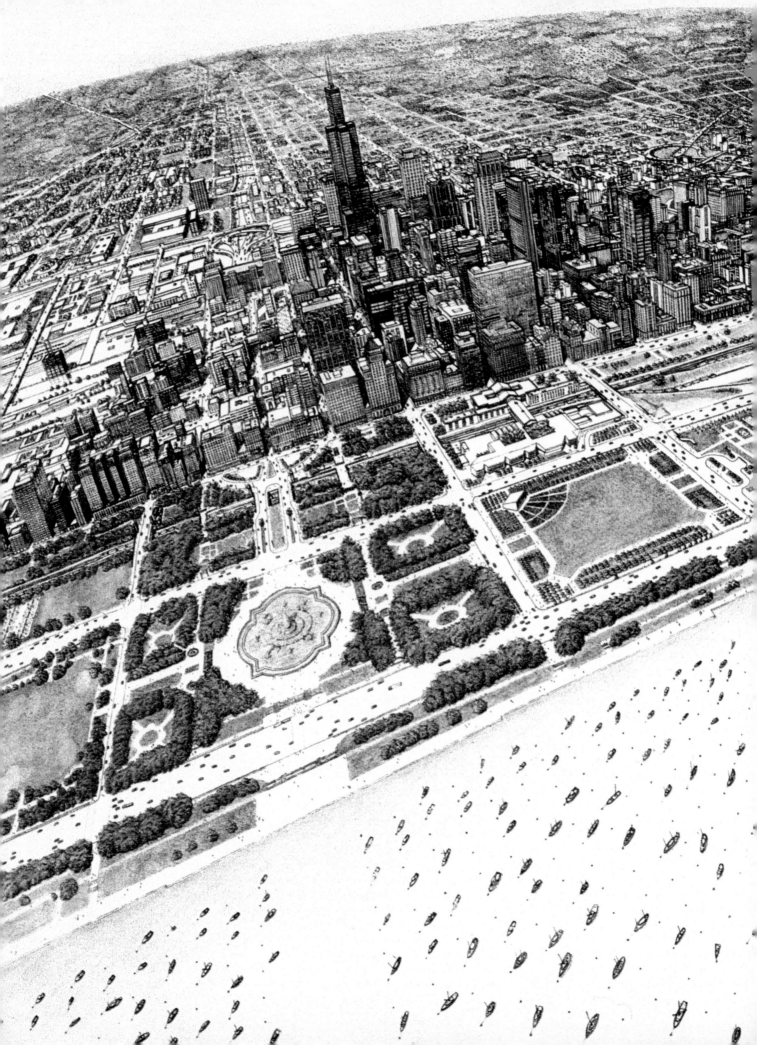

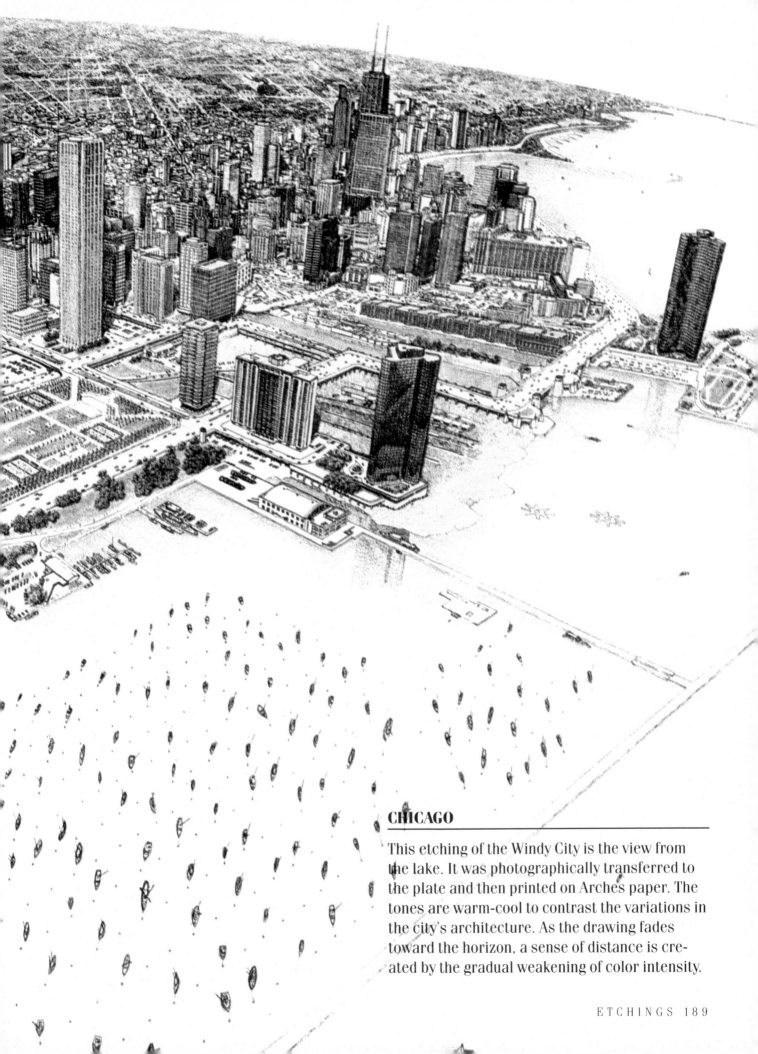

CHICAGO

This etching of the Windy City is the view from the lake. It was photographically transferred to the plate and then printed on Arches paper. The tones are warm-cool to contrast the variations in the city's architecture. As the drawing fades toward the horizon, a sense of distance is created by the gradual weakening of color intensity.

TORONTO

Minimal color allows this etching to move the viewer's eye from building to building.

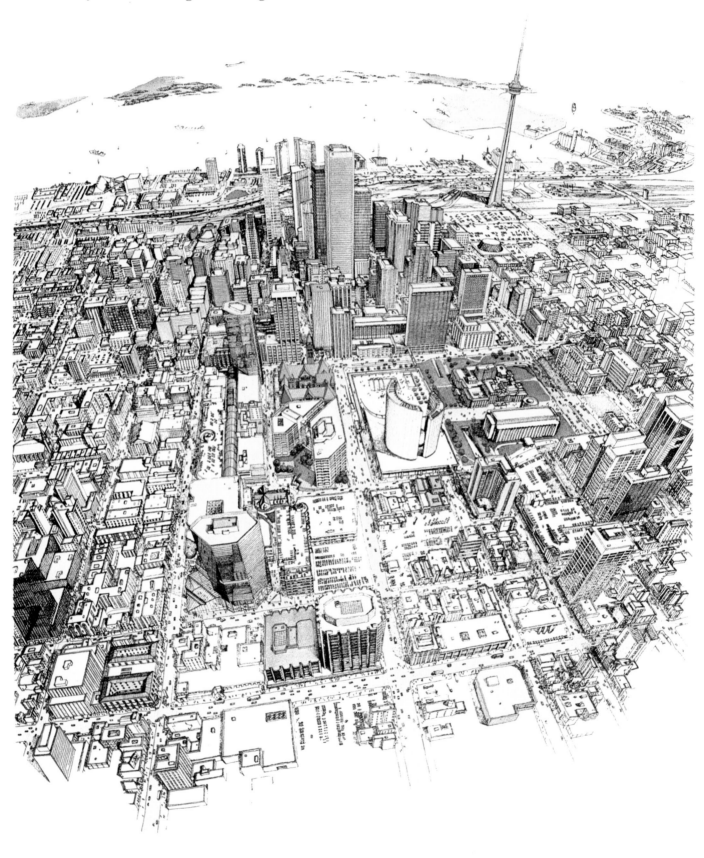

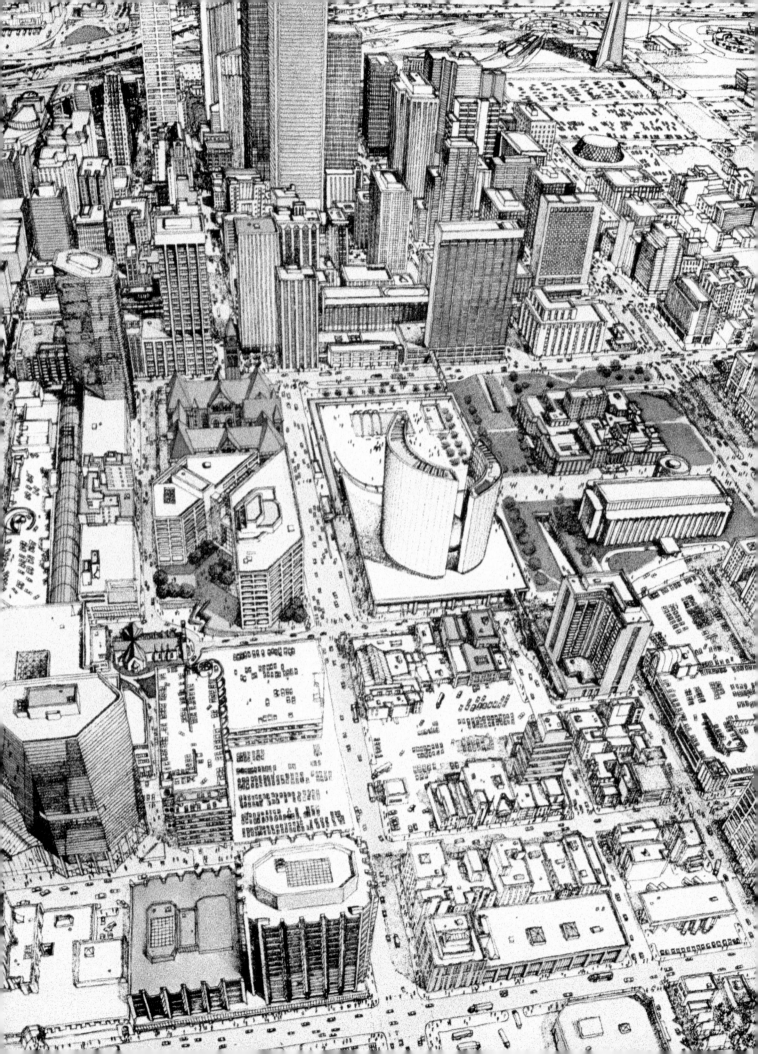

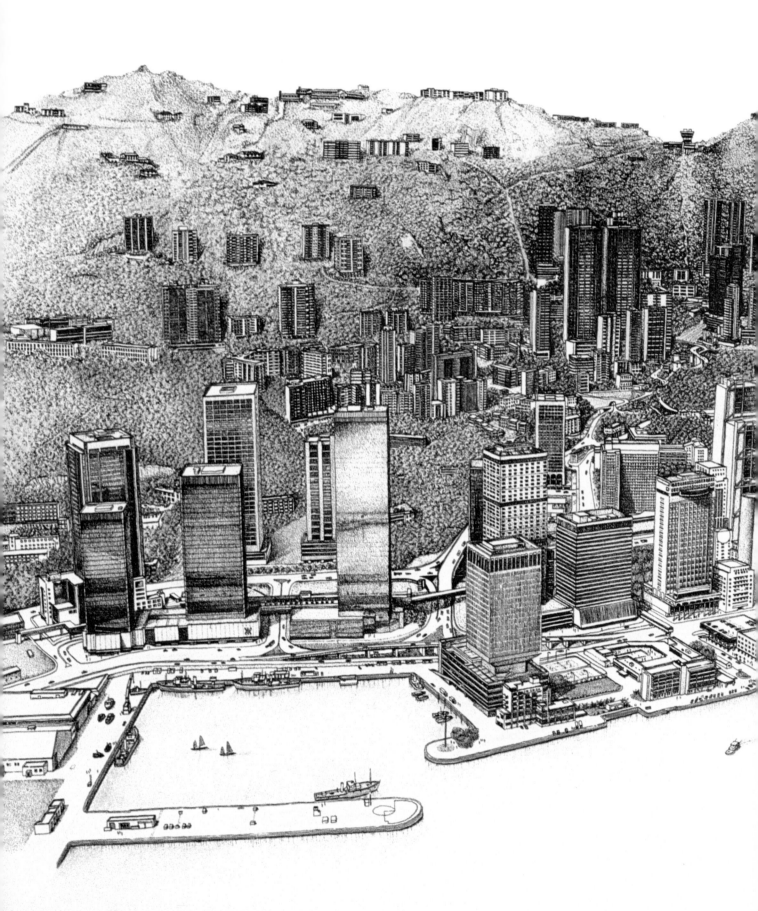

HONG KONG

The green hills of Hong Kong are balanced by the warm tones of the city itself.

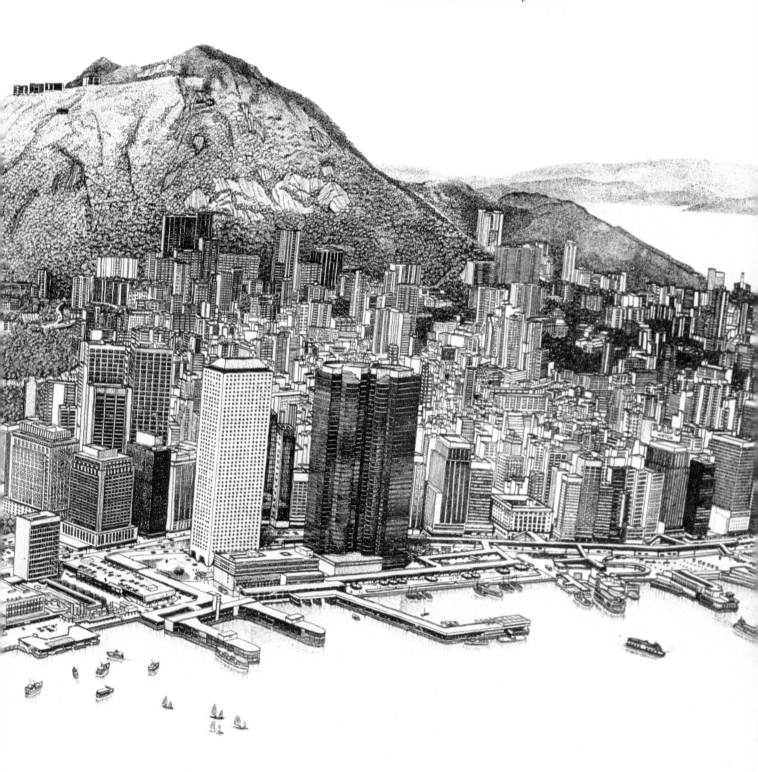

IMAGINATIVE DRAWINGS

WE HAVE THE MOST FUN DO-
ING FANTASTIC DRAWINGS. THESE ARE CONSTRAINED ONLY BY
THE LIMITS OF OUR IMAGINATION. THESE VERY PERSONAL
ILLUSTRATIONS FOR BOOKS, MAGAZINES, POSTERS, AND CHRIST-
MAS CARDS ARE INCLUDED TO STIMULATE IMAGINATION AND
CREATIVITY. THEY INCORPORATE ALL THE TECHNIQUES AND
MEDIA OF THE ILLUSTRATOR AND FOLLOW ALL THE RULES
OF COLOR.

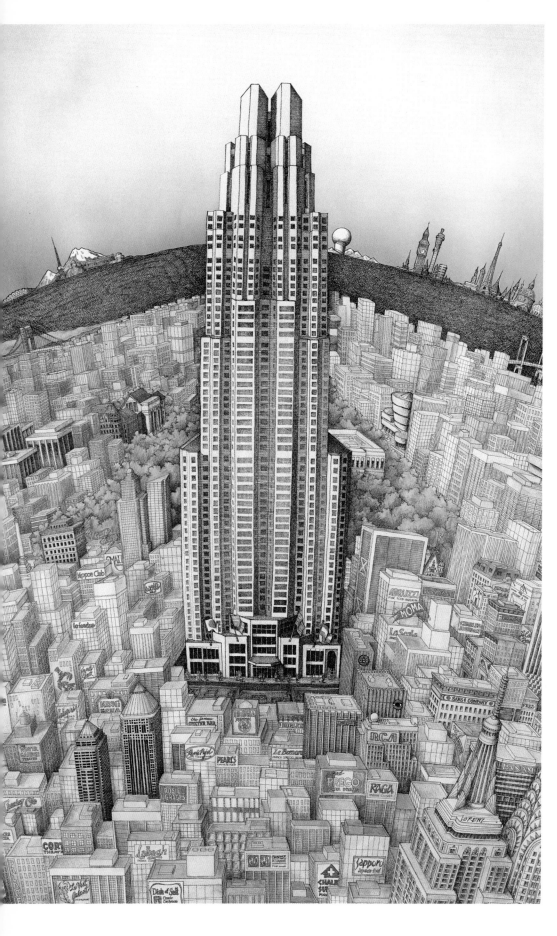

RIHGA ROYAL HOTEL

We were approached by an advertising agency and asked to create, locate, and enlarge an exciting building through our drawing of the hotel. By using subdued, neutral grays on the surroundings, we were able to "pop" the hotel. Water- and oil-base pencil, airbrush, and gouache were used.

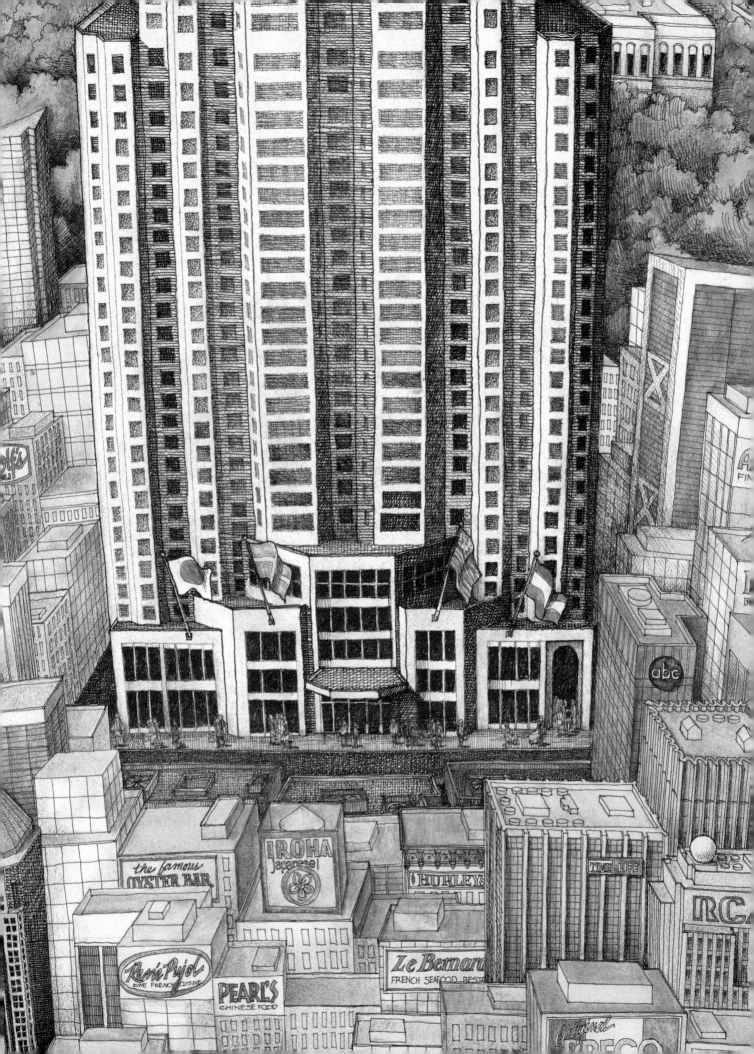

X, Y, AND Z

These "letter-buildings" done in warm-cool tones dominate the city with their mammoth size and intense coloring. Water- and oil-base color pencil were used.

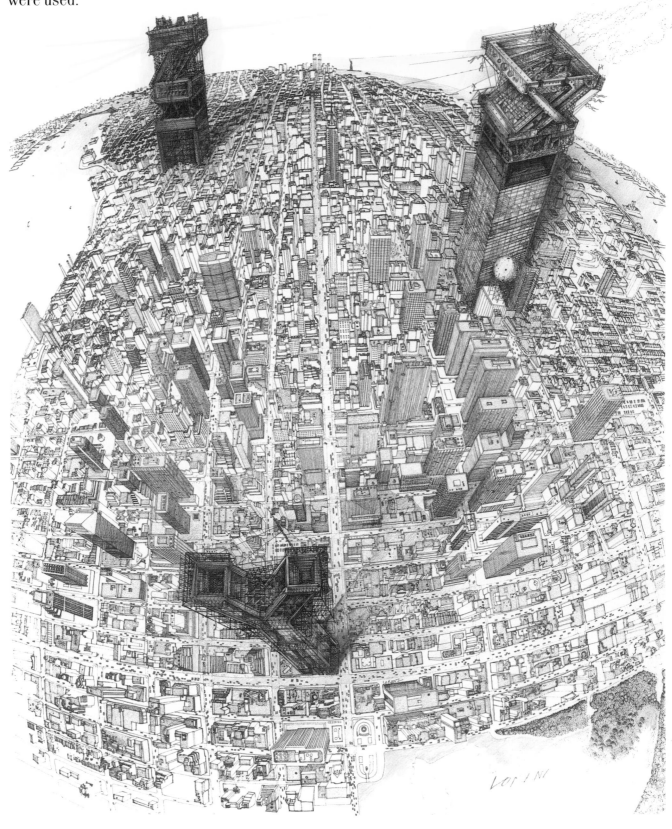

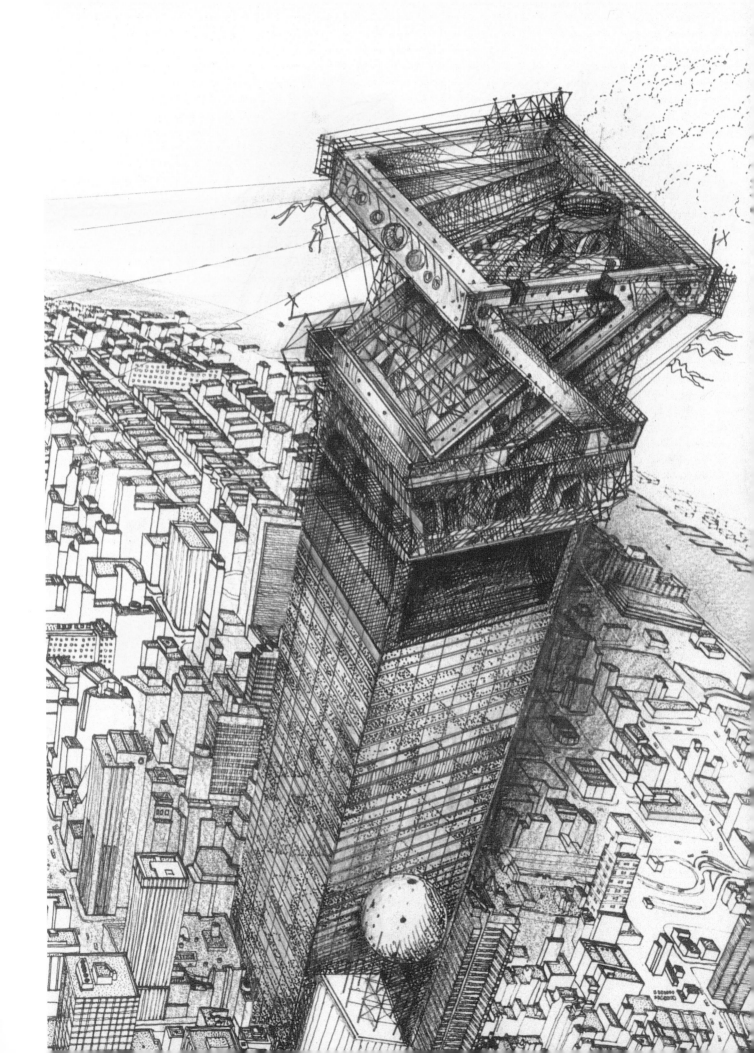

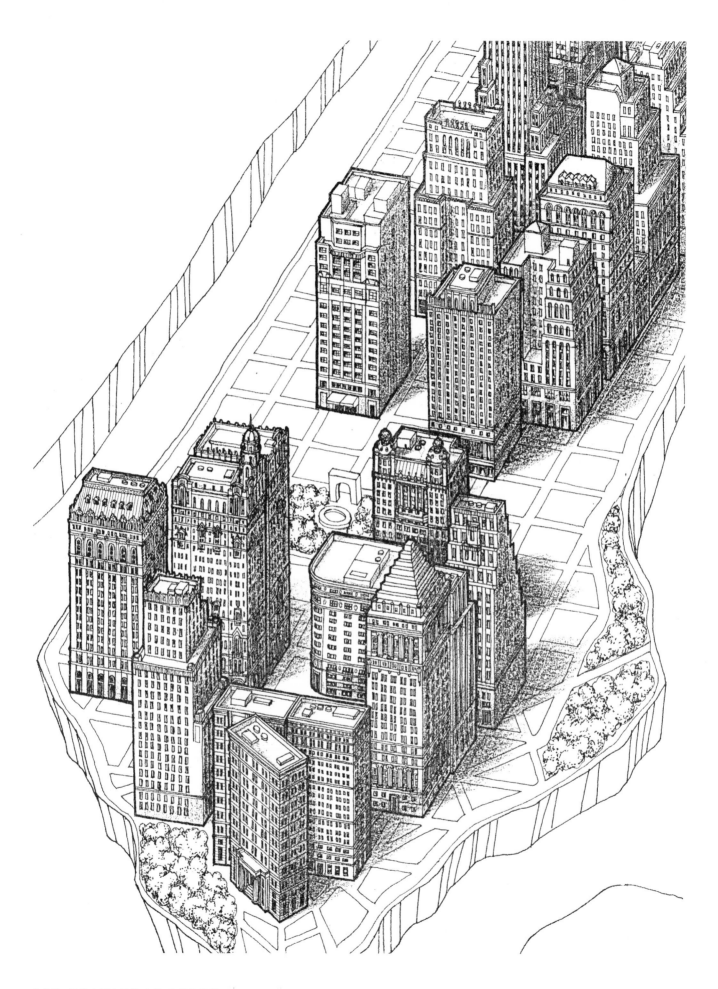

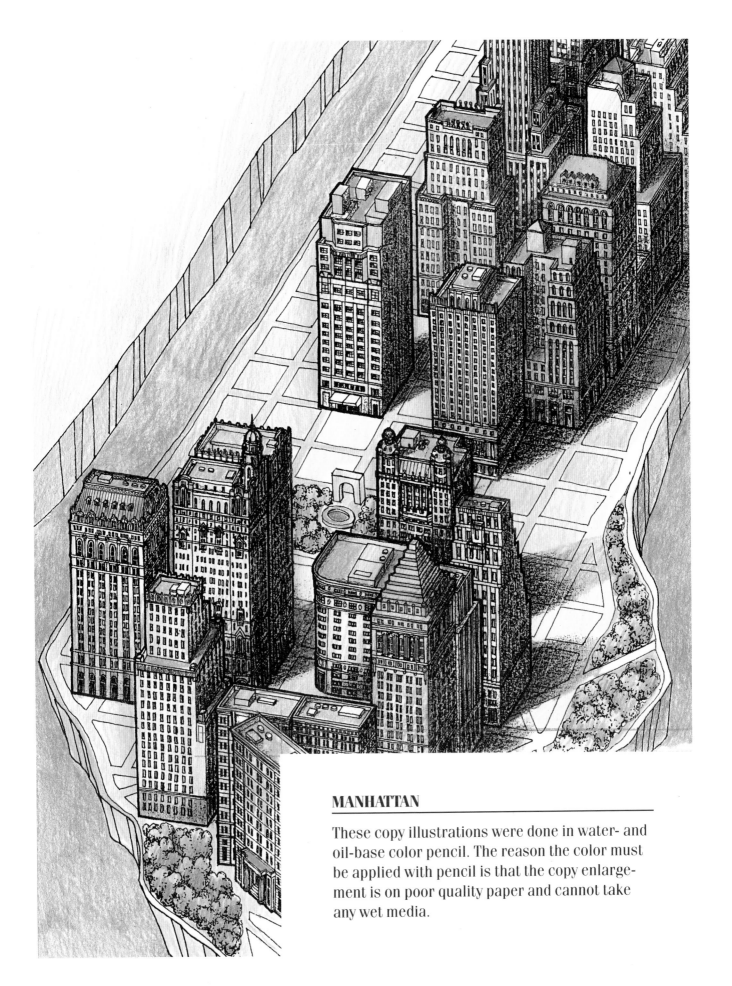

MANHATTAN

These copy illustrations were done in water- and oil-base color pencil. The reason the color must be applied with pencil is that the copy enlargement is on poor quality paper and cannot take any wet media.

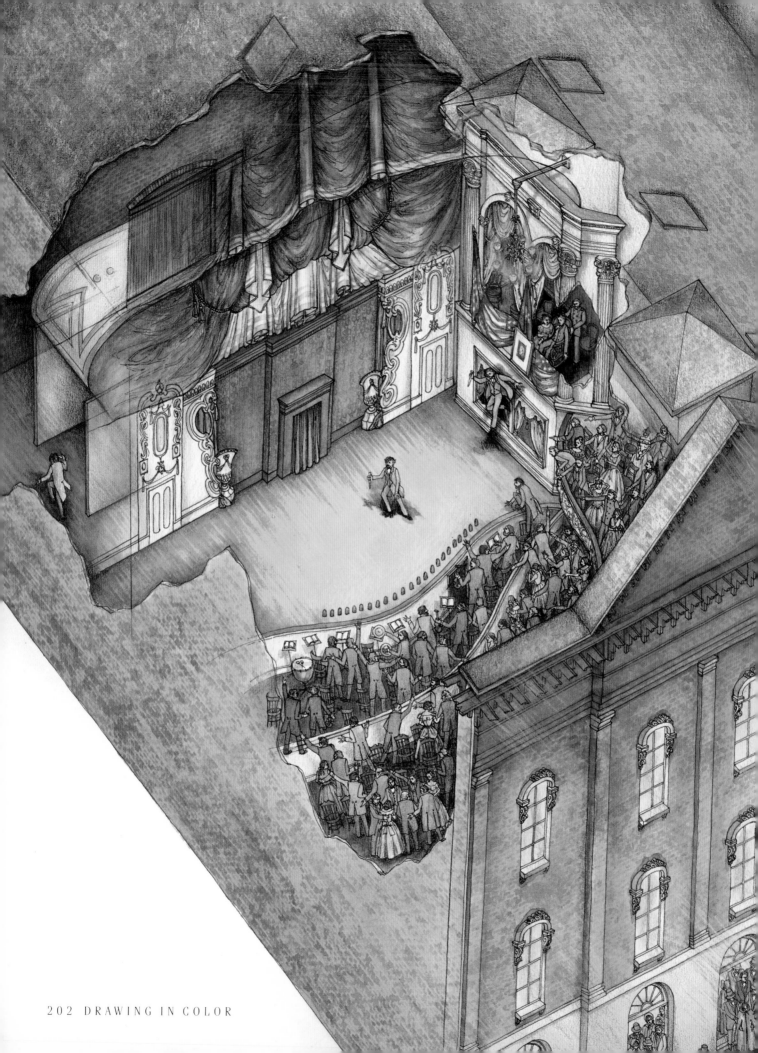

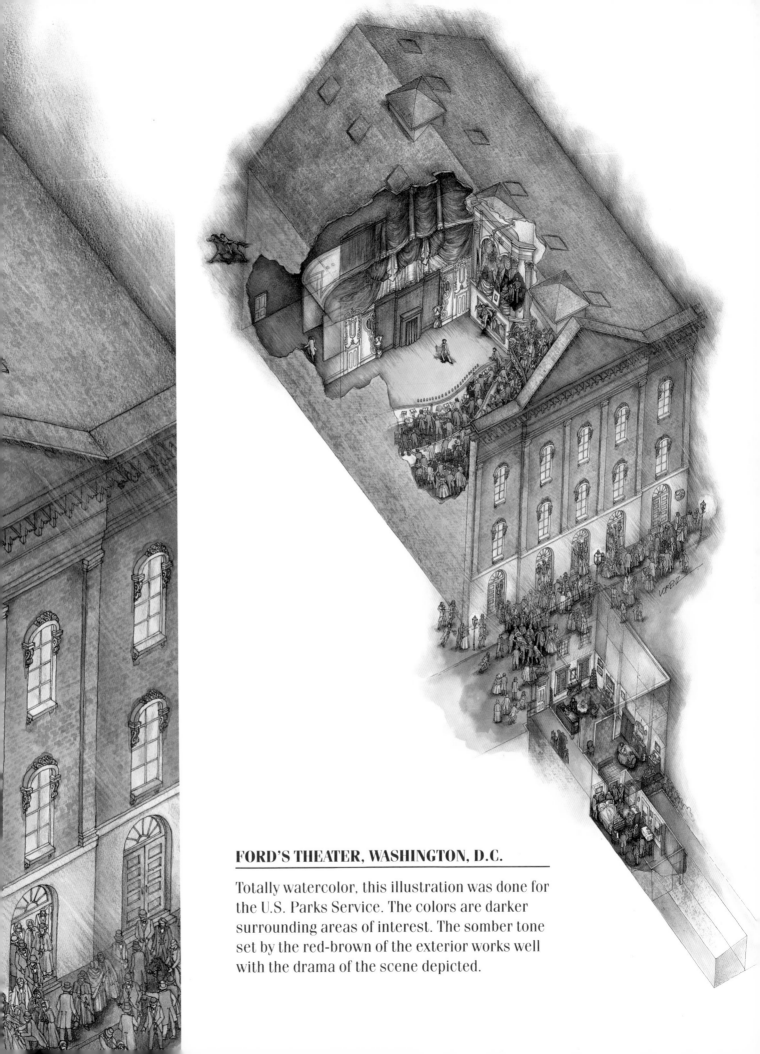

FORD'S THEATER, WASHINGTON, D.C.

Totally watercolor, this illustration was done for the U.S. Parks Service. The colors are darker surrounding areas of interest. The somber tone set by the red-brown of the exterior works well with the drama of the scene depicted.

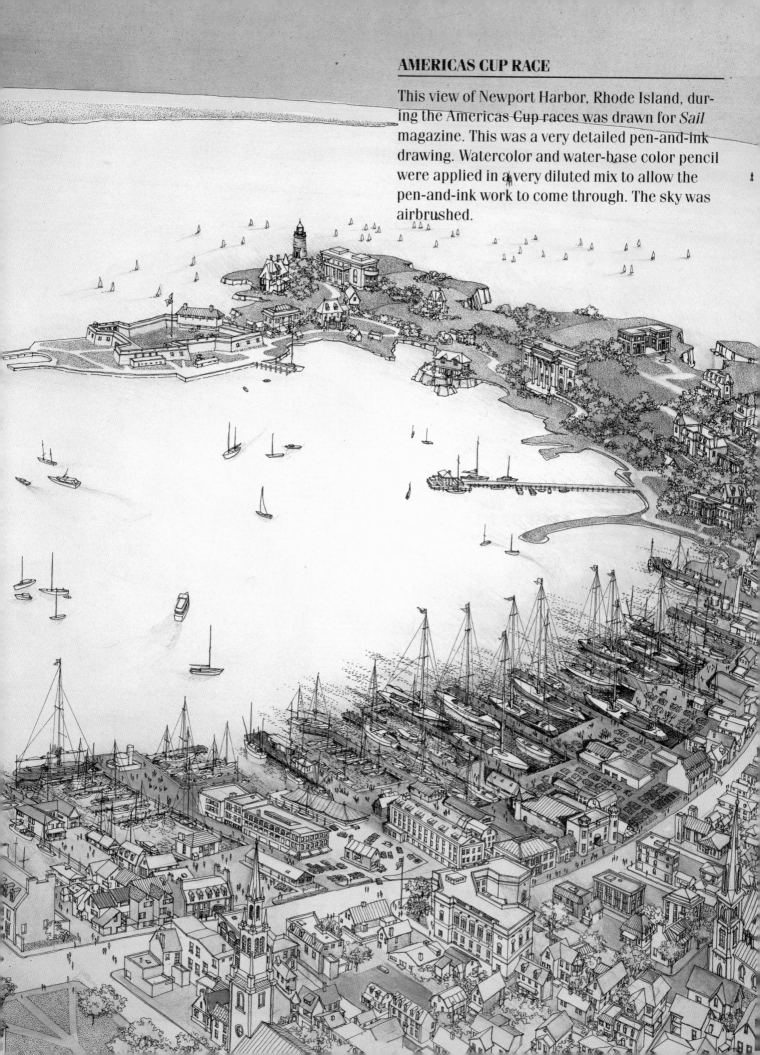

AMERICAS CUP RACE

This view of Newport Harbor, Rhode Island, during the Americas Cup races was drawn for *Sail* magazine. This was a very detailed pen-and-ink drawing. Watercolor and water-base color pencil were applied in a very diluted mix to allow the pen-and-ink work to come through. The sky was airbrushed.

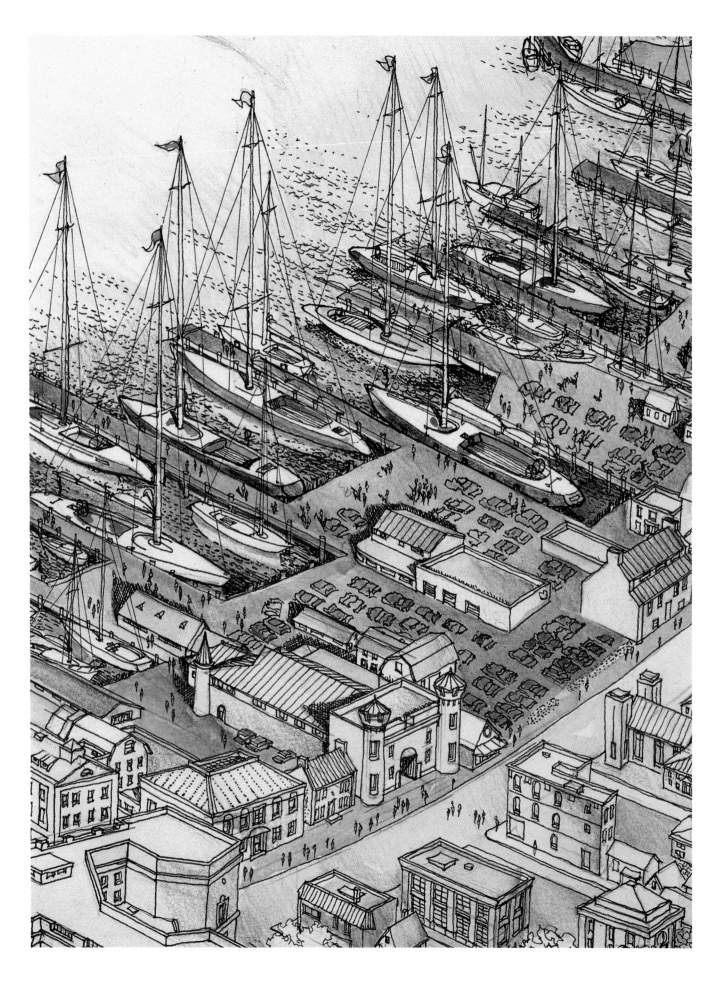

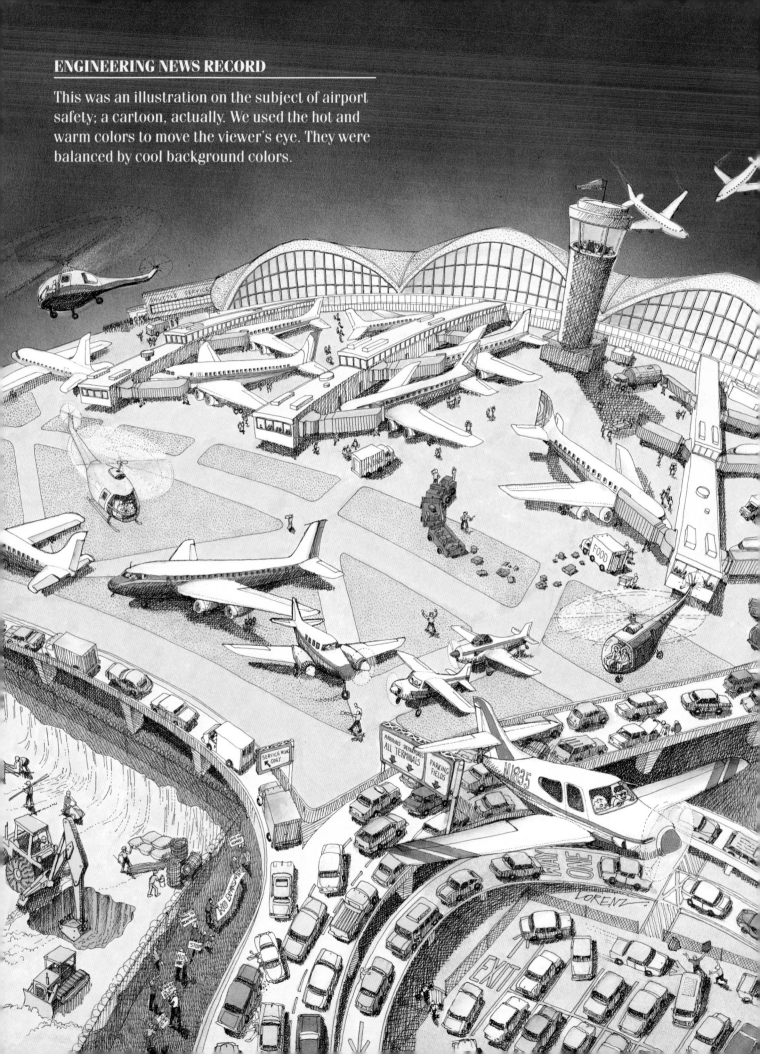

This was an illustration on the subject of airport safety; a cartoon, actually. We used the hot and warm colors to move the viewer's eye. They were balanced by cool background colors.

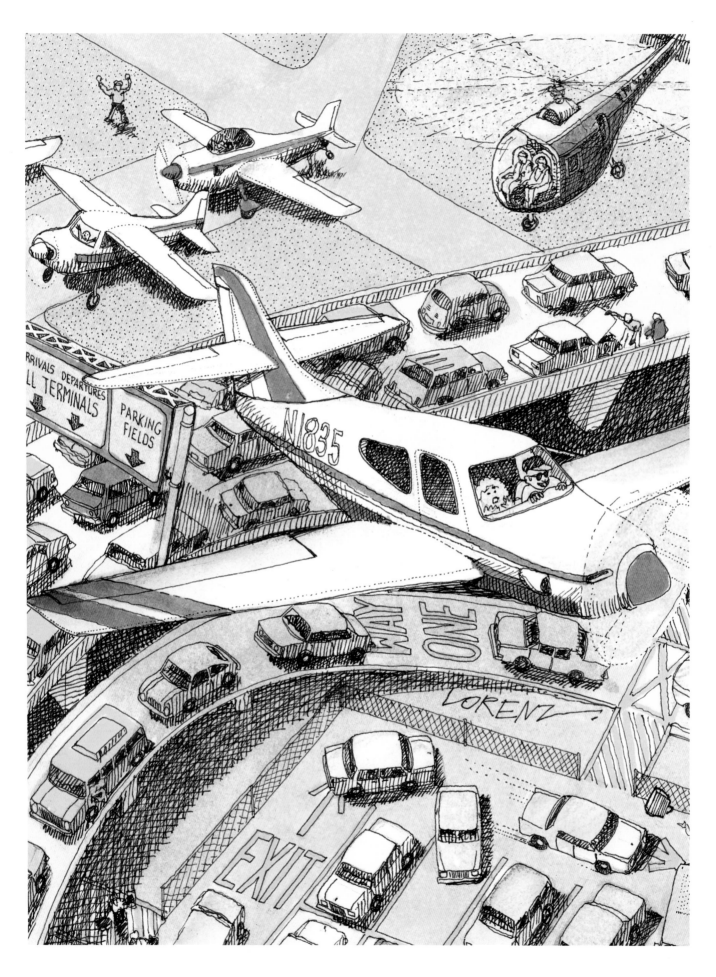

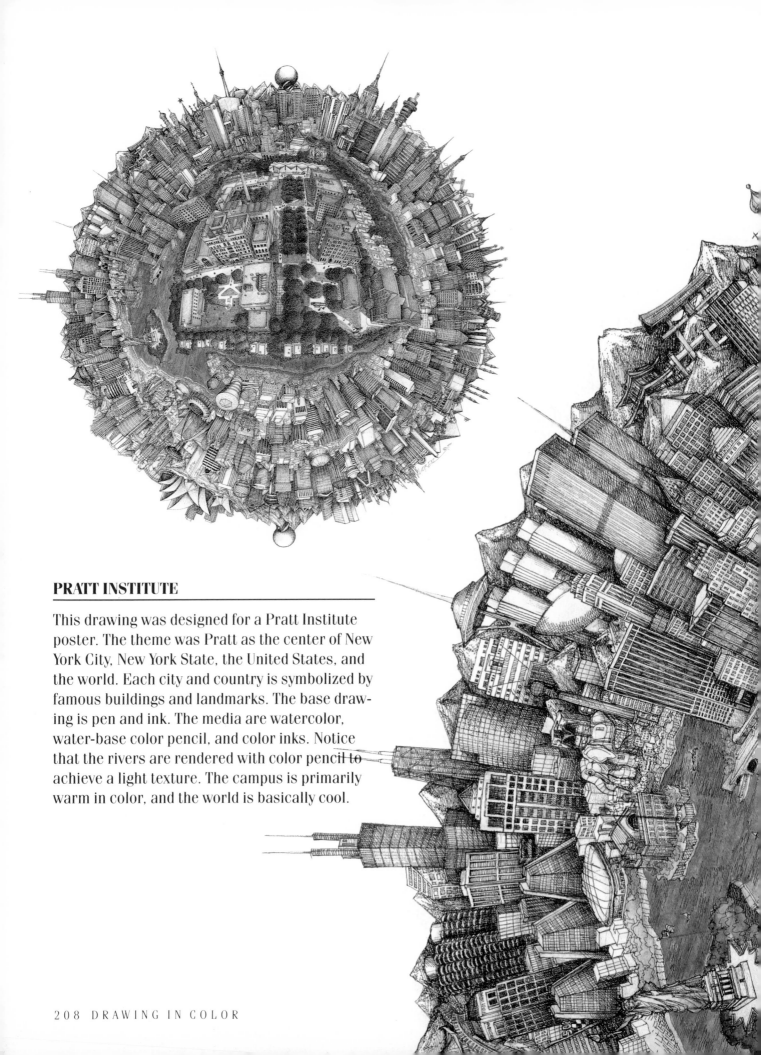

PRATT INSTITUTE

This drawing was designed for a Pratt Institute poster. The theme was Pratt as the center of New York City, New York State, the United States, and the world. Each city and country is symbolized by famous buildings and landmarks. The base drawing is pen and ink. The media are watercolor, water-base color pencil, and color inks. Notice that the rivers are rendered with color pencil to achieve a light texture. The campus is primarily warm in color, and the world is basically cool.

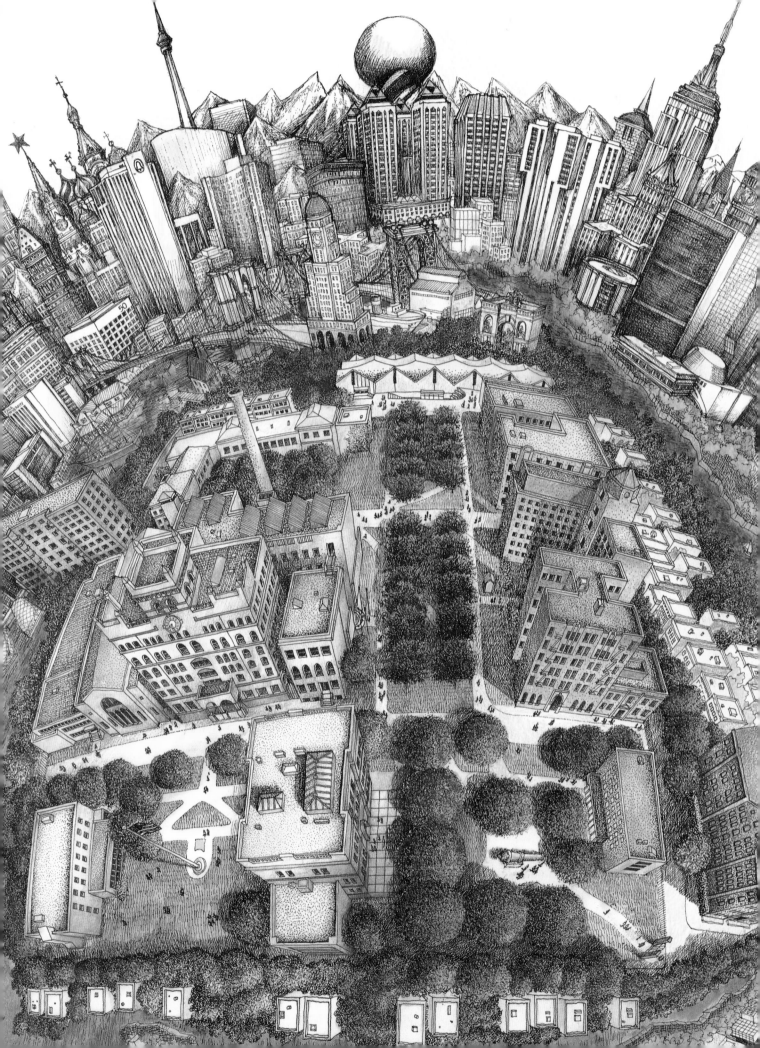

BOOK JACKET

We were asked to do an aerial illustration of the
world for this book jacket. The drawing back-
ground is airbrushed gouache. The pen-and-ink
drawing is freehand. All media were used in
diluted form.

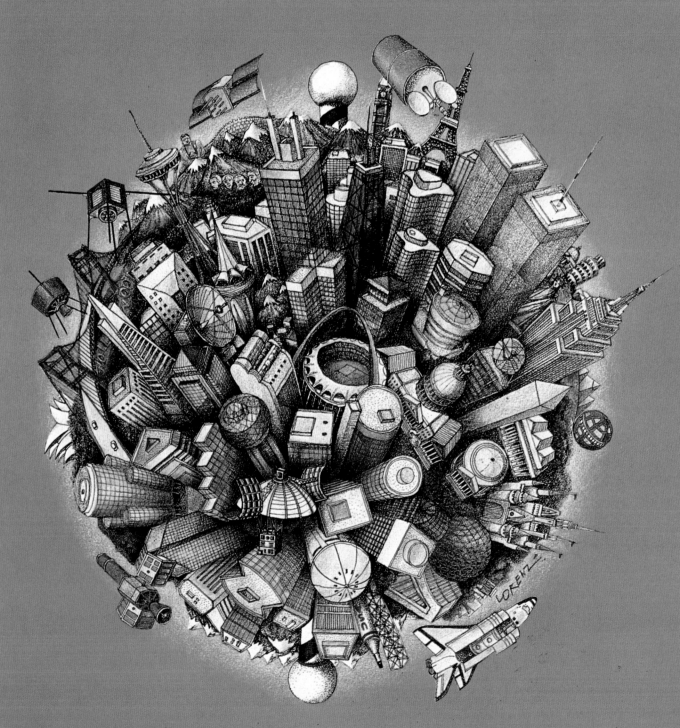

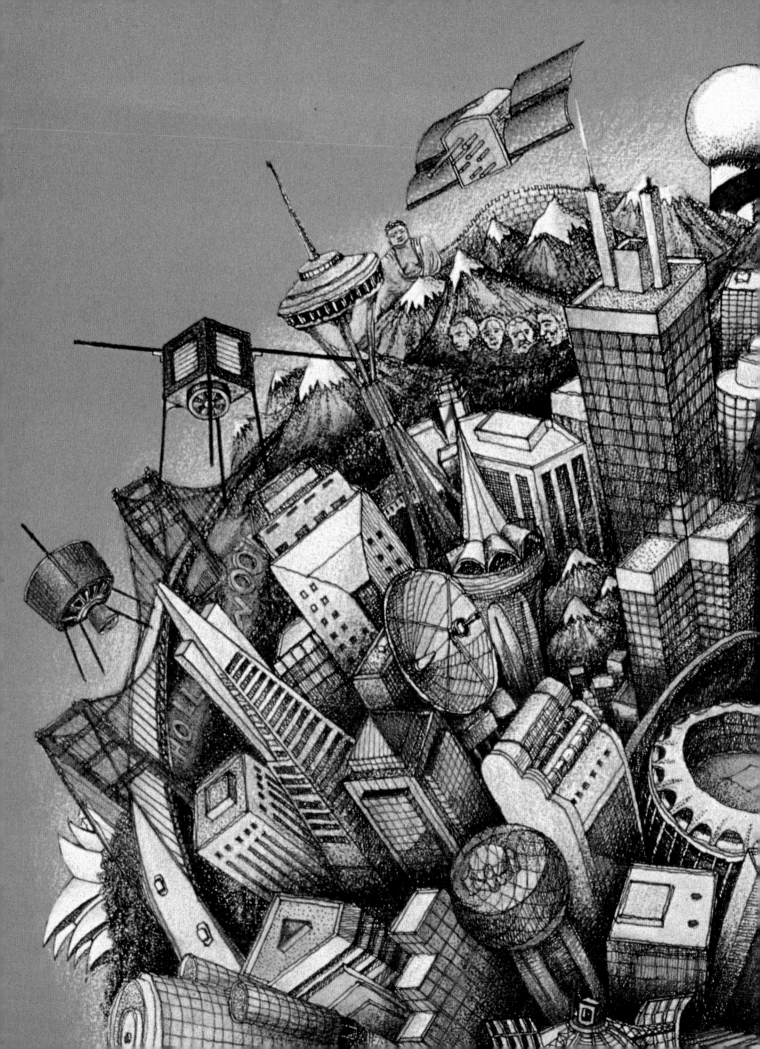

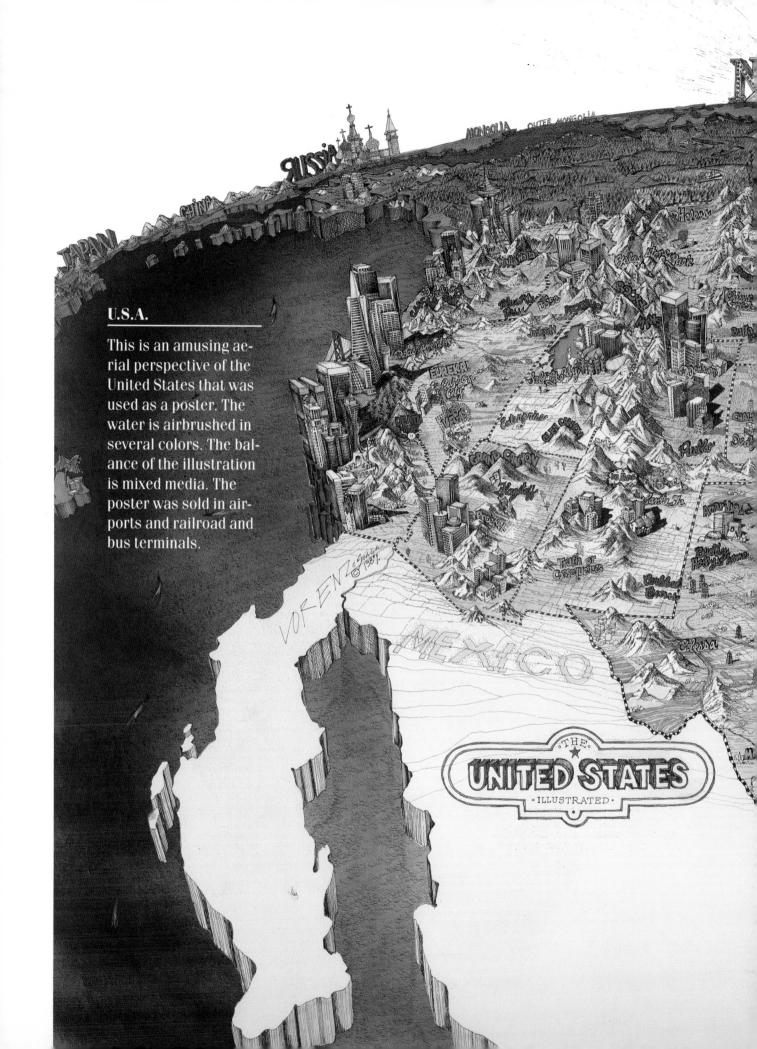

U.S.A.

This is an amusing aerial perspective of the United States that was used as a poster. The water is airbrushed in several colors. The balance of the illustration is mixed media. The poster was sold in airports and railroad and bus terminals.

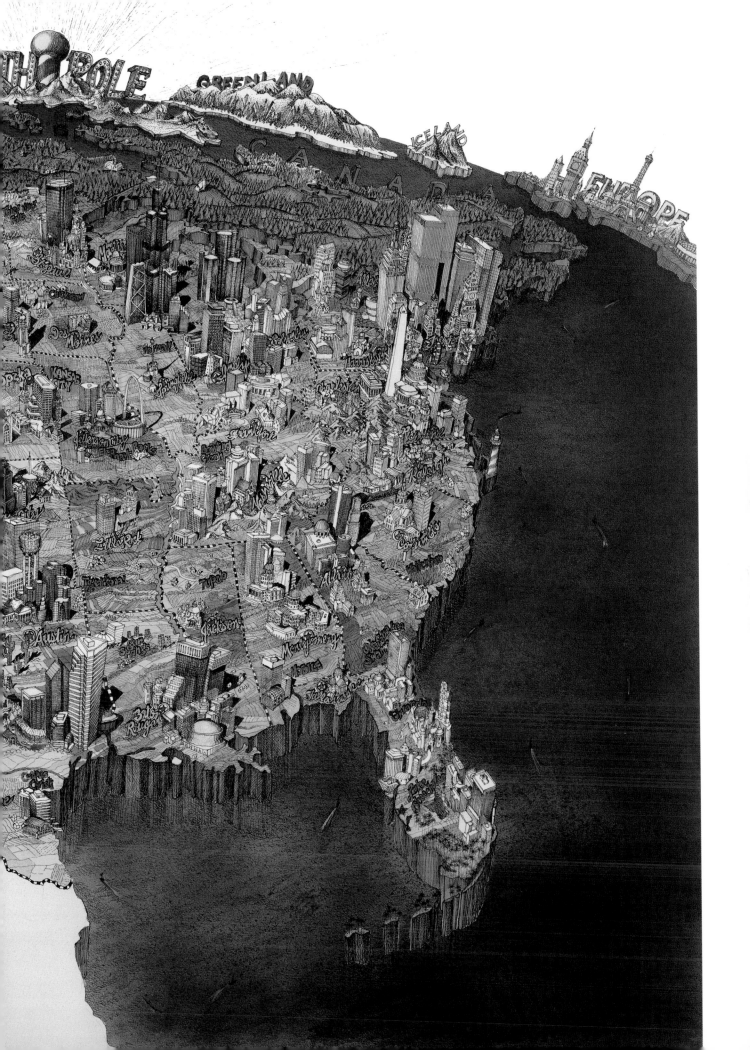

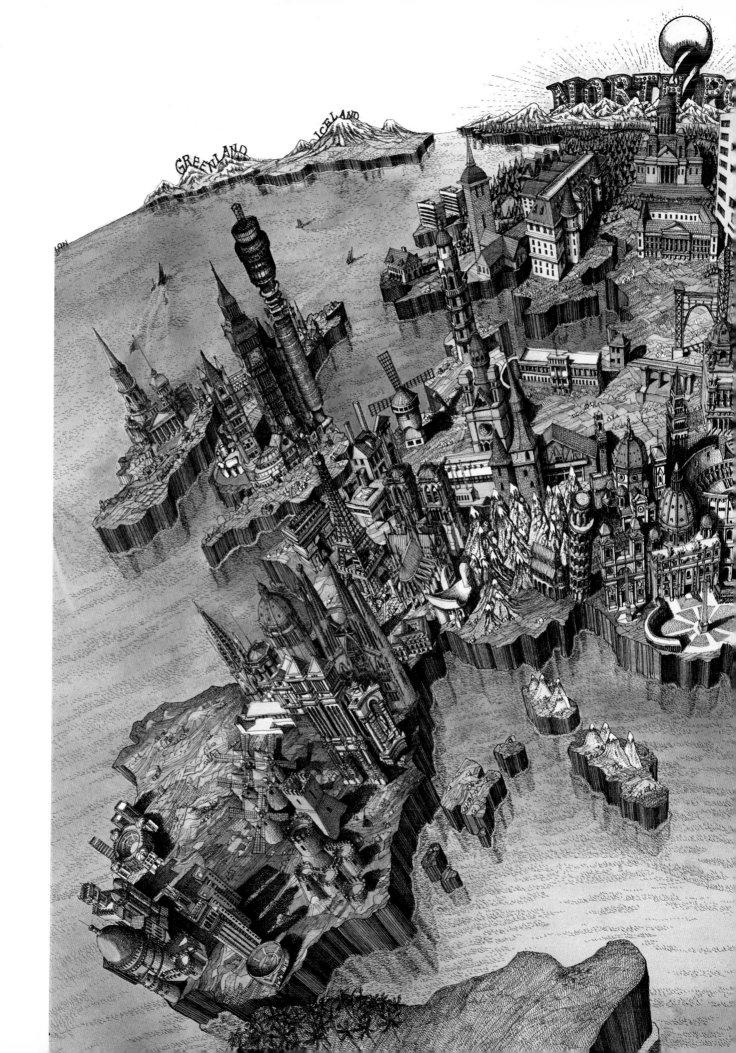

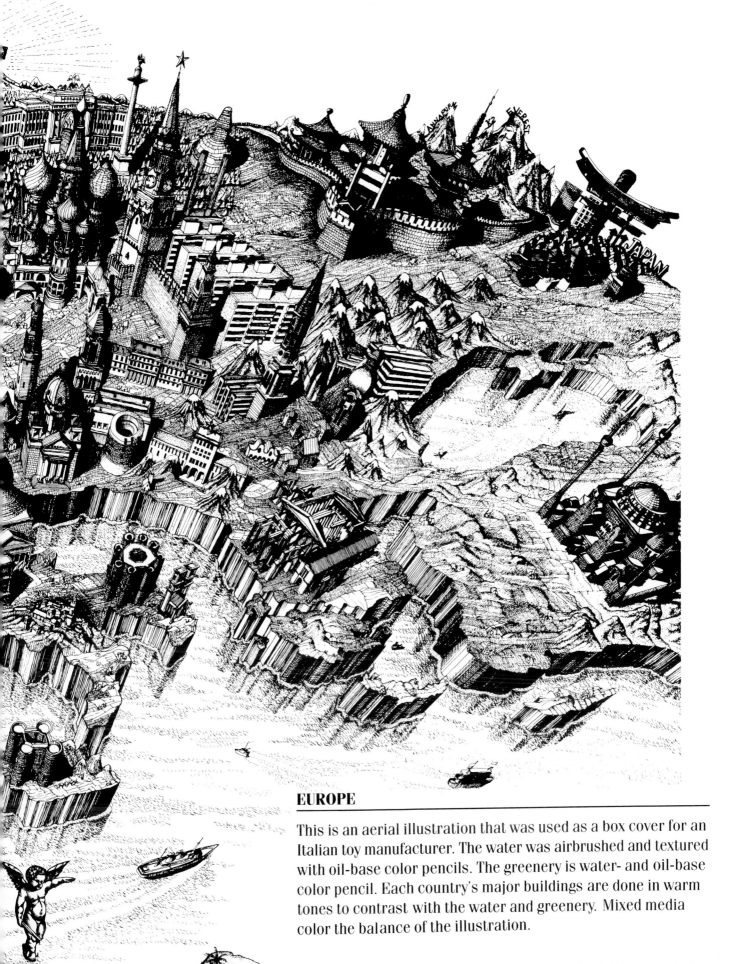

EUROPE

This is an aerial illustration that was used as a box cover for an Italian toy manufacturer. The water was airbrushed and textured with oil-base color pencils. The greenery is water- and oil-base color pencil. Each country's major buildings are done in warm tones to contrast with the water and greenery. Mixed media color the balance of the illustration.

PAUL'S JOURNEYS

This drawing is an example from a Bible for young readers. It was drawn to give children a sense of the apostle Paul's wide impact on the early Christian world. This drawing was done using airbrush, watercolor, and water-base color pencil.

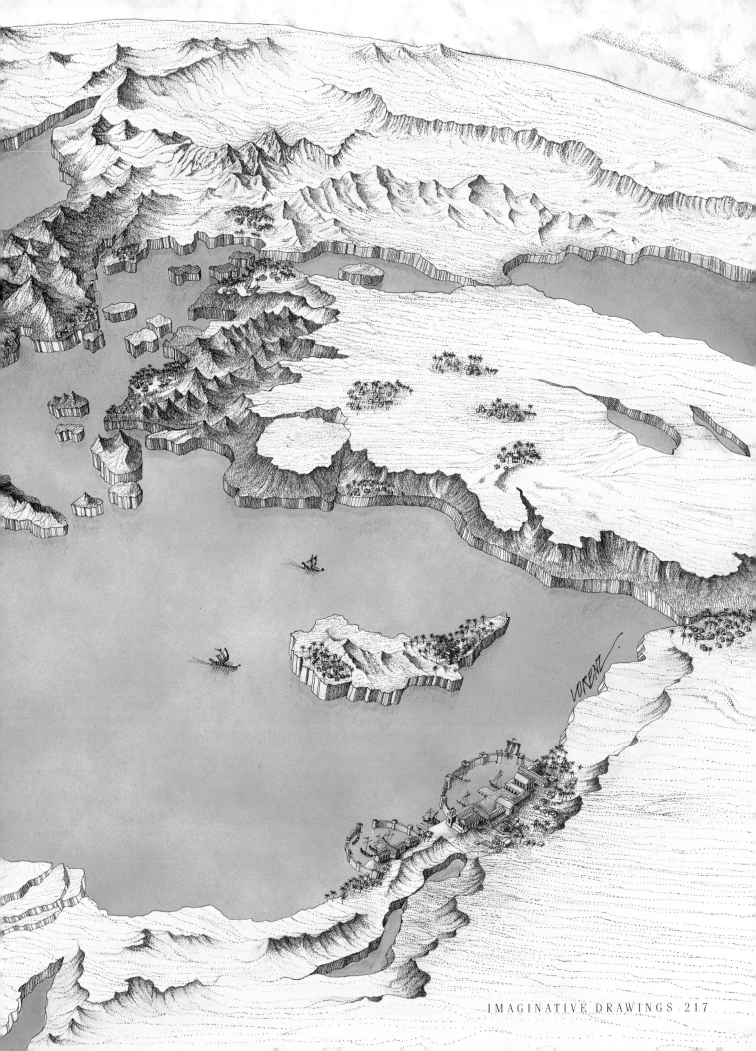

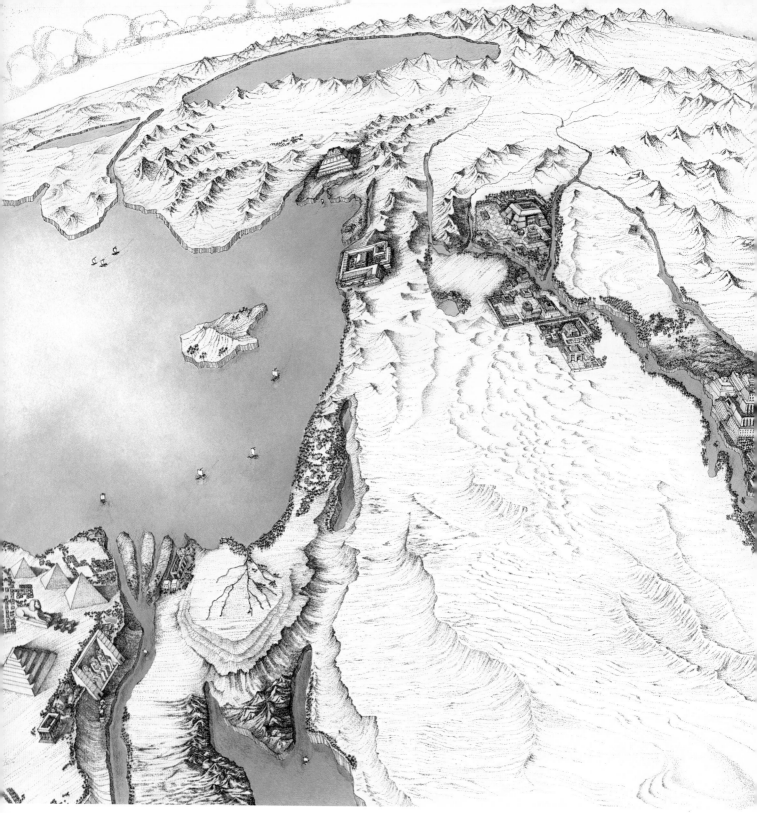

ABRAM'S JOURNEY FROM UR TO CANAAN

These drawings were also done for a Bible for young readers. The aerial drawings were used to give the reader a visual feeling of biblical locations. The drawings were executed using airbrush, watercolor, and water-base color pencil.

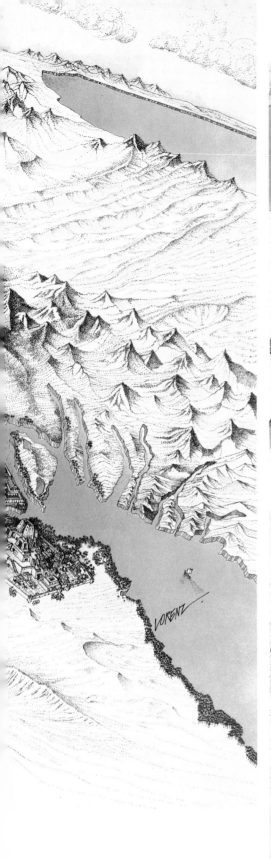

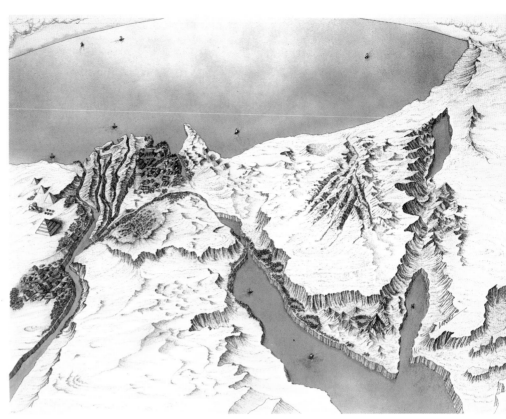

THE EXODUS AND FORTY YEARS IN THE WILDERNESS

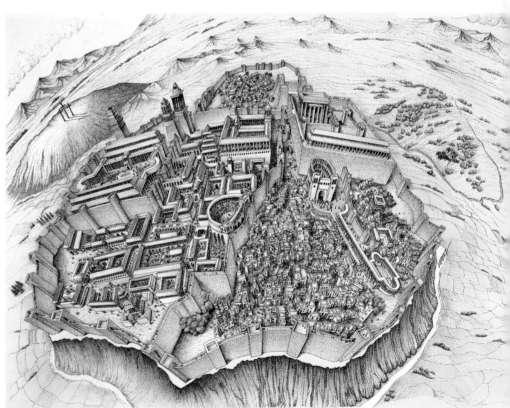

FOOTPRINTS OF JESUS: THE LAST WEEK

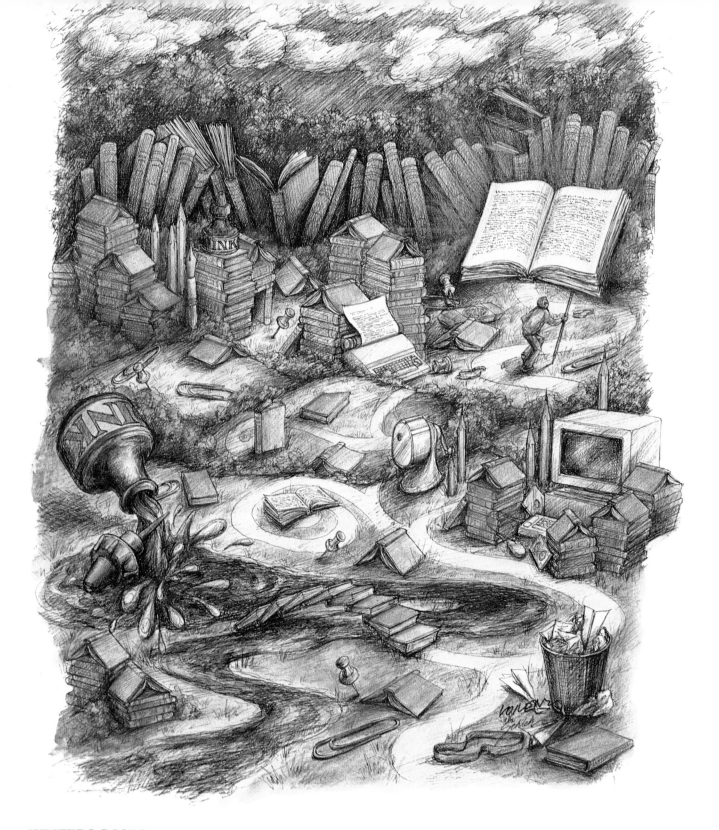

WRITERS DIGEST MAGAZINE

Muted, neutral tones were used for these figures. Hot or overpowering colors were avoided to make the drawing, not the color, take over.

TIME TRAVEL ▶

This drawing for *Scholastic* magazine illustrates the fact that children do not understand time sequences. The moonscape shows a youngster confusing eras from the dinosaur to Charlie Chaplin. The sky was airbrushed. Watercolor, color pencil, and gouache were used.

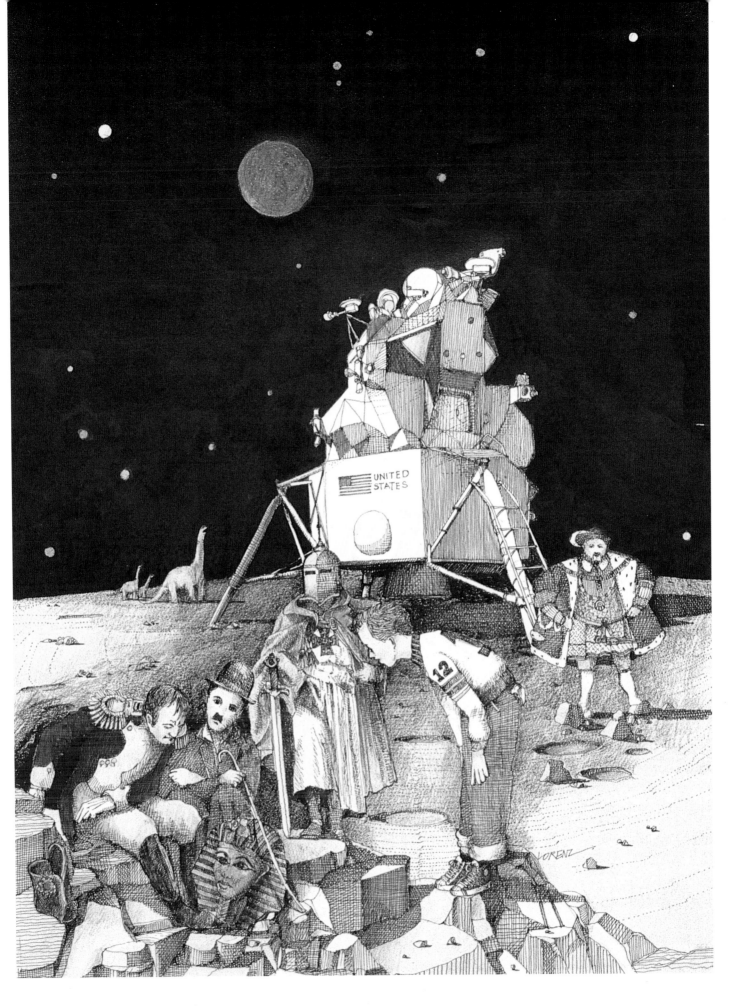

INDEX

Senior Editor: Roberto De Alba
Associate Editor: Carl Rosen
Designer: Bob Fillie, Graphiti Graphics
Production Manager: Hector Campbell